A POTTER IN JAPAN

1952 -1954

Image Acknowledgements

All images © Crafts Study Centre, University of the Creative Arts, Farnham, Surrey, UK. The publishers would like to thank the Crafts Study Centre for access to the Bernard Leach archives and for their assistance with this project.

Unicorn Publishing Group
101 Wardour Street
London
W1F 0UG
www.unicornpublishing.org

Published by Unicorn Publishing Group LLP 2015
Text Copyright © Estate of Bernard Leach 2015

Front endpaper: *Bird of Peace* Bernard Leach 1918
Soft ground etching, 11.7 x 15.2 cm, Crafts Study Centre.
Back endpaper: ink drawing by Bernard Leach, 1972, Crafts Study Centre.

ISBN 978-1-910065-17-4

5 4 3 2

Book design by Felicity Price-Smith
Printed in India by Imprint Digital Ltd

A POTTER IN JAPAN

1952 -1954

by

BERNARD LEACH

UNICORN

THANKS AND DEDICATION

My heartfelt thanks go out to all those friends who invited me to Japan once more and who overwhelmed me with hospitality and co-operation when I got there; above all to Soetsu Yanagi, Shoji Hamada, Kanjiro Kawai and Kenkichi Tomimoto who have taught me to see the light of truth and beauty still shining in their land. To them these pages are dedicated.

To the Mainichi Newspaper, which financed my outward journey, and to the directors of the great department stores where my exhibitions were held I would like to express not only my personal thanks but also admiration for their support of art.

I also owe a debt of gratitude to my wife, Janet, who was my companion during a portion of the last year and therefore shared some of its experiences, and has since helped in all manner of ways (including typing) in getting this book into shape and ready for the press.

CONTENTS

PREFACE

Before I started out on this long journey back to the East at the close of 1952, I made up my mind to keep a diary and to have it cyclostyled from time to time so that I could share with some thirty or forty of my friends in England and America the experiences which I anticipated. Someone must have told the Japanese Mainichi Press about this round-robin diary, at any rate I received a proposal for its publication, and agreed, hoping that some of my comments, and even frank criticisms, about the land which has become my second home might find an echo in the hearts of my friends. The book was published in Japanese in 1955, and is now in a second edition. The writing and the drawings were done in all sorts of odd moments and mostly on travel. I can only hope that what has been lost of form and sequence thereby may have been counterbalanced by some gain in closeness of observation.

Since my return at the end of 1954 my English publishers decided that there was a public in the West which would be interested in an intimate picture of post-war Japan and of the Japanese Craft Movement. The philosophy and aesthetics of this movement, the new based upon the old, were given by Dr Soetsu Yanagi, its leader, during August 1952 at Dartington Hall, Devon. Shoji Hamada, the potter, was also there to represent the craftsmen of the Far

East. Throughout this first International Conference of Potters and Weavers and during our subsequent journey across America, Hamada himself modestly but firmly refused to lecture, leaving that task to Dr Yanagi; so much so that I have been told since that there were some who did not realise that he could speak English quite freely.

Subsequently I travelled with these two old friends for four months from the East to the West coast of America, teaching, lecturing, and demonstrating. The impact of Eastern thought was remarkable and for that reason I have added an Introduction to the diary proper, covering the Dartington conference and our American journey. As one of the organisers of the conference I was too busy to keep a diary at that time, and even in the States my notes were only fragmentary and mostly written on aeroplane flights, but some of the impressions received and conclusions arrived at will I hope, serve to temper the otherwise abrupt plunge into the Japanese scene.

To those who, after reading this book, conclude that it is one-sided and that I am prejudiced in favour of the Japanese people, I plead guilty. But that does not imply that I am blind to their faults and shortcomings. I am well aware, for example, of the difficulty in reconciling the brutalities of their soldiers during the war with the experiences which I have described in these pages. Here is an anomaly which is hard to grasp. My own impression is that many of the stories are true. I do not pretend that I can fully explain them. My contacts have been closest with the Japanese artist and craftsman and I do not know the military, commercial or diplomatic life more than as a casual observer. The artists and craftsmen whom I have known, even before the war, have been uncommercial, anti-militarist and cynical about politics. The bulk of the nation who are farmers are concerned with the soil and the crops and their hardworking lives. They are not individual thinkers, they live in community, conservatively, the base line of the pyramid of society, healthy as farmers incline to be everywhere if conditions are tolerable, but very

easily led by authority. That authority, mainly militarist, has now been broken and there is no doubt the Japanese people as a whole are thankful. But it would be an utter mistake to presume that thereby the average Japanese has become a democrat. We have struggled for a greater measure of personal freedom for many centuries. The social structure of Japan was medieval until eighty years ago and people had to act according to public expectation and the approval of a religious and military dictatorship to an extent to which we have become quite unaccustomed. To some extent, this explains why a Japanese sergeant in the Philippines could butt-end American or British women in a concentration camp by day, when he was on duty, but at night brought them his own rations secretly. By day he was an unquestioning servant of authority, by night he was a human being.

The only hint at an explanation which I suggest is that the Japanese people have long been ground down under the heel of an oppressive system of government and have not until now known social and political freedom. Japan is like a mask with two faces, War and Peace – the Sword and the Tea-bowl. I have been concerned mainly with the latter.

Prelude, East and West

The International Conference of Potters and Weavers, the first of its kind, held at Dartington Hall, Devon, in August 1952, lasted ten days and to it came over 100 chosen delegates from some twenty countries. Thanks to the vision and generosity of Leonard and Dorothy Elmhurst, the organisation of Peter Cox, to an ideal setting and even to perfect English summer weather, this forgathering of craftsmen was extraordinarily whole-hearted. Possibly this was also due to the fact that the undertaking was entirely independent, although it had the support of the British Council, the Arts Council and of UNESCO.

The main objective was exchange of thought, and after the divisions caused by the war it was profoundly encouraging to discover that, in a matter of hours, differences of language and custom broke down completely and that the bond of common enthusiasm in craftsmanship welded the gathering into warm overall unity.

We were anxious that the East should be adequately represented so I was asked to invite my old friends Dr Yanagi, the Founder of the Japanese Craft Society and Director of the National Folk Museum, and the potter Shoji Hamada, to come and tell us about the philosophy of craftsmanship which they had developed during the twenty-five years' growth of their movement.

The Japanese Craft Movement was started and fostered by my old friend Soyetsu Yanagi. I claim that it is the most vigorous, widespread and unified in the world today. With about 2,000 active and supporting members, one central and three provincial museums, some thirty groups of craftsmen and about half that number of craft shops, with an annual turnover of £100,000, it has more impact upon society than any other movement of which I know.

My belief was, and is, that the East and particularly the furthest East has a significance for us in the West of paramount importance, representing, as it does, the greatest divergence of feeling, thought and action at a period in history when the barriers between cultures are dissolving and the need of mutual understanding and interchange is greater than at any previous time. I have myself been intimately connected with this movement from its beginnings and therefore felt a measure of anxiety regarding its presentation and the reception which it would receive. As it turned out, this anxiety proved unnecessary either at Dartington or during the four months of lectures and seminars right across the United States. The quiet message from the inner world of Japanese truth and beauty, presented in words by Dr Yanagi and incomparably demonstrated in clay and with brush by Shoji Hamada, gripped the imagination of audiences everywhere and formed the core of much of the discussion during the conference at Dartington. In all probability this was the first occasion on which an exposition has been given, at any rate on such a level of thought and action. The Japanese approach to the aesthetics of craftsmanship is derived in large measure from a Buddhist attitude towards life.

In that hinterland there is no room for over-stressed individualism. The ideal, whether for man himself, or for the work of his hands, is oneness, or attunement between the 'I' and the 'Not I', between beauty in man's work and beauty in nature. Consequently we heard of humility of a variety and application rare today but more familiar to Western man prior to the Renaissance, the Reformation and the

Industrial Revolution. There was reference throughout Dr Yanagi's talks to that vast world of undifferentiated, or impersonal, group-soul art of unknown craftsmen from which he as a successor of centuries of tea masters has drawn his sustenance and ideals. He calls it 'The Kingdom of Beauty'. The contrast between this impersonal art and our modern self-expression was amongst the more important issues which the conference brought into focus. Dr Yanagi's thesis is that contemporary art might well take a lesson in modesty, not only from the East, but also from our own inheritance of communal and more unified art and make the necessary step forward beyond sheer individualism.

Another and deeper aspect of Oriental thought which both he and Mr Hamada indicated, whether by word or deed, was concerned with Thusness, Nakedness, or Emptiness, a condition of being called in Japanese 'Mu',[1] a quality to be found in all good art, but especially in that of the Far East, where it derives not only from Buddhism but also from Chinese Lao'tze.

The Dartington Conference renewed the contact and interchange between the potters of my own country and that of my adoption and at the same time introduced craftsmen of Japan to fellow craftsmen of other countries. It also paved the way for our visit to the New World of American crafts and our reports both there and in Japan.

In the ample buildings and gardens of Dartington, the days were filled with lectures, discussions and demonstrations. At night there was music and folk-dancing and a constant breaking up into small spontaneous groups with frequent requests for repeated showings in the theatre of the lovely Japanese documentary film of Hamada's pottery background at Mashiko, and of the colour slides of old Japanese and Korean pottery and of textiles from the Okinawa Islands.

1. See Chapter 10.

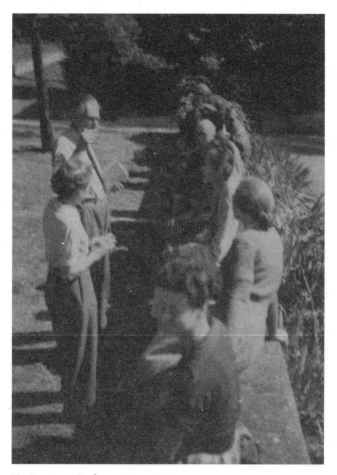

The Dartington Conference, August 1952.

Three exhibitions had been staged moreover to coincide with the meeting. One, retrospective, of pottery and textiles made by craftsmen in England during the last twenty-five years, which the Arts Council subsequently took to London and Edinburgh; another of work by the delegates, and a third of contemporary Mexican crafts. It was planned that the pottery and weaving should be approached from

the three angles of aesthetics, techniques and their place in education and some excellent lectures were given by chosen speakers.[2] With the dispersal of the participants and our subsequent journey to America, it is difficult to assess the practical results of this forgathering. It was not aimed, however, at immediate results, but certain conclusions were arrived at by those of us who have remained in touch with one another. Foremost was, I think, a realisation of the similarity of the problems confronting craftsmen in all industrialised countries. If as craftsmen we consider the world geographically, it separates into areas of machine work and handwork with the latter declining rapidly from decade to decade. Wherever industry penetrates, the products of the primary tool of man, the human hand, diminish and decline. To our eyes a strange shame and inferiority seems to grip people at an earlier stage of evolution than our own, even if their life and habit is more whole and unified, and the loss appears to us unnecessary and pitiful. Even in Japan, where the change has taken place only since about 1880, and where there is the greatest overlap, it was difficult for my wife to convince provincial newspaper reporters that she had really come from the United States to a remote village of potters as a student of rural craft. In like manner, West African student potters coming to England would, many of them, prefer to study our latest industrial methods at Stoke-on-Trent and they would be far more welcome on their return if they did so. I have travelled enough to see the devastating speed with which fine traditions of right making, developed slowly by myriads of patient, loving craftsmen, over hundreds of years, are lost so briefly under this impact. Conditions alter and much has to change perforce, but there is irreplaceable wastage involved because the village potter or weaver cannot make the sudden jump from village to world thinking. On the broadened stage, he can no longer distinguish good from bad and has apparently to make all our mistakes over again.

2. Copies of a published report on the whole conference may be obtained from the Arts Department, Dartington Hall, Totnes, S. Devon.

The only compensation, and it is quite inadequate to replace the wide array of beauty in the common things of life previously provided by hand by the people themselves, is to be found amongst a mere handful of conscious artist-craftsmen and designers for industry such as those gathered on this occasion. Such artists in crafts, drawing their inspiration from all sources eclectically, are too seldom given the opportunity to employ their faculties of design in material to the common good and in close connection with the normal demands of ordinary life. In most cases they have a hard struggle to exist and are usually forced to fall back upon teaching others, the best of whom arrive at the same predicament. The position in Denmark, Sweden and Finland is somewhat better with their smaller economies and greater overlap between the hand and the machine. The same holds true in Japan, but there, in addition, an unparalleled appreciation of artistry in crafts and of the sheer need of art in life still continues.

The evidence brought together indicated, unfortunately, that in most countries, but especially in England and Japan, the cleavage between the hand-craftsman and the designer for industry was wide. In England, the birthplace of both the Industrial Revolution and of the Arts and Crafts counter-movement under William Morris, his followers have tended to be purists and recluses, at daggers drawn with the machine, and on the whole industry and the architect have ignored them. On both sides the waste involved by mutual ignorance and lack of sympathetic understanding of what each could contribute to a living whole is incalculable. It was the Japanese impression, which I shared, that modern Danish furniture gave the best example of the way in which co-operation can provide a better answer. In the field of ceramics we could not be quite so enthusiastic. Dr Yanagi and Hamada visited the Scandinavian countries and Finland and found that although the artist potter was appreciated, and often worked in factories, his interest was in pattern on pots and in glazes more than in the pot itself, and it is noteworthy that he is called

an 'engineer potter'. At the great Arabia factory near Helsinki, the director with pride showed them the ninth and top floor, the whole of which was given over to artist-potters' studios, and explained that the artists were entirely free and that this was the firm's contribution to culture. When Dr Yanagi asked what was the connection between the top floor and all the floors below the reply was, 'None whatever'. It is evident that a new type of craftsman designer is needed, one who know both worlds from inside. That rare type of man who knows with his hands and his brains, but most of all with his heart.

At Dartington, Mr John Bowers, Head of the Fundamental Education Division of UNESCO, gave an address describing the efforts being made to assist or develop craftsmanship in what are called the 'backward areas' of the world. His very sympathetic remarks called forth an almost explosive outburst of emotion from the potters from West Africa. Their protest evidently sprang from a smouldering desire for self-determination in life as well as in crafts. They said in so many words 'We do not want your condescension, but we would be glad of your help when we ask for it.' I shall return to this problem of the interrelationship between white and non-white races when commenting on the first Asiatic UNESCO Conference in the last chapter of this book. Here I would only like to state my conviction that the spirit of a people can only flower as art under conditions of real freedom.

The background of crafts in the United States and Canada differs from that in either Europe or Japan in two ways. In the first place America as a new amalgam of races does not provide a craftsman with traditions of right making born on its own soil, secondly, its contemporary movement is, by and large, a post-war growth in a setting of high industry. It is certainly true that the American Indians developed splendid basketry, weaving, woodcarving, pottery, etc., and that it was indigenous, but their life was too far removed in character to form a groundwork. English, German, Italian, Spanish

and Dutch craft skills were also carried across the Atlantic but died out almost entirely before they could contribute to a new American synthesis. Therefore the craftsman in America looks out over the whole world for stimulation with a greater necessity than anyone else and he does so from the most mechanised of all countries.

Speaking broadly, the two directions from which American potters derive their ideas of shape, pattern, colour and technique today are from the East and from the West; across the Pacific, or across the Atlantic; from China, Korea and Japan on the one side, and from the contemporary movement in art and architecture on the other. One can say of a large proportion of the pots turned out by the 70,000 non-industrial potters that they are 'Bauhaus over Sung'. This does not limit the influence of modern art strictly to the Bauhaus, but insofar as Walter Gropius and Maholy Nagy emigrated to America to escape from Hitler, the former to Harvard and the latter to Chicago, their influence has spread very widely. I met Gropius in Japan and with Dr Yanagi took him and his wife around the folk museum in Tokyo and watched them run with enthusiasm from showcase to showcase. I also heard him blame young Japanese architects for copying the mannerisms of Western architecture without realising its great debt to Japan and without a discriminating pride in their own inheritance. But when I visited the Bauhaus exhibition, then being held in Tokyo, I could but wonder how the 'inside out' arts of Japan were going to absorb 'outside in' arts from the West, born of the age of science, rationalism and industrialisation, without that natural pride. After living for the greater part of two years in the atmosphere of Japanese handcrafts the impression given by this exhibition was by comparison cold and intellectual.

There is evidently a widespread feeling in America that the severities of functionalism need tempering for the purposes of ordinary living. It was interesting to observe that pottery and other crafts, produced today, were in much more common use in modern houses than is the

case here in England. Young architects were introducing them to a broader public and there was nothing like the cleavage which still exists here between studio workshops and the industries. Americans like the irregularities and broken textures and colours of stoneware clays and glazes, and the potters make a point of displaying them, and there is a constant effort to get away from circular form, resulting in what is known as 'free-form', but, as Dr Yanagi remarked, 'it is least free'. In other words the over-selfconscious effort defeats attainment of the objective. In weaving another catchword and pitfall was 'glitter'. Hand-spinning with its long discipline is rarely attempted and in order to obtain texture all sorts of dry grasses, cellophane and metal threads are introduced into the weft of furnishing and other materials.

With the extraordinarily large number of people taking up one craft or another after the war, the general standard is not high, nor for that matter is it in any other country. One must concede that at no period in history has so low a standard existed. Too much has taken place in too short a time and we are all suffering from aesthetic indigestion.

I have searched for the reasons why, after the Second World War particularly, so many people have sought relief, escape or expression in the arts and in the crafts, and in pottery most of all. My own conclusion was brought to consciousness during long night journeys to London, during the bombing, when I heard ordinary soldiers, sailors and airmen, in the greater familiarity of danger and discomfort, say that 'when this bloody war was over they were bloody well going to do a job they liked'.

The disciplines, boredom and destruction which everyone had to endure canalised a deeper-seated unrest inherent in industrial civilisation. The dissatisfaction is due, I believe, to starvation; the lack of outlet in normal work for emotion and imagination. In America, with no craft traditions passed on from one generation to

another in patient apprenticeship over many years, crafts are taken up with great enthusiasm in brief courses in art schools by men and women as a means of self-expression. Women of middle age seem to form the majority, women whose child-bearing is over, whose homes, full of labour saving gadgets, can be run on a couple of hours' daily work, who find an outlet in making pots or textiles, enamelled plaques or silver ornaments in the freedom of a room of their own. Not many depend upon it for a living although there are roadside craft shops on the great motoring highways all over the country. With the disappearance of folk-art that will really become the position everywhere; the American position is therefore a forecast of the one which will overtake us all. The cost of labour over there is, by comparison, exorbitantly high, and, foreseeably, it will become higher here, therefore the craftsman will be driven further and further towards solo production. Economists, even before the First World War, were calculating that, given peace, the ordinary work of the world could, with reasonable international organisation, be done in a four hour day. Clearly that day is not yet in sight, but it seems to me that the position of the American craftswoman is already an indication of what is ahead, a basic wage for basic work, and a good deal of time left over for small-scale, and more expressive, life, with many more people taking up an art or a craft. The first results, to be expected, will be an outpouring of such ill-directed efforts as the world has not seen before since we have a habit of maltreating our newly won freedoms before we learn by painful experience their proper use. Fortunately there is also a dogged persistence in mankind which struggles slowly towards the light. My belief has been fortified by the experiences of these last years in the slow emergence of truer and more widespread appreciation and production of all arts and all crafts. The work of the human hand will then become the ally and not the enemy of the machine.

In St Paul, Minnesota, we three were invited to be the guest judges

of a national competitive exhibition of crafts and therefore had an opportunity for a close scrutiny of the kind of work which is being produced. Let me say at once that it showed far more openness to contemporary influences than could be found in a corresponding craft exhibition in England. This was proportionate to the absence of traditional restraints, to what Americans feel is our dull conservatism and our habitual understatement. Being inescapably British, I cannot get away from the impression that much of the work which I saw lacked the virtue of restraint and the support of tradition, and that an over-selfconscious desire to be in vogue and at the same time 'different' ruined it. That may have been merely British prejudice, but it was shared by my Japanese companions, who whilst they admired much in the openness of character particularly as shown in modern domestic architecture, nevertheless felt that it was still too soon to look for mature American expression through crafts, simply because crafts as we regard them historically are a slow flowering of the sense of fitness and beauty in the normal background of life. But past history is not the sole criterion, for time moves on, and homes are not what they were, and the machine is replacing the hand, and universal education, even though it be but a half-education, has completely altered the degree and quality of consciousness with which such a thing as a pot is conceived and made. Even if American architects and housewives want it to be hand-made and to look hand-made, and are willing to pay the price, it can never have the unselfconscious nonchalance, for example, of the Korean pots in Dr Yanagi's 'Kingdom of Beauty'. But it may transcend showmanship and self-consciousness if it is made by a true enough artist. Hamada remarked that being a new country neither he nor Dr Yanagi expected good pottery but that they both found it exceeded their expectations, and they left with great hope for the future.

CHAPTER 2

Japan – First Impressions

FEBRUARY 16TH 1953

Eighteen hours' flight carries us from Honolulu to Tokyo but by man's regulation of time, this day is cancelled – does not exist. In spite of that we have just spent an hour at Wake Island which is just a bare coral lagoon. Pale green water inside and deep blue out and no coconut palms. The place has recently been laid flat by a storm.

This smooth crossing of the clouded expanses of the Pacific, so briefly, so impersonally – a footfall on a coral beach – seems incongruous and incredible. What would Leonardo da Vinci have said to this fulfilment of his dreams?

We arrived without incident at Tokyo Airport. As we climbed down from the Clipper we were surrounded by a jostling crowd of journalists and press photographers who kept their flashes going vigorously until we retreated into 'Customs and Passports'. By that time we had become last in the queue and had to wait tediously. When our turn did come, however, the officials waved us through without any examination at all. Meanwhile, through glass doors we saw many familiar faces. Released from officialdom I hoped to get to old and new friends, but no. Pushing through the mob, I suddenly came upon Hamada half lying on a seat with people kneeling around him thrusting what looked like vacuum cleaners at his mouth! I

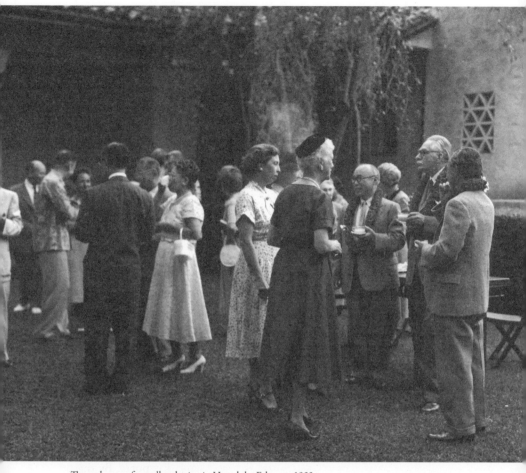

The author at a farewell gathering in Honolulu, February 1953.
Photo credit: Raymond Masato

thought he must suddenly have turned faint and that they were
trying to revive him, but the next moment I was more or less pushed
down alongside and the nozzles came at me together with question
after question in Japanese, 'What are your first impressions? How
long are you going to stay? How old are you?' and I realised that this

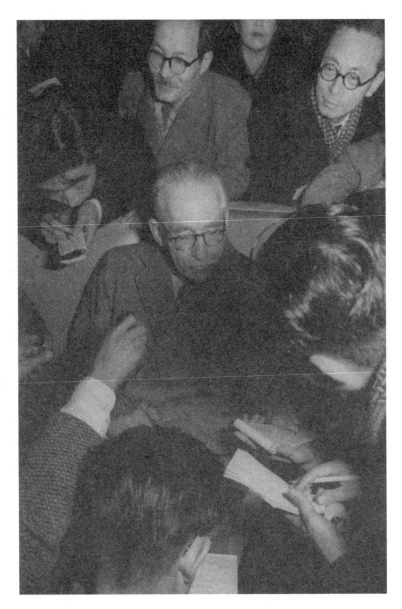

The author surrounded by journalists upon arrival in Tokyo, February 17th 1953

was *RADIO*. Words failed and I stumbled replies and felt as sick as Hamada looked. Eventually we got away in various cars and gathered at dusk at Yanagi's house opposite the Mingei Kwan (National Folk Museum).

FEBRUARY 18TH

I saw the museum first thing this morning – a well-adapted type of old countryside building, substantially and well planned and fitted up inside, containing a magnificent collection of crafts, Japanese and Korean predominating, but also including crafts from China and abroad. It is not limited to folk-crafts either, for work by leading artist-craftsmen is prominent. Everything was beautifully displayed, 'especially for me' Yanagi said. There are large reserves and the exhibits are frequently changed.

Traditional stone buildings are rare in Japan but in Hamada's province of Tochigi a soft volcanic rock is quarried which was used in old days for fire-proof buildings and even farmhouses. Twenty years ago when we were travelling together towards the further Nikko Ranges by car, we saw such a building and got out and examined it, and began to consider the possibility of buying it and having it transported block by block to Tokyo. Eventually this was actually done and that building is Yanagi's house, in which I am living, which forms a part of this independent folk museum. It is interesting to note that this stone is now the ordinary building material of the capital and was employed by Frank Lloyd Wright for the construction of the famous Imperial Hotel in Tokyo. Furthermore, when ground into a fine powder it forms the commonest glaze used by potters in this part of Japan and is called 'Kaki'.

When we got to Yanagi's house last night it was filled with relations, friends and craftsmen and we stood around a long table and ate a great meal out of lovely bowls and dishes and cups. It was a generous sort of medieval affair, steam and joyful voices of children, all very

warm and happy. I noted a greater freedom of the women. My old master Kenzan's daughter, Nami, came and wept as she held my hand saying that she had feared that she would never see me again.

This afternoon we all went to the main Tokyo Craft Shop, Takumi, and looked at its contents, many of which were disappointing. We told the staff about our journey and discussed practical matters. The Takumi shop is one of the sales windows of the Craft Movement in Tokyo and is much patronised not only by Japanese but also by foreigners. It gathers its stock from all over Japan and helps to keep many local handcrafts alive when they would otherwise vanish under the competition of ever encroaching industry. Even so, standards of material, workmanship and design are deteriorating and a lot of work is sent to Takumi which either falls short of tradition or is not up to the standards of the best artist-craftsmen.

Then we drove on to the 'Mainichi' newspaper office to a cocktail-party reception given by Mr Honda and his staff. Quite a crowd including Dr Shikiba, the author of my biography, and Marquis Asano, who is now director of the Imperial Museum. Driving back I could only recognise the roads around about the Palace moats and parts of the old business area. Tokyo and most of the big cities were very extensively damaged, mainly by incendiary bombing, but one has to look carefully before one realises this. Japanese houses are largely built of wood and the race is energetic, so the wounds of modern warfare are already hidden, unlike London with its gaping cavities.

FEBRUARY 19TH

It is after 2 p.m. and my eight-mat room (12 ft. x 12 ft.) is cold until the little oil stove gets going. It has been snowing all day, gently with large flakes, and the pine needles outside my window are thick with it. The roofs of adjacent houses framed by light joinery with paper panes might be taken straight from a soft page of Hiroshige's woodblock prints.

Takamura and his architect friend Taneguchi spent the morning with us and then we had a delicious lunch with all the family. Takamura, sculptor, poet and critic, my first Japanese friend (in London) of forty-three years' standing, he seventy and I sixty-six, both grey-white old men. It was Takamura who, upon his return from Europe a year after my arrival in Japan in 1909, turned on me and said, 'Why do the English people call us "plucky little Japs"? Do they think we like it?' I mumbled an apology for our condescension but he went on, 'When our conscript soldiers were defeating the conscript Russian moujiks in Manchuria, every household in Japan was reading Leo Tolstoi; it was Tolstoi who won the war. He won our hearts.'

It has been a moving meeting and the talk, though in Japanese for the most part, with an occasional explanation by Yanagi, very interesting, recalling old days in London and Paris – recounting parts of our experiences in America – New Mexico with the American Indians – Hawaii. We looked at their products, silver, retablos, tapa, and wooden bowls (which Yanagi has collected, en route, for the Museum) – appraising them with common enthusiasm and the life and climate and racial history behind the work, then turning our attention to Japanese crafts, old and new. Plus and minus in England, America and Japan.

During the discussion Taneguchi, who seems to be a good architect, brought out an indigenous reason for the aesthetic acceptance through Zen Buddhism of the Taoist principles of emptiness, the negative, and of asymmetry. He put it down in the first place to the very form and nature of the land. Volcanic, isolated, irregular, lacking the great continental plains of China or Egypt, or America. Town planning in China is N.S.E.W. and all is squared and symmetrical with Confucius outriding both Laot'ze and Sakya Muni. Here even the graves of the ancient Japanese emperors are irregular. The highest development in this left-handed approach to form has taken place

here in these islands where all the waves of Oriental culture have come to rest and the sea has provided a margin of safety until now. We went on to talk of the 'perceptive eye' – the Japanese eye above all, developed over the centuries by the spirit of quietude in the 'Cha Shitsu' or Tea Rooms, the special rooms used for the Cult of Tea, itself the relaxation in the first place of Zen Monks. Arthur Waley has told us what Zen Buddhism owed to Laot'ze but we have not heard enough of what Japanese aesthetics owe to Zen. Lafcadio Hearn pointed out many years ago how a land of earthquakes was almost bound to develop an art which laid emphasis on the impermanent, e.g. Japanese architecture and poetry, hence, therefore, Japanese difficulty in dealing with town planning and large sculpture and success with the brief and the small and the asymmetrical poignancy – instead of mass.

To these explanations by Hearn and Taneguchi I want to add the partially Malay origin of the Japanese. The roving sea Dyak who cut his way up the China coasts about 1000 B.C. with a steel blade before which the iron sword of China failed and the Ainu inhabitants of Japan fled north. I am convinced that much of the cleanliness, deftness, daintiness, sensuousness and piquancy of Japanese life and workmanship derives from this source.

We met again at a lovely restaurant which we had all to ourselves for lunch given by the leading Japanese monthly – *The Chuo Koron* – during which a symposium was recorded by stenographers as the basis for a long article on our journey. Mr Ishikawa, with whom I stayed in a flat looking down on Leicester Square in London in 1934, and who was then a reporter for the Mainichi, was there as Question Master. Everything was done with ease and naturalness and the setting was exquisite. The party closed with informal ceremonial tea. *The Chuo Karon* wants to publish a Japanese version of my *A Potter's*

Book[1] and is in touch with Fabers about it.

There have been a number of other broadcasts and reports. So many that Yanagi and I escaped round Tokyo Bay to the warm peninsula of Boshu, some 70 miles by train; to a quiet Japanese hotel in a small town called Tateyama, quite near the village where my wife and I spent our first summer holidays in a Zen temple forty-three years ago. There was no railway then and our life, ignorant as we then were of customs and language, was far from comfortable, cooped up, short even of food when the rains came – what rains, ten days and nights on end! This time it was a delightful rest and we got much writing done. I painted with brush and Chinese ink on Japanese papers, pictures and pot drawings for my coming exhibitions, kneeling on the floor. Food was ample and quite good, both Japanese and Western. It was so much warmer than Tokyo which we left under snow. Plum blossom was nearly over, oranges hung golden in the garden, camellias and magnolias everywhere. The lanes with high-trimmed hedges, some were over 20 ft., prosperous farmhouses and glimpses across flat rice lands so pleasant for our saunters towards dusk.

MARCH 3RD

Upon our return I went with Hamada and Yanagi and gave a public talk at the Matsuzakaya Department Store near Ueno Park. About 300 people. I spoke for twenty-five minutes and Yanagi interpreted. We also showed the St Ives pottery film. Interpretation, however good, stops the flow and I wondered if I could manage to speak in Japanese. It is in the art gallery of this store that the Craft Movement has arranged for my first exhibition of pots and drawings sent by boat from England. It is to be held in a fortnight's time.

I had an unexpected visit from a cousin of Kame Chan's. She said we had visited her house forty years ago when she was a girl of fifteen.

1. This has now been published in Japanese and is in its second edition.

She told me Kame Chan had died of consumption at his father's house. She did not know where he was buried. Father and Mother had both died since. Poor Kame Chan! What was the purpose of his life? Would he have been happier if he had never come to me with a newspaper reproduction of one of my etchings in his hand all those years ago, begging to be my student and bottle-washer when he was thirteen? He himself used to say 'NO'. If I had had greater foresight and insight I might have known that a training in art with

The author with Hamada to his right, 1953.

a foreigner for a penniless Japanese boy would only lead to a difficult future. I did realise after two or three years but it was already too late, but I could not have guessed that it would end in dementia praecox and such loneliness and ineffectuality. He loved art, William Blake, Cézanne, Van Gogh, and he did make some good drawings before the mad-house claimed him. Poor Kame Chan.

Supper with the Blakes at the United Nations Club. It was she who saved the museum from sudden and arbitrary occupation by USA officers during the occupation. She just happened to come to see it and found a frantic packing-up going on, listened to the story and quietly went straight to headquarters to the right person and got that folly stopped. The American military headquarters adjoin the museum and no doubt it would have been very convenient for living quarters. Of this I have daily proof because pencilled on the wall of my lavatory above the wash basin are the orders 'Remove – replace with shower' written there by the occupation authorities.

That was the museum's second escape. The first was during the incendiary bombing when the adjacent houses were ablaze and the bushes and trees right in front of the building were burning. The Yanagis were fighting the flames with bucket and broom and the burning wind changed its direction at the last moment.

MARCH 6TH

Meeting of young craftsmen at the museum including a number of women students of Serizawa, the dyer and stencil artist. Discussion on crafts abroad and on weaknesses in the Japanese world of craft, difficulties in selection of work and of leadership without stress on authority. The essential nature of spinning and dyeing, the astonishing lack of these processes in America. They asked me about the textile aspect of the Dartington Conference. I concluded by telling them about Ethel Mairet – of whom they already knew a good deal – her life, her work and her death whilst we were in America. A memorial

exhibition in the museum is proposed.[2.]

The gathering lasted five hours and of course it was fed. I have not mentioned an earlier gathering of about 100 craftsmen from all over Japan who came here to welcome us and to hear our story.

MARCH 7TH

We visited Yoshitaka Yanagi this afternoon – a good weaver – Yanagi's nephew. I looked at his work and tools, new and old, beautifully made old shuttles. He himself designs and makes looms.

They were very fine. Incidentally he introduced me to woven silks from the island of Hachijo with dominant and glorious black and yellow vegetable dyes.

In the evening our old friend Mr Kawasaki came, and we spoke of the war years and of his days at St Ives and of my children. Kawasaki was bombed first out of one and then another house in Kobe. His main concern almost seemed to have been the loss of some of my pots and one drawing. Kawasaki was head of the great shipbuilding firm of that name and as such was 'purged' and had to retire from public life for seven years. Now he is manager of the New Oriental Hotel in Kobe. The same lovable man as ever, but saddened.

MARCH 11TH

Yanagi and I went to lunch at the invitation of Sir Esdel Denning, our ambassador. Amongst the guests was the cultural attaché Mr Redman, and Colonel Figgis, who vies with Sir Esdel in collecting early Chinese pots.

Next morning we attended a cocktail party at the Closes (British

2. Ethel Mairet was unquestionably the outstanding English weaver of this century. Her first husband was the famous Indian art critic Coomaraswami and she spent about four years of early married life with him in Ceylon absorbing ideas of craftsmanship and colour from the Orient which she subsequently integrated in her work, first at Chipping Campden and later at Ditchling in Sussex. The debt which weavers both in England and abroad owe to her inspiration has never been adequately acknowledged.

The author with Yanagi and family, March 7th 1953.

Council) to meet Fr D'Arcy, S.J., who is on a visit to Japan on an inter-cultural mission. Campion Hall, Oxford, very intelligent and clear minded; a philosopher and a lover of art and an English gentleman. Quite a throng, mainly Japanese, some I knew. I was introduced to Princess Rhee of Korea, who said she possesses one of my pots which Hamada gave her. In chatting with Fr D'Arcy about Augustus John's portrait of him and about John's later work compared with his earlier drawings (one of Dorelia which I gave Yanagi in 1920 is hanging in the museum here), and then of Stanley Spencer and a queer repellent streak in his more recent painting, Fr D'Arcy mentioned the 'mid-day Devil' of whom the Catholic Church gives warning. Mid-day to be taken also as mid-life.

MARCH 14TH

We went to the Matsuzakaya Department Store to arrange the exhibition and to mount and hang the eighteen drawings I had done during the previous week. Found a crowd of assistants at work and had practically nothing to do myself except make a suggestion here and there. They have the eyes to see, the deft hands to carry out and an extraordinary co-operative willingness. Posters all over Tokyo, well-illustrated invitation cards, a Japanese edition of the St Ives Pottery Brochure with new plates, meals at good restaurants, transportation, etc., all provided.

MARCH 15TH

Private view all day, half a dozen Westerners and, to my surprise, and somewhat to my confusion, Prince Takamatsu, the younger brother of the Emperor. He spoke to me both in English and in Japanese. I apologised for mine, for the form used for the Imperial family is peculiar and of course I don't know it, but he put me at ease and after he had seen the exhibition we had foreign tea together and quite a talk.

He had an intelligent face and gave me the impression of being genuinely interested.

MARCH 16TH

This evening we all went in force to a public recital by Kaneko (Mrs) Yanagi who has for many years been recognised as a leading contralto in Japan. Frankly I did not expect to be moved by her singing, especially as she is now elderly, for in earlier years, though often surprised by her range and technique, I had not felt that she had reached freedom of understanding and expression of Western music and of the spirit behind it.

The house was full. By the end of the third item on the programme, a group of Schumann songs, I had changed my mind and at the end of

the performance, which included Mahler and a Japanese composer, Nobutaki, I felt I had done her an injustice over many years and that now she was a mature and poised artist. There was simplicity and dignity and great delicacy, not only in her treatment of the music, but also in her every movement, in herself.

MARCH 17TH

This morning Yanagi and I set out early by bus and train for Kamamura to visit Dr Daisetsu Suzuki's Buddhist library. Dr Suzuki is the leading writer on both Zen and Shin Buddhism, both in English and Japanese. We met him several times in New York. He is now over eighty. He has done more than any other man to make known to the West the quality of Zen thought and life. Yanagi was his pupil when he was a student at the Peer's College and is now Chairman of the Committee which is responsible for the future of the library. Yanagi himself has developed his aesthetics mainly from this source, although as a doctor of philosophy he has a wide horizon. We had some hours of very enlightening talk with Dr Suzuki in his little flat looking down on the Hudson River, when we were in New York. All three of us felt that he was a great man, a man of real depth and direct perception. Of Buddhism, he said to me, the objective was that state of mind which lies beyond dualism, but which can employ either approach without attachment. Of Zen and Shin, representing the way of individual endeavour and the humble road of self-forgetting, respectively, he remarked that the apparently different ways meet at the top of the hill. The narrow way of individualism of the genius, and usually the artist, is full of pitfalls and self-deception, he said, whereas the broad path of humility and reliance on 'other Power' (Tariki Do in Japanese), reliance on 'Amida', or on 'Oya Samma' (the nearest Buddhist equivalent to our concept of God), sheds our self-bound propensity proportionately to the giving. Which seems to me good psychology and perennial morality. Yanagi carries this idea to

the modern craftsman.

In the afternoon we forgathered at the house of a man of tea and incidentally one of the best antique dealers. We sat and examined old tea bowls and a set of ten genuine 1ˢᵗ Kenzan dishes. These he has agreed to lend to the Kenzan exhibition next month. One of the tea bowls, of an early Korean type known as 'O Edo', though much mended, was noble, and afterwards, on the way to the station, I noticed Yanagi was carrying a box. He patted it and nodded. I asked how much. 'Y15,000 (£15)', he said, 'Mr Saito let me have it for the museum at half-price.'

After a time we were invited to take part in a somewhat informal tea ceremony and ten of us took our places in a small, severe, but exquisite room of tea. As usual, as a foreigner, I had to be 'first guest'. My bones were already aching from sitting cross-legged on the floor, so I begged permission to sit with my back against the pillar of the recess. Anyhow, I felt it would be wise to break through threatened formality early rather than late, particularly as I had no one ahead of me whose manners I might copy. I watched the ritual with great enjoyment. The implements and bowls were really good. One bowl was old Korean and the other, used alternately, was a 'Doniu' black raku. The room had that diffused light which falls through Japanese paper alone. A young woman entered, serious, silent, to make and serve; she knelt to pull the sliding door towards her, stood, passed through, knelt again and closed it noiselessly. I watched the trim grace of her foot and hand movements. White cottoned feet, cleft between the small and big toes. Poise and economy of movement. A phrase from Hearn came to me, 'the cleft grace of a fawn'. She wiped the bowls, the sliver of a bamboo spoon for taking the powdered green tea from the caddy for each separate brewing, and the caddy itself, with deft stylised movements and folded and replaced the napkin in the breast of her kimono. Taking a ladle-full of simmering water from the kettle on the sunken hearth, she mixed the tea, frothing it with

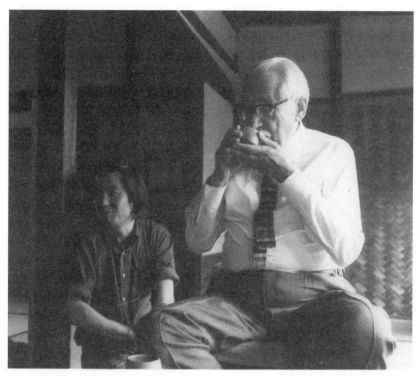

The author drinking tea with friends, 1953.

a bamboo whisk. Turning the bowl she slid it invitingly towards the guest with both hands. He bowed and said 'Ikadakimasu' (I receive), taking the bowl with his left hand under the foot and his right lying horizontally along a slightly flattened side, for the most comfortable drinking. He took first one sip, then another, slowly, then he rotated the bowl so as to gather the green froth at the bottom for a last audible sip, bowed, and with both hands slid the bowl away from him. Then it was the next guest's turn. Previously we had been served with 'Yokan' which is a sweetened bean paste set with gelatine. Only certain kinds of sweetmeats are considered suitable for the tea ceremony, those, and they must be of first quality, which enhance the subsequent somewhat

astringent taste of the powdered leaf. I forgot to mention that, after drinking, the bowl was examined and turned about and enjoyed for its own sake. It is customary to make polite remarks in doing so and on this occasion they were sincere. But a sickness has attacked the cult of tea. It has become, in the main, a training in deportment for young women, or the plaything of the idle, the ignorant and the rich who have debased its noble origins to a formalism. Paying enormous prices for its paraphernalia (e.g. £2,500 for a famous bamboo spoon, or rather for the signature on the delicate box which contained it), as reported a few days ago, if not actually vulgarising it by the use of incongruous elements from the West. Flower arrangement has suffered even more. I saw an exhibition recently which combined the worst aspect of modern movements in sculpture and painting with skilled but uncreative Japanese 'Ikebana' (flower arrangement). I don't like second-rate art anywhere, but this mixture of the worst from two hemispheres was quite sickening.

MARCH 17TH

I heard today that all the pots and almost all the drawings had been sold during the first two days of my exhibition. There has been a request from the staff of the Matsuzakaya Department Store, that we give them a talk one evening after working hours. I can hardly imagine that happening in London.

After lunch we made an expedition to Kamata, which is between here and Yokohama, to call on Serizawa who is the best dyer and stencil printer, definitely an artist-craftsman – a good draughtsman and a steady conscientious man. I knew him twenty years ago. Now he has a considerable following with about fifty immediate students. He showed us some fine vegetable-dyed textiles and printed papers, though there were others in which I felt the design to be too assertive or even florid. He gave me a wad of paper on which to paint and showed me old Japanese pigments for artists as lovely as his vegetable

dyes and as limited in range. This I fancy may well be an advantage, for every craftsman feels it is better to know much of little than little of much.

When we had taken our leave we walked back to the station parallel with the electric main line; we passed through a rather slummy area which had been burnt out and rebuilt in a slipshod temporary way, narrow and crowded. Somebody suggested coffee and sure enough there was a tea-room-cum-bar handy and in we went and had good coffee and fairly good cream puffs, but what was more surprising was that the place was furnished throughout with good modern crafts from the 'Takumi' craft shop, pottery, textiles, papers, etc. On my expressing my surprise they told me that there was another bar-restaurant nearby also furnished in the same sort of way. So we went through more alleys to have a look at it and were recognised on entering and persuaded to stay on for a meal in a tiny room 9 ft. x 6 ft. with a cooking hearth sunk in the middle of the matting. We had a good soup and absolutely first-class pork cutlets, etc., and finished up with hot, sweet fermented rice. I was asked by our host to do him a drawing; ink-stone, paper, brushes, etc., were quickly provided and I did a rapid drawing of a pot. Then we asked for the bill and he absolutely refused to take payment and instead presented us with four bottles of the fermented rice, a photograph of the shop and a match box each, on which he did tiny paintings himself. He said, 'I work hard and make enough. I won't accept money from you.' This establishment was the nearest equivalent to an ordinary English 'pub' and most of his clients were working men.

MARCH 22ND

With Hamada and Yanagi by 9 a.m. 'Tsubami' (Swallow) to Nagoya 200 miles southward. Comfortable train, 2nd class, American style (English first-class). Past the foothills with a white apparitional Fuji San above and flat green paddies below. Little conical haystacks

and factories. On the other side, the shining, sparkling sea, fishing boats drawn up with curved prows like swords, sea-wards and on the pebbly beaches square mats of drying shrimps, pink and salmon against the blue. Torii gateway leading to cryptomeria-shaded steps climbing to little empty Shinto Shrines; emptiness, so full of meaning in Japan. Alternately, the quiet precincts of Buddhist temples with curved grey-tiled roofs, thatched farmhouses thick upon the land and every smallest valley terraced and watered for rice. Tea bushes, round and trim and dark, in dotted ranks, yellow oranges, waxy white magnolias and the pink of late cherry blossoms. Everywhere the plumes of bamboo groves and pines – pines below the conical hills. Sharp slopes propped with dry walling, diamond patterned. Water channelled and guttered from hill to sea, wide rivers running fast between shoals of clean water-worn stones. Tunnels, motor traffic on a sea road.

The service on the train was excellent, our luggage was put away, our shoes cleaned, a loudspeaker gave useful warnings and information and notice of telegrams to travellers. The seats were adjustable, and local products, 'Mae Butsu', were sold on the train, all beautifully parcelled. They brought menus ahead of time to our seats and we chose what we wanted to eat and were served quickly. The food was Western and up to our GWR standard and at about the same price.

How thick the population is, not only in overcrowded city buses, trams and streets, but in the country too; 82 million people, imagine that in the British Isles: where are they to go? They must expand somewhere. The country looks fairly prosperous but I hear that there are 11 millions too many outside the towns. The people have the habit of hard work, and not primarily for money; it is life's expectation and responsibility to them and the patient hand-made beauty of the fields is theirs. Theirs too, I suppose, the horrible rash of advertisement hoardings by day and by neon light, staring

at the traveller, as vulgar and as un-Japanese as the blare of touting loudspeakers and radio and honking motor traffic everywhere.

At Nagoya we were met by representatives of the Mainichi and Matsuzakaya and press photographers and men running with flags. They drove us to the department store which, like all those in Tokyo, was crowded beyond what we consider the limit. We were taken to reception rooms where introductions, visiting-cards, tea and cakes followed as is usual everywhere.

Then to the Tokugawa Museum to see a collection of Hiroshige prints, recently unearthed, which had lined the coffin of a Tokugawa child when buried a hundred years ago. The coffin was triple, one within the other, and despite damp, the paper and colour had stood the test pretty well. Some of the prints were unique. I felt he was a good, unaffected Japanese landscapist – an 'impressionist' as Hamada remarked. Then to this lovely old hotel, the 'Hasho Kwan' just outside Nagoya, the best I have ever stayed in – rooms, gardens and – no, not service, that does not convey the warmth of real courtesy and refinement. Hamada suggested 'affection'. Luxurious, yes, but so much more again, representing a way of life when social relationships had shape and style, and art played an ever-present part in all the actions of the day. Almost everything one looked at, a cup of tea; the twisted pattern of the hot-folded face towel in its lacquer basket; the shape and colour of the cake in an oak leaf on a rough textured stoneware dish, partly glazed; the reticent sprays of flowers painted on tarnished silver-leaf panels of the sliding papier-maché doors; the spacing of rectangular architectural detail on the floor, on the walls, in the lattices, on the ceiling. By such, the heart is fed through the senses, not by the fact-finding busy intellect of the West, but by intuition and emotion responding to innate behests of material, encouraging the enjoyment and use of like faculties in the user. There were twenty guest rooms and a maid for each; one could not do a thing for one's self except eat, and sleep, and walk, and brush

one's teeth. Late in the afternoon we walked around the exquisite garden and the proprietor talked tea and poetry, and there, between the trunks of pines, we caught a glimpse of another guest sauntering with a maid holding a paper umbrella over him, against a few drops of rain, as he composed his verses. We noticed some huge umbrellas in an old out-building and asked what they were used for and were told, 'open-air tea ceremony – shall we have one?' 'Yes, by all means, if it is not too much trouble.' So whilst they were getting things ready – rugs, hangings, charcoal, etc. – I made hasty drawings and then hurried to take part.

That evening there was a huge party and about a dozen geisha to entertain us. They made conversation, served wine and danced. One dance was old and good, the others were more superficial, but costumes and stylised posturing, though not good by high Japanese standards, were very interesting to a foreigner. There was no vulgarity. Such geisha parties cost money, but we paid nothing, everything was either at the expense of the Mainichi or the Matsuzakaya. It is astonishing what the newspapers and department stores do in Japan to forward the interests of arts and sports and other matters outside what we would consider to be their spheres.

MARCH 24TH

Lectures at the Seto pottery school, corresponding to Stoke-on-Trent Technical College, a dreary building like most old-fashioned Japanese Western-style municipal offices. The windows looked out over the smoky city with its 2,000 kilns and its river, white with clay washings, running through the middle. We spent the day visiting workshops in Seto and Arakawa's in Tajime. We examined the last of the enormous old, domed, climbing, wood-stoked kilns holding a quarter of a million pots and taking a fortnight to fire. Seto from ancient times has been the chief centre of the pottery trade. Now it is

semi-industrialised and under changing conditions these enormous kilns which climb a whole hillside are no longer suitable.

In the afternoon we called on young Arakawa high up in pine woods and I made a note of his simple up-draught biscuit kiln and roof. It seemed the most promising of the workshops. After that we visited the Eihoji Zen temple, known as Kokeizan or moss mountain. Extensive, very old in parts and beautifully kept by the thirty monks. The abbot invited us to come to his rooms for tea, powdered green tea. We were served by a young shaven priest in sober dignified garb with severe ritual and ample clean-limbed movement which transferred my thoughts back in time to the beginnings of tea. The nonsense and ultra-refinements of fashionable tea drinking, served by pretty girls, was exposed. The tenmoku bowls, in the earliest Chinese tradition, were all approximately the same, made by Mr Arakawa Sr., and were on lacquer stands. 'Tea' in its Buddhist background was clearly more than art for art's sake. After a quiet pause, the abbot asked me to look out of the window behind me. I slid back the delicate papered framework and looked through on to half buried rocks at eye level and a perspective of green moss amongst tree trunks and a winding path; I was looking at an immediacy of natural beauty. He asked how I liked it and spontaneously I answered 'ii na' (isn't it lovely?). The reply seemed to please him so he took us from room to room, along shining corridors and covered passage ways, from building to building, showing us paintings and written scrolls and glimpses of garden and rock. At one point he pushed aside the paper 'shoji' (door) and there in a private room was a visitor kneeling in deep Zen meditation, oblivious of us. I don't think the abbot knew he was there, but in any case no notice was taken. Back at the fine broad entrance the abbot invited me to return and stay, which I may be able to do.

And so on to Kyoto to a nice quiet Japanese hotel. We stayed in the same rooms which I discovered later had been occupied by Mrs Vining, the authoress of *Windows for the Crown Prince*. I have read her book with great pleasure and would recommend it warmly to anyone who cares to know what the Imperial family is like as seen at close quarters by a good Quaker. Especially would I recommend it to English people who sympathise with the ex-soldiers in Newcastle who, at this moment, want to boycott the Crown Prince in England. It is strange how people under the stress of war-time emotions do the very things least calculated to further their own fundamental desires, in this case, for understanding and peace.

We were guest speakers at a Rotarian lunch and then visited Tomimoto and his new wife in their small home. We enjoyed the clarity and elegance of his painting and his pots, despite a certain tight sharpness in them which has increased I think owing to the difficulties he has been through. What a pleasure to sit cross-legged and talk with him once again, my oldest companion and friend in the world of pots. We were as brothers when we were young and all the cleavage of distance and diverging thought has not cut the essential relationship. He shares with Hamada the most influence on contemporary Japanese potting and both have been honoured by the government with the Order of Living National Treasure. Hamada thinks of him as the best artist potter in the country and he has spoken to me of Hamada as the best craftsman potter.

I sent Tomimoto a copy of my book, *A Potter's Portfolio*, as a present. A few days later, I received an acknowledgment in these words, 'That is the best book before I never seen.'

A lecture sponsored by the Mainichi Press showing the St Ives film and the slides of American Indian pots, 2½ hours and a full house. This time I spoke without a translator and, in fact, never used one after my first lecture. My vocabulary is limited and I use

it acrobatically, often to the amusement of the audience, but it is colloquial and is understood.

Afterwards we all met at O. Harusan's house and had a wonderful meal with fast witty conversation and uproarious laughter. She, Mrs Sasaki, is a widow and an old friend of Kawai's, a clever and nice woman of taste who now runs a hotel but who was once a geisha. There was much chatter about local foods and three times during the evening she sent out for special dishes mentioned by one or another of her guests. And here it may be as well to explain that geisha in Japanese society are entertainers and not necessarily amoral women. In the old life the women of the household stayed at home and there was no mixing of the sexes in social life. Companionship with women was limited to these highly-trained singers and dancers and conversationalists, and their position may be compared to that of the Hetaerae of ancient Greece.

As has become usual, the dinner finished up with strawberries and cream. Japanese menus do not conclude with a sweet course, or pudding, but fruit, of which there is a fast developing variety, often takes its place. They have developed a method of growing strawberries out of doors all through the winter on rock terraces facing south, each huge berry in a paper bag which is turned towards the sun daily, by hand!

MARCH 26TH

To Osaka by car. The Takumi craft shop had the Union Jack and the Rising Sun out in welcome! From there to the small folk museum and then to the Kwansai Club (Kwansai means the central area of Japan). Met many of the leading business men, including a few foreigners – more speeches. Then to the Mainichi with a packed audience of 500 and another 2½ hours like yesterday in Kyoto.

Then sixteen of us went to another geisha dinner – slightly flirtatious. It was amusing to see how Hamada and Yanagi fended

off feminine advances. Finally we were taken out into the country to the house of a man whom none of us knew personally, for a night's lodging. I lay on comfortable quilts in a severely beautiful cell of a tea room, very sleepy, hopelessly trying to convey these experiences to readers half a world away, out of a different modality.

I feel that we in the West need to know, to respect, and even to love what I am having such a unique opportunity of experiencing each day. Time simply flows through the senses from an inner life which all the turmoil of outward Westernisation has not yet destroyed. Voiceless beauty; the almost empty rooms, the exquisite adjustment of things, the colour of the green tea in its bowl, the lie of the chopsticks on their rest, the writing on the wall of the recess, the white light through paper 'shoji' and the shadows of bamboo leaf upon it. I could go on indefinitely, but it has to be lived in to be really felt.

MARCH 27TH

This morning Yanagi came to my room early to say that there had been bad news, Hamada's old father had died suddenly, aged over eighty. I regret not having managed to get out to Mashiko to see him once again before it was too late. A pious Buddhist who spent his later years making huge pictorial charts describing the narrow road of virtue and the broad one of vice, in winter, and travelling the roads of Japan on foot in the summer, distributing them and preaching the Law of the Buddha to all and sundry – an Eastern Bunyan.

We were served a very Japanese breakfast, rice, fermented soya bean soup, raw fish, sea urchin and various cold pickled vegetables. I expect that sounds rather grim to the reader, and I confess that I am conservative enough to prefer a British breakfast; and I get one every other day at Yanagi's, but raw fish, for example, is excellent, and it is largely prejudice which has to be contended with. It is a pity that we

are so conservative, because eating the food of a different country is one of the best ways of understanding its people. The mouth is the doorway of two senses.

After breakfast we looked at our host's collection of Buddhist sculpture and masks. He absolutely insisted on my choosing any one of the latter. Some of these purported to be eighth century 'Bugaku' and, whether they were early copies or not, were valuable. So I compromised by accepting a lively 'O Kame' (Smiling Woman) of probably the eighteenth century. I did a painting for him.

Back to Osaka. More talks – Anglo-Japanese Society, a broadcast discussion by a group of craftsmen – another dinner party and a night at the new foreign-style Osaka Hotel. Its director, Mr Yamamoto (Proprietor of the Asahi Beer Co.), is one of the chief supporters of the Craft Movement. Hamada returned to Mashiko.

Next day, two more parties, one at a craft restaurant with a special show of pots for us to examine. Also another talk to 300 people for the Mainichi with Kawai taking Hamada's place. He speaks very well, too, sincerely and vividly. Finally we got to a Japanese hotel at the base of the hills behind Kobe and to a wonderful hot bath.

The next day an ancient official bus carried fifteen of us 70 miles inland over narrow, winding, pot-holed roads through the hills to snow level and down again to the terraced paddy fields with their funny little triangular haystacks, constant villages, roads never made for motor traffic, children and dogs asking to be run over and always escaping that fate by an unperturbed hair's breadth. Eventually, very bone-shaken, we entered the long valley of Tachikui in the province of Tamba. We stumbled out and were at once surrounded by officials, potters and the curious, especially children, and a great business of introductions and presentation of visiting-cards began. Then we were taken indoors and fed on what was described to me as good country food, which included O Mochi. These are dumplings made of pounded steamed rice of a particularly glutinous variety,

definitely difficult to digest cold, but pleasant if toasted and puffed up and eaten with a salty piquant shoyu sauce.

Afterwards we made a tour of the kilns and workshops. There are some twenty-five climbing kilns of a very old type like the Korean kilns. The tradition here runs back over 1,000 years and is comparatively unspoiled.

Pots were laid out for our inspection, and in one workshop we watched the trailing of white slip lettering with a tool made of bamboo. We also saw the decoration, in the soft stage, of a great brazier over 24 inches wide with complex indentations and applied strings of clay. Free and most potterly, but already debased by showmanship and intricacy of design.

Then we were taken to a large room where about 100 of the village potters gathered to hear what we had to say. All three of us spoke on the preservation of design and craftsmanship, of the difficulties involved in new design for a life they did not know, of the growing admiration in the West for their genuine work. They listened attentively and questions came freely and eagerly, mainly on points of economy. With the thesis there seemed to be general agreement judging by nods and grunts of approval. They really listened to us, they begged me to come and work with them.

I feel that there is a possibility that here in Japan, where the old order of the East overlaps with that of the West as nowhere else, and the hand and the machine work side by side, a new synthesis, which is needed by us all, may take place for the first time. It will require a long gestation, and it will be the work of many men, but a good start has been made.

We got to our hotel in the feudal town of Sasayama late and very cold. Spent the next half-day in the house of a good dealer and bought old Tamba wares for the museum and two pieces for myself at half-price. Back to Kyoto and to bed after 1 a.m., very tired. Kawai quoted a folk-song as we drove, which caught my fancy, and I have

tried to translate it, knowing how almost hopelessly difficult it is to try to carry poetic feeling from one language into another:

Song of Lampreys
(a very small eel found in rice paddies)

When spring flows through the paddy leats
We hanker for the sea.
Summer comes and heats the water
For our daily bath,
Autumn maples burn upon the hills
And warm our hearts,
Comes winter once again with ice
To roof our house.

MARCH 31ST

Returned to Tokyo by 'Hato' (Pigeon), first class tickets provided. We have been away eleven days, have travelled over a thousand miles and paid for nothing.

CHAPTER 3

Japan – Deeper Impressions

April 9ᵀᴴ

With Hamada and Dr and Mrs Yanagi to Atami to visit Shiga. Atami, hanging over a blue sea like Capri. The sweet scent of the 'na no hanna' (rape) through the window carrying me back to fields round Nagasaki where I smelled it forty-three years ago for the first time since childhood in Kyoto. When we were all gathered in a restaurant eating grilled eels, a sudden storm of rain pattered on the low roof and on the bamboos and cherry trees outside, but it was a pink shower of petals which fell to the ground. A warm group of friends of forty years' standing, mainly of the Shirakaba Group,[1] nearly all of whom have made a mark in Japanese life. The painters, Umehara and Yasui, the musician, Kaneko Yanagi, the writers, Shiga, Satomi, Musha no Koji, Nagaiyo, Dr Yanagi, and the architect, Taneguchi.

After the meal there was a further gathering of about twenty members of the Tea Reform Society in our hotel, a 'Koi Cha' ceremony and then 21 'Matt Cha' drinking. That was the first time I have had 'Koi Cha'. It is a variant of the tea ceremony in which the

1. The Shirakaba, or Silver Birch magazine, was for some twelve years the leading artistic and literary journal in Japan. It was founded by a group of Peers' School and Imperial University graduates.

powdered tea is mixed to a thick brew and the bowl is passed from hand to hand.

Tea in Japan, although very much in fashion, has fallen upon evil days. Hence the need for reform. This, however, in the very nature of the changing background of thought and custom and fusion of cultures, cannot be a simple or quick process. The old rituals are far too rigid to be easily adapted to Westernised life. That is why Dr Yanagi, although regarded by many as a modern Master of Tea, practises no ceremonials, but simply proclaims the root principles of tea against a background of degeneracy and anachronism. There was much discussion and we all spent the night in the hotel. When it came to settling up, the proprietor, who is a member of the society, refused any payment.

With regard to the tea ceremony in particular I wish to point out that although the war had the effect of hardening many hearts towards the Japanese people that fact is doubly unfortunate because peoples are made up of all kinds and the Japanese have a high degree of sensibility which they demonstrate in their arts and crafts, and art is by its very nature international in value. They have moreover 'the eyes to see' trained to that purpose during centuries.

Their Tea Masters have been arbiters of taste and culture who have set standards of aesthetic appreciation such as no other race has approximated.

For some four hundred years these men of refined perception, regardless of rank, have forgathered in an almost Quakerish quietism to drink tea together and to enjoy all that pertains to beauty and poetic insight in the things of the house – pottery, painting, calligraphy, lacquer, food, flowers, movement and human relationship itself.

Various untranslatable words, expressive of subtle moods of perception, have percolated from them into normal use, such, for example, as the adjective 'shibui', which is understood by everybody in Japan. It expresses the highest quality of true beauty – austerity,

nobility, warmth, certitude and unpretentiousness combined.

That by itself is a remarkable achievement, for without standards we are lost, and when the standards are too private, as with us now, we are confused.

That the standards of tea gradually petrified and even fell into downright vulgarity under the disintegrating influence of Western industrialism cannot be denied. But one does not judge a culture by its debasement, but by searching into its roots for the secret lore which gave it a unique vitality.

The pots employed in the tea ceremony – bowl, caddy, waterpot, etc. – are probably the most difficult for us to appreciate, to assess and to display. Their virtues, even when one has crossed the barriers of the meretricious and the merely imitative, are often hidden behind rough exteriors. They are at the furthest remove from Greek pots or, in more recent times, Sèvres, Meissen or Chelsea. When best, they are unselfconscious, in fact they are what Buddhists would describe as undifferentiated, deriving their appeal from the born character of the potter working in his native tradition.

They are made by potters, and good amateurs, in a land of earthquakes where nothing can be built for permanence and the tea rooms are like charming human birds' nests in rock gardens where nature, irregularity, poignancy and brevity hold sway.

The prototypes of Japanese tea bowls, so much admired by men of tea, were called 'O Edo'. Originally ordinary cheap Korean rice bowls, they were taken out of their commonplace background and enshrined in the most exclusive and refined tea rooms of Japan wherein alone this unobtrusive beauty can be seen in a plain unvarnished setting of severe exquisiteness.

Our own pots spring in the main from classic roots, Greek, Roman, or Renaissance, and have a bias towards the symmetric. From our point of view these Japanese pots may be said to lean towards the asymmetric and, in a broad viewing of ceramic values, the extreme

East is the complement and balance of the West.

Again I talked with Taneguchi about life and architecture in Japan in the next twenty years. Is the mad rush towards Western ways of living going to be stemmed? Are Japanese going to sit on the floor or on chairs?

In twenty years' time, won't the Japanese room with 'tatami' (the thick compressed straw matting) become a luxury as the foreign style is today? What is the best way to heat a Japanese house to meet modern needs? These are knotty questions and I did not obtain any black and white replies. Electricity seems to be the best alternative to charcoal, but it is too expensive for the majority. Charcoal is also becoming costly and does not give sufficient warmth for the new and more effete living. Incidentally, I find to my surprise that my experiment of a well for one's feet in the floor of a Japanese room, covered with a low table, has caught on to some extent. I have been into several houses, and one shop in Kyoto where it was employed. I worked out this scheme in my first house in Tokyo forty-two years ago. But still it does not provide a rest for the back. I find that some of my Japanese friends need that nearly as much as I do. In northern and colder areas of Japan I found, much later, that a somewhat similar arrangement, called a Kotatsu, is much used for warmth. The hole in the floor contains a small charcoal brazier and is covered with a framework roofed with a quilt. The family sits around of an evening thawing their legs, at least, in the dug-out. My plan was to have a table at which we, as foreigners, could sit in comparative comfort and which our Japanese friends could share equally and on a level, sitting cross-legged or kneeling on their heels as the women always do. Our table was of the unit size of standard floor mats, 6 ft. x 3 ft. x 3 in., and when not in use could have its legs lowered and sunk nine inches back to floor-level.

Naturally enough I notice many Western innovations which are not properly understood, hot food served on cold plates, bread still white

and puffy, half toasted, on one side only, and piled horizontally so that it is all soft instead of crisp and golden. Oh! And English spelling and grammar! It is rare to see any public notice which is correct and one would think in such cases that it would be worthwhile to obtain foreign help. The fact is that many Japanese think too readily that they know when they don't. I have never met a Japanese who had not been educated abroad who could speak or write perfect English. It is only to be expected and I am continually grateful for translations, whether correct or not, as I have never learned to read or write Japanese. When I am asked why, the answer is that in the first place

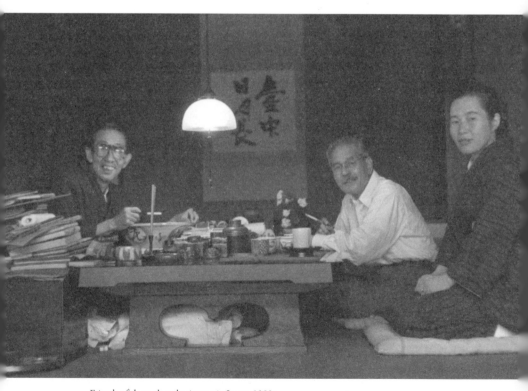

Friends of the author sharing tea in Japan, 1950s.

I grudged the time to be taken from drawing and making pots and, in the second, I am not by nature a student. It takes about five years to memorise the 2,000 Chinese ideographs required for elementary reading of Japanese script.

APRIL 15TH

I spent this day at the Kenzan-Korin Exhibition at the Mistukoshi Gallery talking to visitors and the members of the Kenzan Society. The opening of the exhibition had been set so that I, as one of the two living representatives of the School, the other being Tomimoto, could take part in it. The first Kenzan died 250 years ago. My master was the sixth in succession and this was a commemorative collection of representative examples of the work of the whole tradition thirty years after his death.

There were many beautiful things which we had borrowed and arranged. Also, some pots, especially those attributed to the First Kenzan which I and others thought were either fakes or done by later and little known followers. It is often exceedingly difficult, even for Japanese experts, to judge the authenticity of their works of art because of the great skill of traditional craftsmanship, but yet more because a good model was regarded as a good model and there was no Western individualist sense of shame in copying. For this reason the intrinsic character and merit of the piece is often the best guide to its authenticity.

The paintings by Sotatsu were outstanding and the whole exhibition introduced me to fresh pastures in art about which I hope to compile a book whilst I am in Japan. But I shall call it the *Koyetsu-Kenzan Tradition* for it was the great Koyetsu who inaugurated this essentially Japanese movement in seventeenth-century art and the first Kenzan who brought its major activity to a close, in the eighteenth century. It struck me, and some of my Japanese friends agreed, that Korin (Kenzan's older brother), under whose name the

school is widely known, was the least important artist of the four. A brilliantly clever man but of lighter calibre.

APRIL 16TH

Visit with Yanagi and Hamada to the Tokyo Industrial Art Institute and lecture. We came away feeling depressed by the chasm which separates the world of industrial design from the world of handcrafts. There was nothing in the buildings or their products which spoke to the heart through the senses. This is a criticism which applies outside of Japan as well. There is a gap here which needs filling desperately badly, but more so in Japan, for no country in the world contains so rich an inheritance of traditional craftsmanship alongside progressive machine work. There exists here a greater overlap of two eras, since the conscious modern craft movement is more alive and widespread than anywhere, save perhaps in Scandinavia. It seems to me, therefore, plain common-sense for the promoters of better industrial design to make an alliance with the hand-craftsman in order to begin to fill that unnecessary gap. We are beginning to find out in Europe that we need a new kind of designer for industry, one who knows the world of machines from inside and also the world of handcraft. Japan needs this kind of designer just as much if not more, but she also requires something else of him if the resultant designs are to be alive and original. That is an inside understanding of both Eastern and Western life.

APRIL 20TH

Today in the large central room of the Mingei Kwan there was held a commemorative Buddhist service for Mr Tanaka, the author of a lovely book on Okinawa Textiles who died recently as the result of an accident. About seventy relatives, Okinawans and members of the Japanese Craft Society assembled. An altar with a photograph of the dead man, his names, and offerings of flowers and fruits were placed

at one side of the room. Our friend the Buddhist priest, Mr Asano, intoned Sutras and prayers. Yanagi's nephew, Yoshitaka, quietly and modestly kept the proceedings in form. The young widow came forward and bowed to Asano and Yanagi and to all of us and then burned incense before his photograph. She was followed by his father and mother, relatives, and some friends. Then Dr Yanagi spoke about his life and work. Two Okinawan scholars spoke next, addressing his photograph as tenderly as if it were Mr Tanaka himself. Yanagi then asked me to say a few words. I spoke very briefly in Japanese, simply asking his mourners to take comfort from the fact that, although he was gone in the flesh, he still lived in the good work he had done in giving beauty of a universal type to all through his book. Then we had tea and cakes in the same room followed by Okinawan folk-songs which he particularly loved and dances in which he had taken part. The melodies were beautiful and the folk-dances easy, graceful, alive. The Okinawans spoke directly to his photograph – 'You said so and so, you did so and so – you loved us. We thank you.'

APRIL 22ND

To Hamada's Mashiko for the first time since 1935. The train passed through those northern outskirts of Tokyo which stretch out into paddy fields on the flat plain of the Sumida River. Now, factory chimneys, a grim forest of them, have replaced the farms and little hay-stacks for more than ten miles. On the other side of Tokyo it is like that all the way to Yokohama, twenty miles. I often wonder what the life of the people who live below those tall but unlovely 'trees' is like. It may help to explain the incredible number of thronged 'Pachinko' houses all over Japan. But of that, more anon. Later we came to country proper, the great plain of Tokyo, squared with pungent yellow rape in flower. Two hours later a blue ring of mountains, with snow on the highest, encircled us, now well into April.

At Utsunomya I was met by an art dealer, Mr Kato, and fourteen press men and photographers and the governor's car. We went to an eel restaurant and fed well. I was asked to do a painting for the governor of the province and another, 'if I would be so kind', for the restaurateur. Then we drove 22 miles to Mashiko where we picked up eighty-year-old Masu Minagawa, the famous and last of the pattern painters. For months she had been sending messages saying she wanted to see me once again before she died. At Hamada's long gate-house, 'the family' were all waiting. We had tea and sat and talked, looking into each other's eyes after all the years. Minagawa said to me 'I nearly died of pneumonia last year, time gets short.' Hamada added, 'She has been asking every foreigner who has visited us for months past, peering at them, "are you Parma san?"' (as she calls me, Parma is as near as she can get to Bernard). Hamada told of the visit of the Emperor and of the way he was enthralled by her.

We went through and round the old and new heavily thatched buildings, fine and substantial. The great farmhouse at the back has been sixteen years building and is still incomplete. The workshop is spacious and the large new kiln with its sloping shed. An ample supper of buckwheat macaroni for which this district is famous. A glorious bath and quilts to sleep on in a room in the new house. It was wonderful to be in Mashiko again and to see Hamada in his background of family – grown-up and workshops expanded, large, easy, natural.

April 24th

Back in Tokyo I went to a gathering of Baha'is in the evening. Some fifteen present. I found that I could follow about half the conversation and occasionally join in although the subject matter was difficult – concepts of God and Baha'u'llah's planning of world peace. I find myself a more confirmed believer than before our journey. The Baha'i Faith is not a negation of Christianity or Buddhism or any other

fundamental belief, on the contrary, it is a fulfilment of each within a unity of conception which seems to me the only possible basis for peace and for order in human society as a whole. Attempts to stretch any of the existing religions from out of a long past to the present orbital needs of mankind would, it appears to me, involve too great a responsibility upon any organisation or upon any individual of lesser authority and understanding than one of the Great Founders of religious or, as Baha'is call them, Manifestations of God. To me, the Baha'i Faith represents the only tenable concept of man's spiritual evolution. I believe with my fellow Baha'is that Baha'u'llah is no greater and no different in essence than his predecessors but that he comes at the culminating time of greatest human need when such a work of unification out of breakdown and chaos is required for the beginning of the maturity of human society. I feel an inward obligation to make this statement because so many of my ideas and ideals concerning both life and art and especially the interplay between East and West have either come to me through the Baha'i Faith or have been confirmed by it. The name may be unfamiliar to many who read these lines, yet during the hundred years which have passed since this reaffirmation of the meaning of life was given from behind iron bars of a Turkish prison in Palestine, the teaching of Baha'u'llah and of his immediate predecessor Mohammed Ali has spread all over the world.

I keep asking myself what has happened to Japan during the eighteen years whilst I have been away. So much has gone which was good and true and lovely, so much has come which is not. How can I tell even the little which I have experienced, felt and understood, to people who have never been to the East? The mixture is so great, the changes are so rapid, the flavours so rare. The big cities are as ugly and noisy and vulgar outside as the old life is exquisite within, and the countryside is beautiful beyond the desire for comparison. I marvel as I travel at the incredibly patient fields and farmers, the

hard handwork expended with such a wealth of loving care. Japan is the true home of art, it is in the blood, in the tempo, in the interiors. There is such a sensibility – awareness through the senses feeding the heart – textures, colours, hidden charm; it comes out of a long refinement and art lives here in its right setting as part of life – even foreign art. I find an original Renoir or Rouault or Matisse in this friend's house or that, and they are appreciated.

At the same time, I cannot get over the apparent insensibility of Japanese today to noise, unnecessary man-made noise. Loudspeakers at all busy shopping centres competing with each other for the sale of goods, from advertisement cars, on all platforms, on trams, on ships, inescapable public music in shops, restaurants, taxis – Eastern and Western music, occasionally good, but generally sentimental dope of the worst kind. More significant is the incessant use of radio even in the homes of cultured and refined people. Nobody seems to protest. I suppose individualism and personal freedom and rights, which we take as a matter of course in the West, but which are still strange in a land of Buddhist tolerance and patient acceptance of authority, is the explanation. Authority of parents, and of family, of ingrained custom and traditions, of all-powerful police and military, and of government. In the racing eighty-odd years since the Restoration and the emergence of Japan from isolationism, so much has changed but the West has but little awareness of the effort, of the energy and determination required by a small, poor, undefeated island people to escape from the encroachment of our power-politics and money control. The fate of the other islands of the Pacific, of India and China, stared them in the face. At breakneck speed Japan put her house in order and began sending her bright young men westward to find out about everything – guns, ships, science, industry, education, art and religion. With the power so gained, China was defeated, Russia was defeated. The new wine went to the head of the militarists; the Japanese like the Aryan Germans were

declared to be a superior race, not one of a family, and so to World War II, defeat and the present situation of inward defeat which, as one comes to understand it better, one forgives. 'Tout comprendre est tout pardonner.' That does not mean an easy-going shrug of the shoulders, but a willingness to help, humbly and patiently, when the chance comes. The feeling towards foreigners, including Americans, is friendly. I have not seen a trace of anything else although the papers constantly report cases of bad behaviour on the part of American soldiers. I often see GIs strolling about Tokyo hand in hand with Japanese girls. I was disgusted when I first saw this happen and watched the faces in the street to discover the reaction for, in the Japan I have known, no man ever touched a woman in public. I was surprised to see no signs of disapproval, but much more surprised when I presently noticed young Japanese men and women walking openly hand in hand. That may not be a bad thing in the long run, but it serves to show the violence and speed of change. I must add that I have been much more favourably impressed by the American occupation than I anticipated. On the whole, the hand of authority has been light and discriminating, a thousand times lighter than if the position had been reversed and Japan had won, and the Japanese people know this. Amongst themselves they do speak of American behaviour as 'boyish' or young, which is not so surprising from an historic or cultural angle. It can fairly be said that the Americans have not only been very generous, but in the rank and file have also been surprisingly receptive to the Japanese way of life and to Japanese cultural values. They study Zen and 'Tea' and Nō, flower arrangement, Judo, food, art and customs and even pottery.

Considering what a proud, undefeated people the Japanese were and that practically all their great cities and towns, except Kyoto, were burnt out by incendiary bombing, it is amazing the way they have picked themselves up, shaken off the dust, raised their eyebrows saying, 'Shi kata ga nai' (It cannot be helped), and gone on with their

non-military reconstruction. That feeling is genuine and widespread and I have heard the remark several times, 'It would have been worse if we had won.'

The future is insecure with no place for the excess population and Japan rides like an aircraft-carrier somewhere between USA, China and Russia. I cannot resist a sense of disgust and impatience with those of us who say with a sense of distant white superiority, 'Well, they should limit their population.' The remark is both cheap and self-centred. Japan must export to feed her population, her main market, China, is closed, Russia is closed and our trade quotas are against her. What is she to do? What is her future? At present she is living upon the charity and arms expenditure of America. Ironically, it is we who are pushing her to rearm against the will of the people. Had our statesmen possessed the foresight and wisdom to face up to this underlying problem Pearl Harbor would not have taken place.

APRIL 29TH

This evening I sauntered through the central Ginza area of Tokyo feeling alone and pavement-weary. Bars, restaurants and night clubs. A full moon racing through a streaky sky; neon signs, crowds, incessant hooting, uneven pavement. Suddenly I missed the companionship of women. Women to share feelings with, to take one out of one's maleness, to talk to, to be easy with. Japanese society, despite rapid change, is still male and does not provide this anodyne save for those, whether Japanese or foreigners, who are satisfied with the charm of geisha. It is still quite unusual for the wife or daughters of a friend, even if one has attained to the privilege and intimacy of his home, particularly if one is a foreigner, to converse as a Western wife normally would with the husband's friend. Nor is the education and general outlook of the average woman equal to the task. Her province has always been the home and the Western critic who jumps hastily to the conclusion that it is also her prison must be reminded

that it is he who, in another breath, admits that the happiest looking people in Japan are the women and children and not the men. The explanation of this apparent anomaly is to be found, I believe, in the tacit expectation from birth of feminine modesty, humility and subservience in a background which is both Buddhist and Confucian. The man's world is the outer and the woman's the inner and it is only recently that this is being questioned.

APRIL 30TH

Yanagi, Hamada and I went out by tram to visit Hamada's relatives at Tamagawa. His family comes from that area; farmer stock. They had begged us to come and see the fishing on the river so that I could make drawings and have a feast of small fresh fish with them afterwards. The sky was torn and grey and still racing and the wind grew to a hurricane, then came lashing rain and we were kept indoors, everything rattling in the simple house, and plumes of bamboo thrashing over the nearby thatch roofs. So Munakata, the excellent woodblock artist, who was of the party, and I, did a half dozen drawings each on thin old sheets of absorbent paper. I have never seen anything like the spontaneity of his brush-work, nor such a speed of thought on paper. His brush positively flickered over the white expanse with apparently no premonition or plan – a release of emotion and intuition – sweat glistening on his forehead and occasionally dropping on to the paper and getting mixed in the wet tangle of black and grey composition.

We had the feast of freshwater fish: raw, fried in batter and simmered, all excellent! The cook came and joined the party amidst acclaim. Munakata's wood-block prints are on exhibition now at the Corcoran Gallery in Washington, together with Hamada's pots. He is one of the best artists in Japan today.

MAY DAY

We forgathered at Takumi which I only reached with difficulty – great crowds and thousands of police, ambulances, etc., but this year there were no untoward events between Communists and Anti's such as there were last year. I get the general impression that Communism has more hold here than in England, but that it is not a real danger at present. We had a buckwheat macaroni supper and then went to hear Marion Anderson sing. The largest concert hall in Tokyo was packed.

Our seats in the middle of the deep balcony cost £1 each, which was the average price of the 3,500 seats, but there were three sitting abreast all down the narrow aisle and, as is often the case, I had no room for my knees. The music – English folk songs, Schubert and Spirituals. She had a fine reception, serious and appreciative of a good artist. The development of a widespread appreciation of Western music is astonishing – all my friends have good records – radios are in the remote farmhouses.

I often listen with real pleasure to Kaneko Yanagi's students singing in the room below mine. The thought came to me that until we in the West have a corresponding appreciation of the arts of the East, the emotional and human basis for world peace and the concord of humanity will be lacking in depth. At the end of the concert, hundreds were trying to reach this negro singer's dressing room.

MAY 3RD

Today I had arranged with Kenzan's daughter, Namiko, to meet me at Uguisu Dani (Nightingale Valley) Station on the fast outer-circle line. She did so in a car (to my surprise) belonging to Bishop Goto whom I met at my exhibition when he invited me to come to see him. Nami and her sister are Christians and it was the bishop's deceased brother who baptised my master, Kenzan, before he died. Nami said it was Christian kindness that won the old man's heart and incidentally hers. The bishop's church was burned and the new

one stood stark – he asked my advice about decoration. I said, 'Make it warmer in appearance and keep it simple.' He took us up to his tea room – the oddest – situated right in the spire of his Christian church looking down on the very area in which I first taught English in Ueno High School for Girls in 1909.

Afterwards we wandered through Sakuragi Cho and past the front of our old house built at a cost of under £200 in 1909. Memories flooded back, jolted here and there by unchanged buildings, but everything was so much narrower and smaller than memory allowed. The school of music was much the same, but all the tall cryptomeria are gone and the park is full of large buildings instead, and largest of all the new museum which is a sham Japanese edifice. We strolled down Dango zaka way to the apartment house in which Namiko has a single eight-mat room. She made tea and we ate the 'dango' (small round rice dumplings) such as I remember buying with my wife soon after we were married. Then she showed me Japanese stick colours for painting, and how to use them, and we talked about her father and family, and of how he became a potter and about his master, Kenya, and Shimaoka Renzo her grandfather who was the first Japanese photographer. After that we walked round Shinobasu lake and found a little 'Sobaya'[2] which she knew and I rather surprised the young proprietor, unaccustomed to foreign guests, by asking for things by their right names. I enjoyed the afternoon and I think she did, hers is a lonely life – unusual in Japan. I don't know why she never married but she seems content and is a nice, kind and selfless person. We planned another meeting after I have had some practice with the paints.

MAY 6TH

I went to a meeting of English speaking students at the American Chapel Center to listen to the ideas of a new generation but they

2. Buckwheat macaroni restaurant.

Pots made by the author in Kurashiki, 1953.

kept asking me to speak, so I asked them questions. What were their greatest problems and hopes after the war? Their English was good and they talked freely and intelligently. To have room to live in, peace, impatience with social conventions which held them back in the past, religion conceived as a formality, no assumption of God as a creator, but instead essence within all and ultimate responsibility – man's. There was no defence of Russian communism, rather a leaning towards democracy instead. A genuine hatred of militarism, and even

thankfulness that the war was lost as the only way of escape from the footbinding of the past. A dislike of egocentric individualism, personal, political and national, rather took me by surprise but they had only a vague idea as to how it could be formulated into a unity of action.

MAY 14TH

With Yanagi and Hamada to Okayama, 350 miles south once more. We were met by Mr Ohara and his car which took us on to his home town of Kurashiki. A day crowded to the brim. In the evening there was a packed audience of about 300 in the Ohara Museum. At the commencement of our lectures, Mr Ohara paid me a sincere and moving tribute in which he recalled a forgotten remark of mine made to him at Dartington Hall in Devonshire as we parted at the time when the clouds of war were gathering, something to the effect that I feared Japan would suffer defeat. At that time, he said, he did not take me seriously.

Mr Ohara is a remarkably nice and able man, a humanist, sensitive to art and a great benefactor. He owns a large rayon factory and is one of Japan's leading men of business. His father founded the Ohara Art Gallery and he himself built up the local folk museum, housed in four 'Kura' (old fire-proof storehouses). Both are very good. In the former one can enjoy good paintings by the French Impressionists, by Cézanne, Van Gogh, Toulouse Lautrec, Rouault, Picasso, Segantini, etc., and el Greco, in the latter the best collection of crafts outside Tokyo. Kurashiki escaped bombing and the town is delightful and full of solid buildings of this Kura type. We had a walk through the older part and called on a cloth merchant who had no less than fourteen of them behind the quiet and respectable front of his shop. He took us all through and showed us his secluded tea room with bamboo thickets around it. I saw a Hamada vase in the recess. On our return to Mr Ohara's fine house, or houses, where we were staying,

we looked at good paintings by Sotatsu, Mokubei, Gyokudo and Taigado, outstanding painters of the Tokugawa Era.

MAY 16TH

We motored back to Okayama and went to see the exhibition which had been arranged of my pots and paintings made years ago. There was a large wash drawing of Myogi which I still liked but often I find work which I regret. After that another pair of lectures with film and slides. Dinner followed with the mayor and city officials. More speeches and much talk – too much for one day. Night at a Japanese hotel – rather exhausted.

MAY 18TH

Larks overhead,
Swallows building again,
Semi (cicadae) trying on the pines,
Wheat yellowing in the fields,

Time flying past.
We ate watermelons yesterday
And it is already hotter than our English summer.

MAY 19TH

A party of us, including my old friend Mr Tonomura, the keeper of the folk museum, motored to Yakage 30 miles inland. We stayed at a house 200 years old. Yanagi and I slept in a room with a raised floor which was formerly used by feudal lords. All through these days in Okayama Prefecture we have been treated like feudal lords ourselves. Here and elsewhere we are given the best in the land with a warmth of both feeling and incomparable hospitality. We perambulated

the streets, crossed a winding river, climbed a hill and looked down on the delightful Tokugawa period town and I did some drawings. Unfamiliar architecture ties one down to study of detail which curtails freedom of expression in fragments of time, of five or ten minutes at most, whilst others are walking on slowly. I am also hung up halfway between the hard pen to which I was born, as it were, and the soft brush and absorbent paper on which ink spreads with a wet touch, and to which I come as a foreign amateur. In the evening, another gathering to see our slides.

MAY 21ST

Back to Kurashiki where I visited a small pottery and worked for some hours with unfamiliar clay and wheel and lots of people watching, the potters ready to help at every turn whilst I was feeling all thumbs and knees and preposterously clumsy, but able to see clearly where they were at sea in untraditional form and pattern. Nearly everywhere I find a half-digested influence from Hamada or Tomimoto or even from myself! At dinner we were the guests of the mayor and corporation of Kurashiki. I was asked to give my impressions of the town and province. I joined with Yanagi in praising their character and begging for its preservation by town planning, telling them what we were doing in England. I tried to make it clear that it paid in the long run. We asked for their co-operation in the establishment of an Ohara public library, for draining of the smelly river in front of the existing museums, for by-passing, for some check on public noise and rampant advertisement. It was a very receptive audience and there is a probability that Kurashiki will become the most culturally important town in the provinces. At dinner we had roast turkey! The food at the Ohara's was exceptional, but to have a roast turkey put before one in a country town was a surprise. There are not many turkeys in Japan and almost no ovens in which to cook them. No traditional food is baked.

Films at Tonomura's till late. We also had a wonderful meal at Mr Takeouchi's house and slept there one night. He had ordered a cook and two assistants to come all the way from Okayama and prepare fresh 'sushi' before our eyes. 'O sushi' are beloved by all Japanese but prejudice dies hard and the very idea of cold raw fish may be too much for many English readers. I can give assurance, however, that it does not taste as fishy as a kipper, nor is it as difficult to the untrained palate as an oyster. Sushi are large mouthfuls of cold boiled rice, wrapped in slices of boned fish of various kinds, fresh and salt water; prawn, seaweed or sometimes omelette, etc., deftly and appetizingly put together and the ingredients absolutely fresh.

I shall conclude this chapter with a couple of the many funny stories which I hear but usually forget. An elderly Japanese professor travelling abroad for the first time was placed opposite an elderly English woman, at a small table in the saloon of a British liner. He could not speak English and he did not know Western customs, so he decided that he would carefully copy her. All went well until the end of the meal when she asked for a bowl of milk, he did the same and broke his bread into it as she was doing, but then she put hers down for the ship's cat!

Japanese are still very fond of gold teeth. Forty years ago I often noticed half-width gold teeth deliberately inserted for effect. Well, I was given the name of a man who was so fond of his dog that he had two of its teeth extracted and gold ones put in their place!

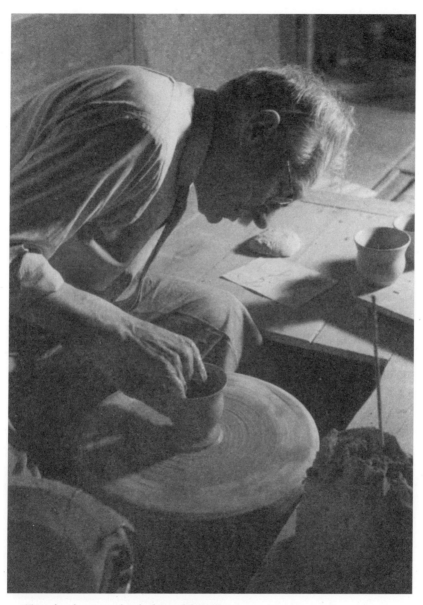

The author throwing at the wheel, Kurashiki 1953.

CHAPTER 4

Southern Travel

MAY 22ND

Farewell to the Ohara's and all our good friends at Kurashiki. By car to Okayama and a ferry steamer which took us across the Inland Sea to the city of Takamatsu on the large island of Shikoku. There we gave public lectures with the Governor of the Province, Mr Hisamatsu, in the chair. But for the Restoration he would have been the feudal lord; a charming and cultured man who had spent five years in the British Isles during which he had travelled in Cornwall, Ireland and Scotland. After the lecture a great dinner party, officials, artists, potters, etc. and, to my surprise and pleasure, Dr Nishimura who was the doctor on the 'Kamo Maru' when I returned with my family to England in 1929. We also lectured at the University and at the large Christian High School.

The next morning we called at the town hall and were shown specimens of provincial craft work which we discussed with a group of some thirty officials. Then we were driven about ten miles out to the small town of Tobe where there are some sixteen kilns and about 350 potters, mostly working on the last of good tradition. We went through five hand workshops and an electric porcelain factory. The clays and kilns were excellent but it was obvious, as elsewhere, that the springs of design had dried up. The power of assimilation was gone,

aesthetically confusion reigned. We discussed the problem frankly, and with some thirty to forty old and new pots in front of us. The governor came out to hear what we had to say. A young 'individual potter' protested that our advice to stick to good old traditions was cramping. Yanagi and I, each in our own way, replied: 'Be modest, these results of wild experiment show indigestion, launch out into the new only as you can understand it and feel it, in any case only a few have this natural creative capacity in any country.' New designs in a Western idiom made by men who have little or no experience of Western life are almost bound to be stillborn. If we in the West had to design for a purely Japanese use, I shudder to think of the incongruous results. On our return to Matsuyama, we made a twenty-five minute broadcast and so to our hotel, bath, supper and bed.

May 25TH

Called to thank Mr Hisamatsu and say goodbye and found that he was providing us with a car in which to drive 50 miles along the coast road of Shikoku to our little port. A delightful road in and out of little sunny, sandy bays and cutting through rocky pine-clad promontories. Lunch was provided at a restaurant perched up 300 ft. looking down on the calm translucent sea. Boys' festival, cotton carp floating over rice fields and fishing villages.

We embarked at Imabaru and spent two hours recrossing the Inland Sea by a longer route through fast tidal currents and between innumerable conical islands, large and small, blossoming with scarlet azaleas amongst scrub pines. These islands are cultivated step by step right up to the pine belt where the angle gets to about 30°. But some are terraced to the grey rock crests. Rice below, then barley, then fruit trees, then serried rounded tea bushes and a kind of white feathery chrysanthemum much exported as a base for anti-insect powders. The constant variety of pattern and colour made by this vegetation was of absorbing interest to me and it was exasperating not to be able

to make more than the briefest drawings.

On this and other journeys, I have noticed that large country houses and many temples are falling into disrepair. The American occupation took various sweeping measures to counter the reactionaries, on the one hand, and the communists on the other, and most of these regulations have not been rescinded. Why, I do not fully know, the fears remain no doubt, but some of the consequences are disastrous. The fields were taken from the landlords and the temples and given to the small farmers and only nominal compensation seems to have been paid, hence the decay I noticed. The Imperial family remains, wisely, but shorn, and all other titles have been swept away and nothing takes their place save money-barons. That is a very fast leap from medievalism. We took centuries longer and made a smoother transition. Much of the formlessness of postwar Japan may, I think, be attributed to the breakdown of long-established cultural institutions, historically connected with the principle of aristocracy. The young generation of students appear to have no knowledge or interest in their cultural inheritance, they cannot even read the best writers of forty to fifty years ago, let alone the classics, because the number of Chinese characters taught in schools has been reduced to an insufficient 1750. This however, is not entirely due to American pressure. But the occupation forbade the teaching of Shinto morals, encouraged Christianity and discouraged Buddhism. This was probably because Shinto and Buddhism have become so popularly interwoven and because Shinto was twisted and used as a prop by the militarists. But take a liquid clay cast out of its mould prematurely and you will have a formless mess on your hands. Some of the behaviour of the post-war generation in Japan gives just such an impression. Actually the Americans quite rightly insisted upon the freedom and equality of religions and a separation between church and state, but as this involved the native religions in a deprivation of their lands and income, the result was unbalanced.

MAY 26TH

To Matsue in Shimane Province on the other side of Japan, four hours by express. Still the little terraces cling and climb: so many people, so little land. The grey porous roof tiles give place to brown-glazed ones made at Unotsu in the province of Iwami, which I visited with the potter Funaki eighteen years ago. That was before the war and I remember an incident in the second-class carriage in which we were travelling. A man entered and rudely demanded of me, in Japanese, 'Who are you? What are you doing here?' I guessed immediately that he was of the secret police, for Japan was already thorny for war in 1935. I replied quietly, 'Who are you?' He answered, 'Police.' Funaki then broke in with long explanations and, after further incivility, the man left. There were two old gentlemen in the same compartment and they each came singly and, bowing, presented their cards and apologised for the mannerless behaviour of the detective, adding 'We have to put up with it too, please don't take offence.'

MAY 30TH

General meeting of some fifty local craftsmen and supporters of the movement. A probing discussion on the Mingei Society today and a general recognition of its need of fresh impetus and a closer tie with the living needs of the Japanese people, but that is quite a different thing from mere popular demand which has become increasingly vitiated by the deep-seated feeling of inferiority to which I have already made reference. That, more than anything else, appears to me to be the real cause of the headlong imitation of Western civilisation. Every psychologist explains how such an attitude on the part of the individual quickly reverses into arrogant behaviour at the first opportunity. This seems to have taken place with the Japanese people as a whole, or at any rate, to the men with the power of sword and credit, and also in degree to the rest of an historically subservient community. Magna Charta is so long ago that we forget the centuries

of struggle for a greater degree of individual freedom than Japan has ever experienced. This shows itself in daily life in Japan in a thousand ways, one of which is an undiscriminating popular demand.

How heart-warming it has been to meet almost all my old friends at or near Lafcadio Hearn's Matsue. Funaki, the potter, has greyed, and his father, mother and first wife have gone, but his son Kenji is one of the most promising young craftsmen, already saying something fresh in a medium of lead-glazed slipware. As I mounted

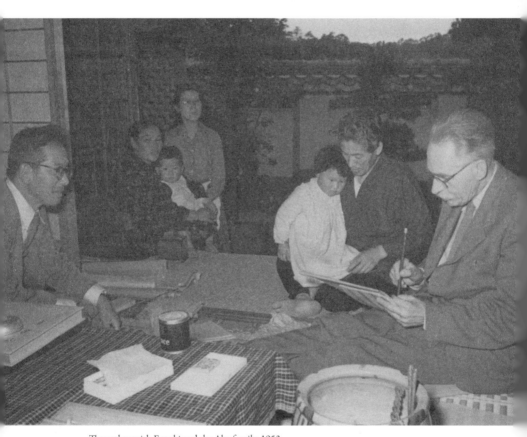

The author with Funaki and the Abe family, 1953.

the steps of Funaki's studio on the very edge of Shinji Lake, I noticed the delicate frond of a young shoot of bamboo still in bud, curving across the wide expanse of water and the hills beyond and made a mental note to draw it (I kept my resolution within the fortnight, but already the purity of line had changed to a featheriness of leaf). Five days have passed like a cloud shadow and with the help of about twelve practised potters at the Maruzan Pottery, next door to Funaki at Fujina, and at Fukuma's pottery, upwards of 100 very large and medium sized dishes have been decorated with slip and some 250 smaller pots made. I threw the prototypes and my tremendously willing assistants made the repetitions and then I did the decoration. Amongst my helpers there was always one young potter hard at work before 8 a.m. who had risen at dawn and come about eighteen miles by bicycle and rail from a small co-operative pottery run by a group of sincere young Buddhists who regard their work, whether in the fields as farmers, or with clay as potters, as part of their vocation. They call themselves the Shusai Brotherhood and make no pretence to be artists. I was much impressed by their earnestness and sympathetic towards the problem which faced them. That of making good pots without a direct transition of traditions of right making, especially of form and pattern. They possessed that humility which is so rare amongst artists, but they lacked a certitude and leadership. How far one can compensate for the other is the question. My belief is that failing that communal verity of action built upon generations of experience, which we call tradition, the only expectation we can rely upon is the occasional appearance of a creative artist.

The minor creativeness of the more average man can function magnificently when it is focused and concentrated by a convinced and healthy society, and even so requires leadership, but it is not enough to stand the internal strains of a confused period.

One evening we had supper with Mr Morinaga who used to be a good weaver but who has become a discriminating dealer in objets

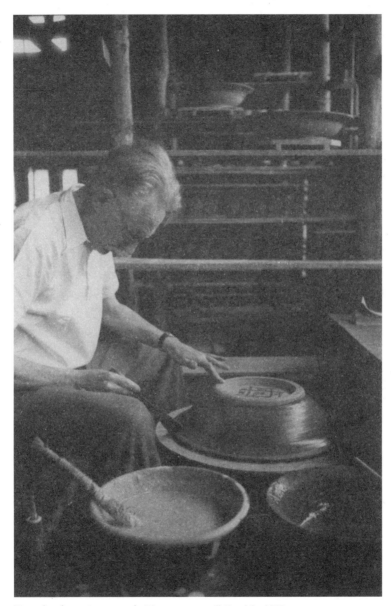

The author decorating pots at the Maruzan pottery, Fujina, May 1953.

d'art. He showed me a drawing purporting to be by me, and signed. I had to confirm his suspicions that it was a forgery. That was the third I have come across. Two pots were brought to me in Tokyo. They were in boxes which had been made for them, which I was requested to sign. All three were bad imitations.

I enjoyed staying with Funaki once again and had long and intimate talks with him. He is one of the few who has found a way and who thinks for himself.

June 6ᵀᴴ

With a group of Shimane craftsmen to the annual Craft Conference at Tottori. It is a pity we have no such meetings in England, to rub shoulders, to wrestle with fresh ideas, to help one another and to arrive at some concerted action. Here were close to 100 men and women from all over Japan, and for the first time as many as five foreigners. Among them were the young French potter, Laloux, who spent a year with Kawai and who has now returned to France to do his military service. He came to me at St Ives three years ago and asked for introductions to Japanese potters saying that, being a healthy young man, he was determined to work his passage out via Australia, as a seaman, rather than accept help from his family. He got to Yokohama and was refused admission, not once but twice, and it was only on the third journey from Australia that he was allowed in.[1] Then there was young Richard Hieb from California who had just arrived, and who is now working so satisfactorily with Hamada, and, beside myself, Mrs Blake who has unfortunately left Japan quite recently after eight years' residence.

The importance of international exchange in modern craftsmanship, as in the arts in general, was emphasised by our report of the International Conference of Potters and Weavers in England

1. This promising young potter died suddenly of polio in 1957 at the beginning of his independent career.

in 1952, and by Hamada's and Yanagi's impressions in Europe and in America. We were agreed that some of the best work being made in the world today was the Danish furniture produced by a fine co-operation between hand and machine. I gave my impression of the Japanese movement as the most unified and widespread, but I made two criticisms of it. First, that there were far too many would-be artist craftsmen, second, that there were too many others working in the manner of folk craftsmen when they were no longer anything of the sort. I gave my conviction that the present situation calls for humility on the part of the artist so that he can work with the artisan on one hand, and with industry on the other; humility on the part of the artisan so that he can recognise his natural limitations and accept the artist as composer, and humility on the part of industrialists both towards the artisan as man and the artist as designer.

JUNE 15TH

The last day in Matsue to which we returned after the conference. Visited Mr Abe, the fine paper maker at Yakumo. We watched the various processes of hand making, so close to the fields and the fibres in character, so friendly and easy to grasp and so good to use. I was given so much that I can draw without parsimony. Drawings are all that I can give in return for unending hospitality. I gave away about thirty before leaving Matsue and had a party of my own at the Minarnikwan, the nice hotel on the edge of the lake, where I stayed years ago. Another illustrated lecture at the high school, a visit to the famous tea room and gardens behind the feudal castle which used to belong to the Matsudaira family. A good tea room, beautifully situated. Oh! I had almost forgotten a fast ride over the waves of Shinji in a private motor-launch with the name 'Herr-un' (Hearn) painted on its bow. I did not visit his old home and the ugly little museum this time but visitors run into tens of thousands, now fifty years after his death. Japan does not forget her real friends but the

museum is a perfect example of good intentions misapplied. A small white pillared 'Western style' sepulchre which would have made Lafcadio Hearn weep.

During these weeks we have been taken all around the district in official cars and on one long drive to the great extinct volcano of Daisen on the borders of Tottori Province. There, leaving the car, we sweated up the old rough stone-paved pilgrims' way, innumerable steps through cool tall cryptomeria groves to the Kongoin temple. We were served the best meal I have eaten in Japan, vegetarian priests'

The author at Mr Abe's paper workshop, June 15th 1953.

food, over which infinite pains had been taken; 'udo', a sort of wild asparagus with a slightly resinous flavour, gathered deep in the mountain forest, strange fungi, mountain potatoes, crisp fried bean curd and some soft curd mixed into a paste with crushed sesame seed.

But this life is not all honey, and it would not be worth a jot if it was. Don't imagine that my body likes living on the floor, however nice the thick, clean, springy matting – it is too far away! My joints are getting stiff, my bones are too long and I feel like an old stork taking off and lacing my shoes twenty times a day, and I am sick of looking for letters and razor blades in bulging nosebags, and having no desk or drawers (except tiny ones away down there) and having no back to lean against, and the everlasting assumption that I understand twice as much as in fact I do.

JUNE 16TH

Urgent messages from Dr Yoshida at Tottori City begging me to return there on the way to Kyoto to make drawings of the sand dunes as part of a protest against their scenic destruction. He is the leader of the Craft Movement in that part of Japan, the head of the city hospital, and has been my good host several times, so, although tired, I stayed there for a night and made some drawings. Later on, I heard from him that the protest had been successful, but what my drawings had to do with it, I don't just know. (This land has since been turned over to the National Parks.) Dr Yoshida has lived in North China and his wife, who is also a doctor, is an excellent cook and she prepared wonderful meals – real Chinese home cooking.

JUNE 18TH

Kyoto, staying with the Horiuchi's. Dr Horiuchi's father was my grandparents' dentist, and my father's too when he was visiting them sixty or seventy years ago, and his son is mine today, so the connection is of long standing. The first thing he said when we

The author sketching the sand dunes at Tottori, June 1953.

met again was, 'Ha! I see your teeth need attention – tomorrow morning.' In twenty-four hours he made a complete set of teeth which fit perfectly, and then he would not let me pay for them so I exchanged pots for teeth. I found I was very tired and got a little sick in consequence, so I decided, at the persuasion of the whole household, to take things more easily for a few days, and that I was very glad to do in their warm-hearted Christian home. Here I slept in a bed once more and had home-made foreign food which, in spite of my liking for things Japanese, I thoroughly enjoyed. I spent two evenings and one morning with Tomimoto and his wife in their tiny bird's nest in the middle of Kyoto. I was so glad to be with him again. We used to be like brothers during the first ten years of our beginnings as potters when there were no others in this field of modern craftsmanship in Japan. Truly we are of very different temperaments and, with the passage of time from youth to old age, our outlooks on the meaning of life have been formed by different combinations of circumstances and natural character. But underneath differences of surface opinions, the old attraction and admiration remain. He was full of life, showing me his drawings, pots and treasures and talking of the past, the present and the future. His work is clean and clear, narrow and deep, with a thorny beauty of its own. He is embittered and disillusioned by the frustrations of his life, and he wants to get away from Japan and would like to come to England and live in my house at St Ives for a time. But of course, as I told him, England after the two great wars is not as he remembers it.

For the first time I visited the Katsura Palace and the Moss Temple (Kokeidera). Kokeidera dates back to the eighth century when it was the site of the great and peaceful Prince Shotoku's villa, but the present garden is mainly the product of the fourteenth century and many men famous in history have had a hand in it. Rock pools, shrines, tea rooms, trees and moss, tucked away at the end of a

narrow valley. Great plumes of 40 ft. bamboos with stems a good 6 inches thick. Water, rock, leafage and stillness.

The Katsura Palace and garden have long been attributed to the well-known Tea Master, Kobori Enshu, 1579-1649, and the legend is that he only undertook the work on condition that, first, he could take as long as he liked, secondly, that he could spend as much as he liked, and, thirdly, that nobody should be allowed to see the results before they were complete. Unfortunately, it has recently been proven that Kobori Enshu was not the architect so the accuracy of this pretty story falls to the ground, but it serves nevertheless as an introduction to the spirit of the age. The acre or two of the garden is astonishing in its variety and spacing but to me it was spiritually breathless and I felt that if I had had to live there I would, like a goldfish, have been gasping for oxygen. Everything so thought out, so conforming to a mould, that no thought, no wayward imagination could wing its way thence in freedom. It is the use of rock which impresses me most in Japanese gardens, subtle, symbolic, timeless. It is Buddhist and pre-Buddhist, taking one back in sense response to emotions as old as the childhood of man. This instinct, developed over the centuries into great traditions, shakes the complacency of our ferro-concrete era of architecture. I spoke of this later to Yanagi, who agreed and added that the absence of stone buildings on these earthquake islands made stones in gardens all the more symbols of undifferentiated life – of eternity – of Nirvana.

June 19TH

Returned to Tokyo by 'Tsubame' (Swallow). The rains have come, heavy and damp and hot. I am still not very well. My former assistant from the art section of the Imperial University finds that he can go to Europe with (Marquis) Asano, Director of the Ueno Museum, so he has suggested his assistant, Mr Mizuo, to help me to gather material for my. book on *The Four Great Decorators*, Koyetsu to Kenzan.

This undertaking is really beyond my training and natural capacity, particularly as I cannot read Japanese texts.

We talked at breakfast about fear – childhood's fear of the dark, etc., and of how people carried these fears into adult life, for instance George Dunn, our first pottery worker at St Ives, who could not understand how I could walk three-quarters of a mile across the fields to Carbis Bay after a late firing of the kiln. 'Don't ee be a-feared, Cap'n?', as he used to say, and there were many Cornish folk like him. Yanagi instanced a Mr M whom I used to know as a mature Foreign Office official. 'You know,' he said, 'that man was so unable to overcome his fear of the dark that when he had to get up at night to go to the lavatory, his wife always had to get up too.'

'Neu Bai', the humid month of rain. I went out to post a letter, pavements and walls gleamed with damp, the air luminous with mist, the high note of insects.

JUNE 23ʳᵈ

I was invited to see the work done at the Women's Art University where Yanagi's nephew Yoshitaka and Serizawa teach. The girls are allowed to follow their own fancies in design and, as might be expected, most of them were just fallacious but there was some good work being done after only four years. The patterns were large and explosive and I wondered if that was symptomatic. They asked me to speak so I pointed out some of the difficulties in the way of free personal expression and suggested that as this was the epoch of broken local tradition and acceptance of all other traditions, it was a time for great caution in designing in alien modes which spring from, to them, unexperienced ways of thinking and living. It is fatally easy, for the Japanese in particular, to pick up the mannerisms of the West but it is very clear to us, who come from the West, when the meat is lacking. After that, I went on to the opening of the British Council offices on the ninth floor of the Maruzen building. Mr Close, who

represents the B.C. here, and the British ambassador were there, also Prince and Princess Takamatsu and Princess Chichibu to whom our old friend, Mr Kanda, presented me. A nice informal talk during which Princess Chichibu mentioned that she knew my work and had one or two examples of it. She is the widow of another brother of the Emperor, who died comparatively young. The opening speeches were almost inaudible owing to the noise from the street nine floors down.

June 25th

Yanagi and I were the guests of the Korin Club at Prince Takamatsu's residence. A British 'Coronation' dinner party, most of the members being leading bankers and business men. We ate on the large lawn at small tables, thick slices of beef, Yorkshire pudding (like lead) on cold plates. But I must say that Japanese beef is very good indeed. Our friend Mr Yamamato, proprietor of Asahi Beer, was chief host, Kirin Beer (fifteen years in England), whose name I have forgotten, sat next to me and was pleasant. We showed a number of lovely slides of classic Japanese and Korean pots, but they were only appreciated by a few members of this Club. I have not known such a weight of hot damp atmosphere in eighteen years. I lay in my pyjamas last night and sweated. At 3 a.m. I heard heavy flight after flight of American planes high overhead, opened a window but could see nothing. That horrible dragging war in Korea. How far off is peace – the real peace? What will bring it?

June 28th

Spent the morning with Mr Yamamoto and had a wonderful lunch at his house just around the corner from the museum – the best cold roast beef in years and a bottle of good champagne. I had some talk with this big Osaka business man, alone. Yamamoto spoke with understanding and feeling about Hamada as the one who had genuine balance and practicality to offset Yanagi's idealism.

JUNE 29TH

With Mr Mizuo to the Ueno Art Research Institute. He laid out hundreds of photographs of work by Sotatsu and Koyetsu, painters – calligraphists – craftsmen and poets. A revelation of a world of Japanese beauty. Undoubtedly one of the high peaks of decorative art in history.

JUNE 30TH

Meeting with Robert Blythe at a supper party with the Blakes. We sat and talked for five hours. Zen, Haiku, crafts, Japan and life. I was delighted to meet a sensitive English poet who knows the inside of the East. We just flowed. I am reading his book on the tiny poems called *Haiku*, sip by sip. It has opened the windows for me into the Oriental poetic mind, not only by the translations, which do not fatuously aim at Eastern forms, but also by his provocative and suggestive comments. Blythe lived for years in a Zen temple in Korea and has drunk deep from that source. He has published various books in Tokyo in English, but nothing in England. I have found his *Zen in English Literature* very illuminating. He teaches at the Peers' School in Tokyo.

CHAPTER 5

Hamada's Mashiko

JULY 1ST

Hamada's oldest son, Ryuji, who is a journalist, met his mother and me at Takumi and helped with buying bread, butter, coffee, etc., and saw us across Tokyo to Ueno Station. As the train steamed across industrialised northern Tokyo, my mind slipped back forty-five years to a spring morning just after I had first arrived, when I had strolled on narrow paths between rice paddies, whilst green frogs leaped into the water to right and left of our clogs, where there are now miles of depressing slums. Two hours by train to Utsunomyia from where a car took us on to Mashiko in half an hour, a total distance of about 80 miles. No sooner had we arrived and greeted everyone than two visitors turned up, who were old-style patrons and officials, bent on kindness, on exhibiting my work in the Province of Tochigi and on taking me on jaunts to fine scenery and hot springs, etc. 'Why do they do it?' I asked Hamada afterwards. 'They are kind and want to do you honour,' he said. 'Mr Suganuma is chairman of local government and represents culture and literature in Tochigi.' They stayed and talked and, as always, photographs were taken (I have accumulated hundreds) and eventually departed before we had supper. A great feed of continental sausages and Chinese riceballs stuffed with mincemeat and 'Funiu'. The last is a strange and fascinating decoction

of fermented bean curd something like a smoky camembert in taste and texture. I chatted with Richard Hieb, the young American potter whom Hamada has accepted as a student, and found that he was getting along splendidly. So to the big house up the hill, mosquito nets and welcome quilts.

Mashiko lies at the foot of the first mountains across the Plain of Tokyo; formerly they were well clad in pine but the war made inroads and now the tobacco growers and the pulp scavengers compete with the potters and the price of wood has risen and risen. There are about 300 men and women occupied in pottery work in some forty workshops at Mashiko. Hamada is of course the outstanding figure, as he is in all Japan. He has built up his establishment from a humble start; it consists of several acres on a slope coming down through bamboos, cryptomerias, garden land and trees to the edge of the paddies. There are now five main buildings: his old farmhouse, a larger new one up behind, a spacious solid workshop and two long gatehouses, as well as two kiln sheds and outbuildings. Beside Hamada and his second son, Shinsaku, who works with him, the youngest boy, Yochan, and Kazue, his wife, make up the family members who are regularly at Mashiko. In the small Tokyo house there are the oldest son, Ryuji, the third son, Atsuya, also training as a potter, and two daughters. There are two maids and an odd man and an old woman about whom Hamada told me the following as I watched her turning some barley over to dry in the sun. 'She won't accept more than Y200 (4s.) a day except once in a while when she wants to visit some Buddhist temple and leave a small present. She works out of doors continually, quietly, methodically; lives alone in a nearby cottage, on bare boards summer and winter, and radiates a spirit of contentment and peace.'

JULY 3RD

Worked all day in the large workshop, throwing. Evening stroll with Richard, two invasions by pressmen with cameras. Hamada

was quite firm to one lot who tried to get into the workshop after a refusal. Work goes on so smoothly all day, mostly in silence. Everyone seems to share a spirit of content and mutuality, there is no Western excitability; perhaps too little for creativeness in our acrobatic sense. Hamada works alone in the main house facing the front gatehouse, keeping an eye on all events and upon visitors. The latter are frequent and as there is no showroom they have to be taken around singly, or in groups, and usually fed as well! How he keeps his steady balance and equanimity I do not know. One secret of traditional handwork is the absence of wasteful effort of mind as well as body.

Mashiko clay is not particularly plastic. I labour to draw it up for it 'squats' on the wheel head. They manage it quite easily with just the appropriate movements and so there are hundreds of effortless pots when dusk comes. I use a hand-wheel turned clockwise with the strength of the right arm, catching a notch on the circumference and twirling. Hamada does the same, but the others employ kickwheels propelled by a pull of the bare foot. One scarcely notices the automatic action of the foot on the polished slope of the lower flywheel even when a mass of 20 lb. of clay is being spiralled up into a cone 15 inches high.

July 4th

It rained solidly all night and even now at 7 a.m. I hear the voices of a thousand frogs through the plip-plop of drops falling from the heavy overhanging thatch. There are the sounds of voices in the house below getting breakfast ready, coffee, bacon, eggs and my beloved bean soup; now for oilskin, clogs and mud!

Footgear! Since the Japanese have houses like birds' nests into which no outside footwear ever enters, one has to take off and put on one's shoes many times a day; 'zori' or slippers are provided for the polished corridors, and again different ones for the lavatory, and they are always too small and my toes will not slip under the central thong of clogs or zori as they have been cramped for sixty years in shoes.

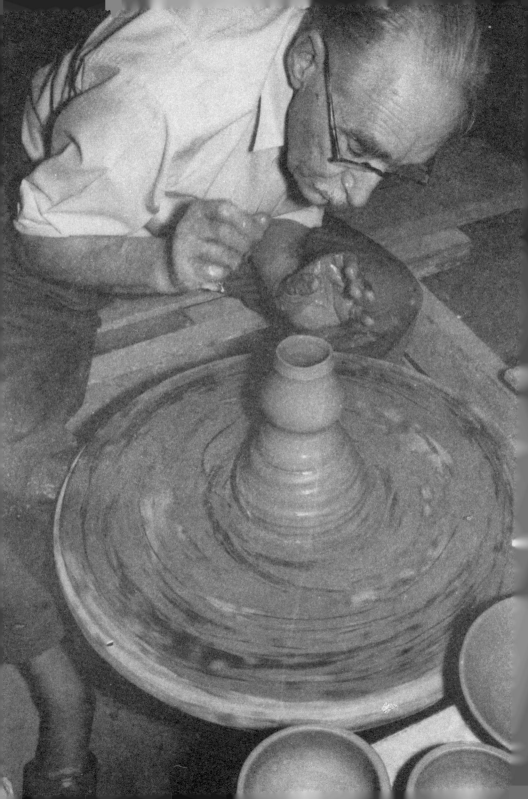

I am always fumbling with laces and grumbling under my breath at the constant bending. Practically all Japan wears shoes today, but they manage to slip into them somehow without treading down their heels. Everyone carries a shoe-horn. They can even manage the single thonged zori with socks on which is, I think, to foreigners, the most exasperating of all house sports.

Japan has burst into leaf after the more delicate spring. Hot sun behind the June blanket of cloud pouring onto a sodden volcanic soil breeds carbon-dioxide and chlorophyll and the result is rank.

Richard Hieb fits into Japanese life quite exceptionally well, but he does not learn the language quickly. Late yesterday afternoon a visitor came and stood outside the windows of the workroom and bowed to Richard, who was engrossed; he looked up with confusion and loud and clear said, 'O hayo de gazaimasu', 'Good morning'. The room rocked with laughter.

JULY 6TH

I decorated a hundred-odd pots all day. The workshop is not comfortable for my old bones, it is made for nimble, short-legged people like everything else in Japan. It is amazing what a difference a mere 9 inches makes! In spite of being on guard, one is caught unaware at both ends. The light comes low down. Overhead, where the pots are stored on boards like ours at St Ives, but without cleats, and always dirty with clay as they turn all their pots and it does not matter, there is shadow, so I bump my head against the overhanging bamboo racks and then kick against the overflowing pots on the uneven floor. There are no tables or stools where one can sit comfortably and see what one is about. They sit cross-legged on low platforms into which the wheels are sunk. I sit with my legs dangling in the void and, to keep moderately clean, I wear a pair of Hamada's 'mompei' (baggy overall

The author working at the wheel, 1950s.

trousers) and rubber boots and clump around like a clumsy bull in a china shop. Mid-morning and afternoon there are breaks for tea and we all wander down to the lower house and chat around for a quarter of an hour. Work starts at about 8 a.m. or a bit earlier, and goes on until 6 p.m., seven days a week. Recently a suggestion was made that Hamada's workers should have regular holidays, but when it came to the point, nobody wanted them.

At 6 p.m. I am called for the first dip in the bath which is, in these parts, an iron cauldron set in concrete, large enough to sit in comfortably up to the neck, squatting on a protective wooden board tethered (not always) to the bottom. A maid comes and calls from outside 'how is it Leachsan?' If I answer, 'rather hot' she pumps and a flow of cold water rushes through a bamboo pipe until I cry 'stop'. If it is not hot enough, I soon hear the crackle of more wood underneath my stewpot. Of course one washes before getting in, sitting on an upturned tub and splashing ad lib. One washes more thoroughly after the first dip and then sits and simmers and all the worries and strains of the day float away with the steam. Then at last the household, usually the men, gather around the long table on benches to a hearty meal in the central farmhouse kitchen whence the wood smoke rises to the rafters and a vent in the thatch 30 feet overhead.

JULY 7TH

The English *Mainichi* and the *New York Times* full of the ghastly tangle in Korea. Who can blame the Koreans for being bitterly and blindly concerned about their own affairs? The Americans have lost 25,000 men, the Koreans millions, and the 'Land of Morning Calm' is laid waste in the name of United Democracy – and what was the alternative?

I have watched Hamada throw and turn this curious soft, sandy clay. The local subsoil appears sandy but when pinched most of the granules smooth out between thumb and forefinger. Nevertheless,

the various mixtures which he favours as the years pass contain a high proportion of siliceous grit which yield the broken, bready, textures which he likes to contrast with heavy wood-ash glazes. He throws boldly and fast and turns great strips of shavings off when the clay is only just sufficiently dry to keep its shape on the chuck. A special technique of coiling is employed for the upper parts of large pots, the lower portion having been thrown normally and half-hardened. The freedom and ease with which he does this is a marvel. But the more one watches, the more one realises that it is the result of a balance in Hamada himself. Clear and quiet conceptual thought proceeding spontaneously into equally clarified, articulated actions. People come and talk to him about practical matters, visitors arrive and have to be looked after, the old carpenter who has been working for years on the new house wants to consult with him; he gives directions, chats, etc., and most of the time he does so sitting eyeing his pot, or goes on throwing, talking over his shoulder, undisturbed in himself. Yes, his pots are articulated like the bones of a human arm, movement following movement with joints in between, unlike the smooth curvature of Greek pots or German Bellarmines. Actually the pots themselves, whether being thrown or turned, are rarely perfectly centred. Not that Hamada tries to keep them out of centre, he simply is unattached to mechanical accuracy for its own sake. If the pot functions and feels and looks good – that is enough. Our Western judgment as to whether it does these things is radically different. We, speaking broadly, start off with an expectation derived from the machine and its deadly accurate precision and we have built a way of life and an evaluation around that conception of labour and its productions. Until recently the East has not done so, consequently Eastern expectation of both use and pleasure from pots, and other things of course, is fresh with the vitality of irregularity innate in handwork and natural raw materials. Not only may the clays be rough for many usages, and the shapes of only approximate symmetry, but,

more significantly, a far greater scale of human expression is allowed the potter in play of texture, colour brush work and form. Their inner life has a chance to come out. Watching Hamada, one sees this taking place.

JULY 9TH

Second earthquake jolt. The bushes are festooned with spider webs this morning, beaded with dew. Some prudent hens are high-stepping in the shade beneath looking for the early worm with one-eyed, head cocked vision: A power-saw whines across the paddy fields in the village; mist wreathes slowly across the mountain.

Our anxiety has been to get the pots dried in time so that our plans may carry through. It has rained and rained and everything is damp and mouldy. Yanagi sent some brown bread from Tokyo and it arrived green. Yesterday about 1,000 pots were carried in and out, three times for sun and shower. Today the pots stayed out until 4 p.m., then the whole lot, 2,000, were carried on boards down the muddy, slippery path to the smaller kiln beyond the lower house, 250 yards away, and massed around the long shed on the ground. After tea, the biscuit-firing kiln-packing was started and was nearly complete by supper time. Finished afterwards by candlelight and the fire started. I have never seen anything like it. Everybody, except Richard and I, knew their jobs and had a deft control of their bodies. The four chamber doors are only four feet high and one packer was in each compartment, standing with a bent back, or kneeling on the soft sand floor, packing the fragile pots on shelves like ours, but much rougher, and at a speed which would have shaken our St Ives folk. Outside there was a running, skipping, high stepping flow of pots to the kiln – nobody flustered or irritated and there were not more breakages than with us. Hamada took no hand, he was throwing a late order of small winecups and they too were turned and dried and squeezed in at the last! A slow stoking went on all through the night with big wood at

the main firemouth with all the vents open. Progress next day as at St Ives – the first chamber done by 3 p.m. Then side stoking with very small wood and all four chambers finished by 8 p.m. The height of the kiln is lower and the width is a little less than ours and there is much more space left at the tops of the bungs of saggers and above the shelves. Also there is a porthole for stoking to right and left of the main lower firemouth. No chimney.

Their last stoneware firing was a failure, the temperature would not rise. The same thing happened in other kilns nearby due to exceptional absorption of damp into the kiln walls. We called upon the expert stoker who fired our kilns eighteen years ago and he said the cure was a longer firing in the lower firemouth to drive out the damp and increase the main bulk of heat whilst at the same time avoiding choking with ember. He added, and Hamada agreed, that when the temperature refuses to rise, this principle holds good in general. Thus side-stoking may be combined with main stoking in alternating periods of, say, half an hour. This keeps the heat going and prevents choking, too.

JULY 12TH

A lovely sunny afternoon walk with Hamada and his youngest boy, Yochan, to Clay Valley over the hill, Hamada's hill. Acres of wooded land. We visited three cottages and sat and chatted and drank tea.

The mosquito pipes
His high note at dusk,
Fire-flies light the dim,
And the wet chorus of the frogs
Continues to the dawn.
But by day it is the semi on the pine[1]
Who bays a pallid moon.

1. 'Semi' = cicada

July 14^TH

Glazing pots all day under the trees, surprisingly cool and sunny. What a perfect setting! The long sloping kiln like a sleeping prehistoric animal under its thatched roof, the pots on boards on the ground, tools and glaze-tubs, Hamada sitting decorating great 24-in. bowls swiftly and thoughtfully. Shinsaku, two other men and two women squatting, sorting, cleaning, trailing and fingering wet and damp glazes, one over another, or carrying them in and out of the stockroom. Richard doing whatever he could, and talking finger language when necessary, and myself in a corner busy with my batch.

Just before lunch two foreign visitors were announced and turned out to be Mr and Mrs Kring of Worcester, Massachusetts, who were so kind to us when we were there. Nice people. He makes stoneware pots as a hobby and is the Unitarian Minister there, and runs the Worcester Art Center.

They stayed to lunch but were careful not to interrupt us seriously. There were other visitors, too, including a bunch of minor provincial officials who were a nuisance but, as Hamada said, one has to keep in their good books if one wants anything done. They are part of the pyramid of government. But the undertones amongst the working potters were not very complimentary. There were two press photographers dodging in and out for a couple of hours with their tripods. In spite of all these trifles, however, the speed of work was about twice ours, and calm within the bustle, which it certainly would have not been if we were forced to put up with such disturbances in St Ives.

Richard is liked all around and it has been a pleasure to see how this young American of twenty-three has accepted the habits, the food and the life in general. What is more, his own work is not a slavish imitation of Hamada's.

JULY 15TH

A couple of days in Tokyo, shopping, catching up with the more urgent letters, agreement with the Mainichi Press for the publication of this diary a year hence. Very pleasant supper party at the 'Hungaria'. Mr Harr, whose wife runs the restaurant very successfully, is a sensitive Hungarian photographer who has just finished making a short documentary for the Americans on 'The Arts of Japan' about which I have been consulted from time to time.

JULY 18TH

With Yanagi to Mashiko by car. Rough roads, the best are about equivalent to third-class in England. Road making is a new and heavy burden in Japan. Nevertheless there are cars, buses and lorries everywhere, whereas eighteen years ago there were only a few and, forty years ago, none.

JULY 19TH

Opening the stoneware kiln all the morning. It was fired whilst I was away. The results are very good as a whole but my batch was mixed because of niggly design and partly because of inexperienced use of material. The pots, making use of regular clays and glazes treated more or less as a cross between English medieval and local tradition, were better. Hamada has resuscitated a method of placing pots in the kiln with heavy running glazes, like Tenmoku and rice-husk opaque white, on several small seashells stuffed with clay. These shells, being more or less pure lime, break away after firing, leaving a charming impress much preferable to a ground-down foot ring, and at the same time preventing the pots from sticking to their supports.

JULY 20TH

Yesterday we were whisked off in an official car to Kinumura (silk village), 30 miles away, to see some traditional fine silk weaving

in a sort of experimental institute of which Mr Suganuma is the patron. We watched the wad of silk thread being stretched from the cocoon over four pegs about 9 in. apart, in warm water, just like handkerchiefs, and an old quiet-faced craftswoman coaxing the thread out so patiently, and a girl weaving expertly on a small hand loom. Then we were taken into the design room and there we fell silent. In the discussion over tea which followed, Yanagi took the bull by the horns and bluntly told them that they were producing the worst designs from this locality which he had ever seen. Bad synthetic dyes replacing good vegetable dyes, smart modern patterns displacing the plain but fine austerity for which this village was well known, thus nullifying the value of the traditions they inherit. Hamada and I backed him up and described what was happening not only in Japan, but in the world at large. The turn away from good traditions, born of the life of the people, to the unreal, unlived, world of the department store. Mr Suganuma took the criticism in admirable part and vowed that he would act upon it, but the director of the school was upset.

Then we were driven to Nasu Hot Springs, 70 miles away, 3,000 ft. up in the mists. A great wine drinking by the provincial officials, at which we, who don't like heavy drinking, were rather poor sports. Sulphur baths and mist again next morning. Then we called on a paper factory at Karasuyama and found wood pulp displacing mulberry bark and quantity ousting quality. The same story everywhere. Twenty people at lunch. Back to Utsunomiya to a supper with ninety of the intellectuals and officials of Tochigi Province. Speeches and public discussion and a frank avowal by Mr Suganuma that Yanagi had convinced him. This all came out in the press later.

JULY 28TH

It is hotter than it ever is in England – hot and sticky. June rains

extended over most of July producing disastrous floods in the south. Then came the full heat of the sun over the sodden land. Our shoes grew green beards, the bamboo shoots raced their 30 to 40 ft. in a month, everything with legs crawled, or jumped, and with wings flew and the sap rose and we sweltered and swore. Mosquitoes, buyu, a voracious little devil, small and silent, who digs in unnoticed until one sees a stream of blood and the hole itches like hell; hornets, enormous dragon flies, the praying mantis, heaps of great stag beetles and of course the incessant cicada!

The Hamadas and their youngest and I took a car to the nearest sea, at a place called O Arai, 40 miles away. There were multitudes on the beach and I got sunburned and yesterday my back and chest began to itch unbearably. I went off by myself with a fan and some baby powder and walked up and down in the coolest place I could find, naked.

JULY 30TH

Mashiko Matsuri, the town festival. The town is divided into sections for this annual event which lasts for days. The nearest division has its headquarters close to Hamada's house and one evening we strolled round through thick mud to see the decorations and the charming square lanterns on posts, painted by the local folk, all along the winding path between the paddies. The village elders begged us to come again on the main night. This I did alone and, being tall, watched the proceedings indoors from outside behind the throng. Those kneeling on the matting were packed tight in ranks leaving an open space in the middle where an immense sake bowl was filled with about 4 gallons of hot wine from a large white coffee pot. In order of rank, or precedence, one after another came and knelt (with their backs to me) and bowed and drank, bending – just how I could not see. Then there was a whispered consultation. I had been spotted and, before I could escape, I was dragged into

the circle and invited to drink my good wishes for the year whilst a camera was produced from somewhere to record the fact. I knelt and bowed awkwardly and then did not know whether to try to drink from the lip or from the middle of the steaming pond. I decided that the latter was politer and more hygienic, but I was mistaken because my long nose buried itself in the liquor! I noticed that the younger men put away an astonishing amount within brief seconds. It was all very friendly and local in character but oh! why that ghastly coffee pot? And in a potter's town like Mashiko of all places!

We called on Masu Minagawa, the painter of teapots, now aged eighty-two and no longer able to work. This rough-tongued old woman has become a legend in Japan. I first met her twenty years ago when I was making a 16 mm movie of pottery life in Mashiko. Hamada had suggested that as the local kitchen teapots, which she decorated with such incomparable verve and lightness of traditional touch, were going out of fashion, I should design a teaset for foreign tea to be made by the local potters and decorated by her. This I did and we got her to come and demonstrate the twenty or more patterns which her father taught her in her teens. It was with difficulty that we persuaded her to do them either on paper or even on unaccustomed shapes. She protested that it did not feel right. 'The round pot and the regular shape are comfortable,' she said. 'This isn't.' I still keep a set but they did not catch public taste to any great extent for it was bent on the genuine foreign article or copies by Japanese industry. At one point whilst she was working at one side of a table and I was working at the other, she burst out, 'Oh, I can't remember this pattern, how my father did it, you are an educated man, you do it!' She cannot write her own name but in her prime she painted 1,000 teapots in a day for which she received thankfully about the equivalent of 2 s. Yet Dr Yanagi said there was not an artist in Japan who could do what she did with a brush in her own limited field, and he gradually made her work known to

the nation. When I showed my film to the local potters one evening they roared with derisive laughter when they saw her on the screen and she, sitting amongst them, laughed too. At that time I was anxious lest her traditional skill should be lost, and often spoke to Hamada about it, so on this visit I was delighted to find that in the interval she had begun to teach her granddaughter the old patterns. She made her own brushes from the hair of the village dogs taken from the top of the tail or the back of the neck where the body gets least friction and therefore the hairs grow to a diminishing point. In the old days when there were many painters they say there was a competition between them over the dogs with the best coats. These pencil brushes are long and floppy and quite unsuitable for writing but wonderful, in the right hands, for the flicker of these old patterns of peony, bamboo, plum and calligraphic impressions of Mount Fuji.

In the interval of twenty years Minagawa's standing in Mashiko has changed. Mrs Vining, the tutor of the Crown Prince and the author of *Windows for the Crown Prince*, brought two of his young sisters out to watch and the old woman chatted to them in broad local dialect, but the little Princesses were silent and so well behaved that tough old Minagawa asked them outright as they were leaving, 'Did you enjoy it? Was it interesting? Don't forget to tell your father and mother when you get home. Be sure!' A week later the Emperor himself came to visit Mashiko.

Minagawa was told she must not speak to him at all. Before the Emperor arrived some twenty press photographers kept worrying her to start but she retorted, 'Today I am painting for the Emperor, not for the likes of you.' When the Emperor did appear, she, who had never been abashed by celebrities or pressmen, suddenly became nervous. She forgot her specs, she couldn't see, couldn't centre her pots on the wheel and her hands shook. The Emperor asked her how old she was, how many pots she painted in a day,

etc., but she remained dumb. Afterwards her local friends came and congratulated her but she complained, 'I only saw his trousers and the chamberlain's hand tapping his leg impatiently. I could not work because of that fluttering white hand.' Only one minute had been scheduled but the Emperor forgot time. When he returned to the palace, he wrote a short poem about her and when this was sent to Mashiko the town officials had it carved in stone and set up as a memorial and after that, of course, old Minagawa became a somebody even in her home town. She was painting these teapots in 1909, when I bought one for my own use, and has been the sole painter ever since. Making all allowances, Hamada and Yanagi have calculated that she must have painted over three million pots during her long life.

I also visited a potter called Sakuma, who has been a friend and follower of Hamada's for many years. He is a local potter with his own workshops and kiln and a man of simple upright character, who, without copying Hamada, has yet managed to absorb much from him in a healthy and natural way. Hamada has a wide influence but no outstanding pupil and Sakuma is not a direct pupil. He is just an unassuming plant upon which the sun has shone and so he has flowered.

His character, which is reflected in his best pots, may be gathered from this story which Hamada told me: He came up to visit the folk museum recently and was deeply impressed by the New Mexican 'Bultos', or carved and painted figures from churches – Maria Guadaloupe, Saints, Christ as a boy, or Christ in the bloody agony of the Cross. They were made by pious devotees and are the antithesis of the ghastly statuary of the Roman Church today. Apparently he went home with his heart full of their intensity and began to make some figures himself, throwing a cylinder of clay on the wheel and then modelling it by hand. Hamada said they were strangely impressive and that one of them was shown with its hands pressing

against the two sides of its chest, and that he asked Sakuma what the gesture signified. He replied, 'The hands are holding his heart, on the way to prayer.' We shook with sympathetic laughter and Yanagi said it reminded him of a story he had once heard about a simple peasant woman who was asked why she always prayed to Mary and not to Jesus.

Her answer was, 'I am not worthy to pray to Him.' This called to mind my own first visit to Rome when I was twenty. I was rambling alone and came out unexpectedly from a small 'calle' into the square of St Peter's. I entered the great building in a dreamy frame of mind and walked slowly down the colonnades until I came upon the famous statue of St Peter, whose iron toes have been worn away by the countless kisses of the faithful. I leaned against a pillar and watched a German scientist, notebook and footrule in hand, taking its measurements for a quarter of an hour, meanwhile I observed a little old peasant woman, candle in hand, patiently waiting until he had finished. Then she went and knelt before the statue and reverently kissed the iron stump.

JULY 31ST

The month at Mashiko is gone but it was only during the last days that I began to feel easy in the sense of just wanting to go on making drawings and pots, knowing everyone and the whereabouts of things. A last wonderful meal together, presents of drawings and of sake for the team.

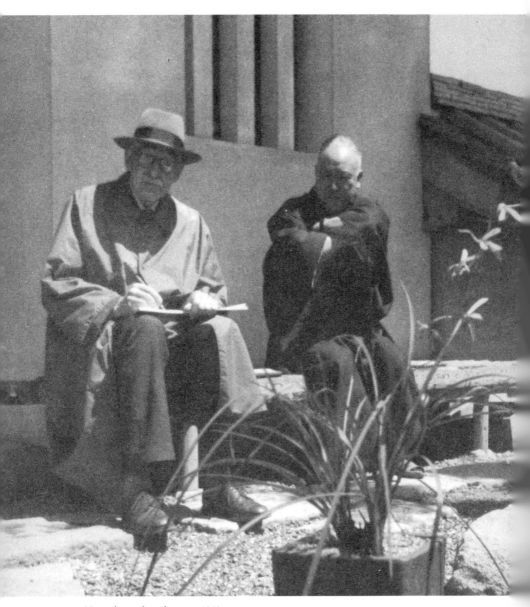

The author making drawings, 1950s.

In the Mountains, Matsumoto

AUGUST 3RD

To the central mountains of Shinshu, the Japanese Alps. Got up at 5 a.m., reached Shinjuku station by 7.30 a.m. and caught the 8 a.m. for Matsumoto, a five hour journey. Nevertheless it was so crowded that we had to stand for half the time.

We were met by a group of local craftsmen and escorted to the town hall to pay our respects to the mayor and his officials and then drove out some ten miles to the Kazanso Hotel in a secondary valley. A warm welcome from the proprietor, his wife and the staff who all know Yanagi well and were most anxious that we should spend the summer with them. The room allotted to me was last occupied by the Emperor, very nice and quiet. I felt somewhat abashed.

AUGUST 5TH

At 6.30 this morning I was awakened by voices at my outer door and mumbled 'Ohairi' (come in) and sat up and saw a bevy of females who said that they would like to see the room in which the Emperor slept. I rubbed my eyes but not until I had put on my spectacles did I take in the fact that they were guests and not maids. I asked if they would not come later when I had had time to get up, but one with a long nose actually came into my bedroom and peered around with

her head on one side like an old hen. I felt indignant but realised that rudeness was not intended and that this was Japan and not England. I was at least glad that some of the old feeling towards the Father of the Country still remained.

From the front windows of the hotel, my eyes followed our valley stream down to the big plain of Matsumoto and over to the foothills, twenty miles away, and up to cloud bands and up again 10,000 ft. to the spear peak of 'Yari', and high above a small pale moon riding the blue races of the sky. Our side-valley with hill villages perched on the slopes is dominated by a 6,000 ft. peak called 'Utsukushiga Hara', which may be translated as 'Exquisite Heath'. Does that convey the feeling from the onomatopoeic sound (vowels as in Italian)?

View from the Kazanso Hotel, Matsumoto, August 1953.

AUGUST 6TH

For two days I have had my eye upon three gardeners pruning, cleaning and training a few 12 to 18 ft. pine trees in the garden below my verandah. Everything from top to bottom is inspected, the young shoots nipped off, the oldest needles thinned out, the outer bark removed and the branches tied and trained along thin bamboo sticks radiating from the secondary branches as desired. The agile gardeners, bass and scissors at belt, get into position by means of light ladders leaning away from a couple of guy ropes which are adjusted as they shift position. One of them has been at the top of the tallest tree for three solid hours this morning working away patiently with an occasional whiff of tobacco. When one thinks of the skill and labour

The author sketching the view from the Kazanso Hotel, Matsumoto, August 1953.

required for large trees, one gasps, at least I do. The ultimate effect is formal and usually rather suffocating. Lines and masses conform to traditions which have lost their vitality. The accidental is eliminated and the power of creative concept has waned as in the tea ceremony and most of all in flower arrangement.

But the alternative is equally barren, free-for-all individualism. Then style, the result of communal acceptance of an overall ideal, is absent and idiosyncrasy and self-conscious eclecticism tend to take its place with effrontery and offence. There is no longer a way for the easy flow of sub-conscious selection. It is the same with potting except in the case of a very small handful of sincere and naturally creative craftsmen – creative in the sense that life flows through them and their hands, unspoiled, unchecked.

AUGUST 9TH

I leaned out of my window this sunny morning at 7 o'clock to look at the mist on the mountains; below me was a paddy field of rice a foot high and the sun gleamed at me through green stalks.

During these days in the blessed mountains, 3,000 ft. above the worst attack of heat and carnivorous insects, in this nice hotel with Hamada and Yanagi, I have had more time to think and to write. We go to bed early, at 9 or 10, and I wake with the light and thoughts go wandering freely for an hour or two in the half-world. As in dreams, they travel almost regardless of time and space but I can control them to some extent and remember them afterwards. Ideas flow best at this time, patterns and shapes of pots appear – whence I do not know, as if from some other reservoir waiting to be tapped but not always accessible in the busy hours of day. Whatever may be the explanation of this other world of day-dream, of night-dream, and of intuition and imagination, I feel more and more certain as the years pass that we have far less claim to possession of that land than we think. We visit it as strangers, and by courtesy. As with the more familiar

market, it is a place of evil as of good. I only know that it is shot with flashes of certitude and clarities which we can bring back to earth.

AUGUST 11ᵀᴴ

I continue asking myself what has happened to Japan these nineteen years whilst I have been away. I look into the shops of Marsumoto and there is far less of interest than there used to be, woodwork, metalwork, textiles, toys, foods – genuine Japanese things. I ask for this and that by the old names and the young shop assistants don't know what I am talking about, or I go to Haibara, the largest paper shop in Tokyo, and ask for 'Tori no Ko' or 'Hodomura' papers, which I used to buy there for printing etchings, and I am offered pulp and an old man sighs and says, 'it is not made now, you might get some good paper still in Kyoto'. 'Why?' I ask. 'Oh well we have to live and export,' he replies. 'But we want these good papers over there, I have been asked to search for them.' 'Ah well,' he replies, 'that is only small business.' So big business is sapping the life, stealing the inheritance, making the contribution to the real life of the world less and less every year. And in restaurants the radio plays on and on, silly, sentimental slush, Japanese or American. The maids even in Hamada's house are unhappy if the banal drug-sound stops. Outside in the roadways of Japan that voice drums in one's ears ceaselessly from shops, and radio cars, 'buy, buy, buy' and the fair-haired mannequins in the shop windows, all over Japan, smile their silly deathless smiles. Sometimes I could cry with the pity of it all. Often I see some of the causes of this defeat. This worship of the West, worship mixed with distrust, uncertainty, insecurity, over population; the same indigestion, at second-hand, from which we suffer ourselves; and then the desire to criticise dries up.

When the Manchus defeated China, Chinese women were forced to bind their feet, but even before the defeat of Japan, Japanese women began to dye their hair – voluntarily. The Chinese made a

virtue of foot-binding – are the Japanese going to make a vice of black hair?

Yanagi is to be editor and questionmaster for the book on the *Way of the Potter, East and West* for which Hamada, Kawai and I are providing the material. We spend the mornings, and often the evenings too, discussing one aspect or another of the making of pots, talking out of years of workshop experience and about the conclusions reached. Today we were working on transparent glazes and the exchange was intimate and exciting and, as usual,

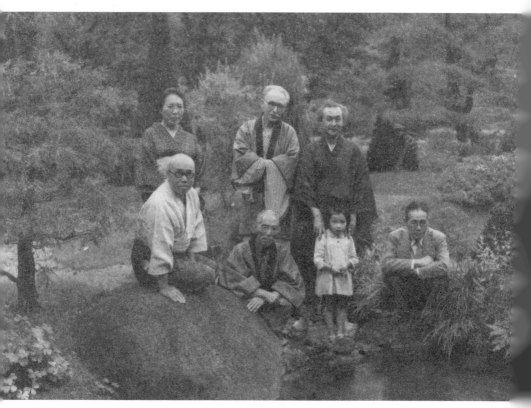

Kazanso Hotel, Matsumoto with Yanagi family and Hamada, August-September 1953

passed through our personal experience in Japan and in England through Korea, China, Persia, Europe and even America, to broad generalisations. The give and take among the four of us is evenly balanced and so far we have not come to a pronounced division of opinion. Kawai is a mine of information and he sparkles.

It rains, it has rained a lot in Japan this year and in England too, apparently. There has been a great loss of life and property. It is difficult for Japan to defend herself against such disasters with water running so fast between conical mountains and the sea. Conical mountains! The volcanic core, so important in the history and make-up of the Japanese people.

This afternoon we went down to Matsumoto and talked to some forty-five members of the Craft Association about local crafts. In the evening we had a smaller party over a long supper and the conversation was fast and funny and full of anecdote. Those who say that the Japanese have no sense of humour would have been confounded.

AUGUST 19TH

Yesterday we set off by bus at 7 a.m. and trained to Nagano, two hours, then bus again for nearly two hours, twisting, lurching, bumping over a mountain road to the Kambura Hotel in the pilgrim village of Togakushi which is made up of very large thatched houses. Panoramas of mountain ranges and canopies of mist and cloud, very beautiful. We bought well-made bamboo baskets and trays. The hotel bill was very moderate, 12 s. a head including beer and supper as well as bed and breakfast. I enjoyed the ride back still more, no doubt being more inured to the anxieties of transport; hamlets hanging over deep valleys, mists wreathing amongst the peaks, little terraced rice fields climbing 3,000 ft. or more up continuous slopes, some paddies so small that, as Kawai remarked, if a farmer threw down his grass coat, he might not be able to find his field again.

When we arrived in Nagano, the promised car was not at the large ugly station, so Hamada and Kawai went off to the city office to find it and I stayed and watched the crowd for three-quarters of an hour inconspicuously. Over 90 per cent of the people were dressed in foreign clothes and almost all the women had their hair 'permed'. It should be added, however, that the Japanese women, as a whole, take to blouses and skirts mainly in summer weather as the kimono with its 'obe' (heavy sash) is unbearably hot. A loudspeaker bellowed to the public to come and see a circus right in the middle of the city and every so often it played jazz variations of 'Yankee Doodle' (no, this was not American propaganda). Then from time to time large advertisement cars with great horns fore and aft came swinging into action, and all the while from above my head the railway announced arrivals and departures and connections with strident monotony to the ridges of the blue mountains which looked down on new Japan.

Eventually Hamada and Kawai turned up in a smart low-slung Lincoln and we went to have a look at the very large and famous Buddhist temple, Zenkoji. The building measured 200 x 300 ft. at ground level. Strolling amongst the fine old trees in the surrounding gardens, we commented upon all the commercialised signs of Buddhist decadence, as far from Sakya Muni as Rome from Christ. Thousands visit this shrine and of course many are pious, but the vulgarised business of popular religion is equally sickening, East or West.

After that we made our way to a Sobaya (buckwheat macaroni restaurant) and ate 'Zaru soba'. Then to the surprise and evident pleasure of the restaurateur, I asked for 'Soba Gaki' which was not on the menu. This is a kind of porridge no longer in fashion. It was brought to us in good old fashioned lacquer boxes and black raku bowls to eat from, both of a kind none of us had ever seen before. We ate it first with shoyu sauce and then with sweet adzuki beans. We planned to try this porridge at Mashiko with cold milk, sugar

and honey. Leaving Nagano, we drove through a lovely long village with fine old thatched houses facing the old high road and reminding me of some villages in North Devon. With the rapid increase of motorised traffic, these old highways are vanishing. The roads have to be widened, and so far there is little sign of a discriminating effort to preserve the character and beauty which, at the lowest level of argument, the much desired tourist comes to Japan to see. At Kashiwabara we stopped to visit the last home of the famous 'haiku' poet, Issa. A single bare room, a tiny window high up, a doorway. There he died in poverty 120 years ago after a hard life. We compared him with Vincent van Gogh. An unhappy childhood with a cruel stepmother, from whom he escaped, half fledged, into an unfriendly outer world. He never grew a skin thick enough for its climate. Here is an attempt to translate four of his couplets:

Little sparrow, orphan sparrow,
Come and play with me.

Listen, you world of insects!
That is the famous voice of the nightingale.

Courage, little thin frog
This is Issa, who will take your part.

A fire-fly slept upon this leaf last night
Keep off; 'Big Feet'.

Eventually through cloud mist we reached the lake side of Nojiri and drove to a thatched semi-European hotel on a promontory. With foreboding we noted the half-hearted welcome and the cheap furnishing of the Japanese style room which we preferred to the foreign. Nothing spoke with the silent voice of quality. My Yukata

(provided cotton kimono) reached to my knees, and from it I picked off grains of dried cooked rice showing that it had not been washed since it was last used. In the tiled bathroom three half-Japanese children were playing with soap in a very small bath, a thing unheard of in Japan. They played on and on. One of them replied to me, 'I never heard that soap was never used in Japanese baths[1.] – yes, I have lived in Japan ten years.' The food was poor, in fact everything was half-baked except the panorama of mountains and even they were spoiled for us by the ugly little foreign red and white houses popping out from amongst the trees. Yet this hotel is famous and, as Hamada remarked, most of the guests were of good family and they would doubtless return with glowing reports of their visit to Nojiri. We all agreed that it was not the lack of this or that comfort, but of any live spirit – everything was dead, in a limbo between two worlds, and neither hosts nor guests knew it.

A short recording has been made for the Japan Radio Co., and in it we contrasted our experiences in fine Japanese hotels with the one at Nojiri. This experience we rubbed in because the conclusions apply in all sorts of directions, certainly in the craft world. All is well if the mixture of East and West is a good one, but nothing stands in the way so much as a misguided idea of what is good.

Again on the last leg of our journey back to our hotel by bus from Matsumoto a loudspeaker gave us more prices of shares and popular music, very loud, right from the low roof over our heads. One's ears actually hurt. I just endured wondering if anyone would protest. After a while Kawai's voice from behind me called out to the driver to turn it off. No notice was taken. He called again, and yet again and it went off with a snap. Someone else joined in, 'you need not turn it right off, turn it low' but the driver was huffed. I doubt if he had ever been asked before to stop playing with his toy.

1. Japanese wash outside the actual bath-tub and keep the bath water clean.

How nice it was to get out and be met by a couple of the decent maids of this friendly and comfortable Japanese hotel, anxious to hear our adventures and carry our things. After bath and supper, we ate very large cold peaches, the best I have ever encountered, sent to us in two big boxes by Mr Ohara and Mr Takeouchi from Kurashiki. Most of the fruit in Japan is ripened on the tree in water-proofed paper bags. This makes a very odd impression on first sight. Fruit growing has advanced tremendously in eighteen years despite the difficult task of preserving the flavours of foreign fruit upon a humid, fast growing, volcanic soil. Apples, figs, pears, grapes, melons, oranges, persimmons, etc., and a seedless watermelon developed by Munetami, Yanagi's youngest son, a botanist.

Our discussions for the book are centred around the exchange of ideas and information on clays, kilns, glazes, etc., and usually end in philosophies, religious influences on outlook, the interplay of East and West, the present state of Japanese and European art and life, on history, the effect of science on traditions, on education in art and many other subjects which may not seem to be closely connected with a book on pottery. It may seem strange that the prospect from a potter's small window should be so extensive, but any subject probed deepens towards totality, and in a period like this, with the old localised traditions breaking down right and left and the new yet unformulated, a group like ours, howsoever inadequate, is obliged to reach out in many directions in the search for new and more universal values.

AUGUST 23RD

Provided with a car, we drove along the Matsumoto-Nagano valley which runs perhaps 50 miles across the very middle of Japan. Sparrow scares glittered silver, or fluttered red and white, over the green paddies where the rice was coming into berry. We rode through one long and well-preserved village with fine houses with as much as 50 ft.

frontage and depth and curiously flat roof spans for high lands where snow lies heavy. Water ran fast and clear down the sides of the road; in old days it used to be in the middle. We called upon an elderly scholar, Mr Yokoyama, living in retirement very simply amongst the farmers. He pulled out picture scrolls and printed illustrated books of a kind the artists of the West have had little opportunity of seeing, more is the pity, 300 to 400 years old.

Then our car wound its way up a high pass until we eventually looked down on Lake Suwa and made our descent to the ancient town of Shimo (further) Suwa, to the house of a Mr Ito (who has unfortunately died suddenly before this was written). He welcomed us to two sorts of food for a fine collection of pots was spread out on Chinese felt in a couple of upper rooms, and a meal in another. One Korai celadon bowl showed with unusual clarity the derivation from its Chinese source, but it was gentler and more beautiful as Korean glazes in general always are.

Here in the mountains of central Japan we have been able to get back to former Japan. Our hotel, the Kameya, was in the old quarter near the famous Shinto shrine of Suwa Jinja. We were given the rooms which used to be occupied by the feudal lords when travelling, looking out on to a garden which could have only been produced by centuries of topiary and care. It was like a scene from a theatre and took our breath away as we came to it unexpectedly down polished passages. After bath and supper we strolled through the streets of this remaining corner of Tokugawa Japan enjoying the old signboards and forms of architecture and all that we had missed at fashionable Nojiri. Mr Ito had succeeded in getting the opposed forces of the Shinto priests of the Suwa shrine and the municipal authorities to forget an old feud and combine in making a part of the shrine into a museum showing the ancient excavated treasures of this area. Very nicely done too. Jomon pottery 3,000 B.C. on to Yayoi from A.D. 0 to Haniwa figures from A.D. 600. During the last few

years the origins of pottery in Japan are becoming clearer. Overmuch stress has previously been laid on the influx of Korean potters after the ravaging of that country under Hideyoshi in the seventeenth century. Now it is becoming evident that Chinese Sung and T'ang wares were emulated previously, that influences came up even from Cochin China and that far back in prehistoric times, before the Ainu occupation of these islands, a high development of unglazed, hand-built pots, called Jomon, took place amongst a people of whom little is yet known.

AUGUST 25TH

We got to bed late and I was overtired which probably explains why I was not well for a few days. On the way back through Matsumoto we called on old Mr Yamazaki, aged eighty-three, but as bright as a bird. He is a curio dealer and I have bought a few pieces from him, but I wanted to try to do a portrait drawing of him. Kawai uses one of the pots I got, an old Seto water pot, in our daily informal tea drinking. We also spent some time at two establishments where groups of craftsmen are working in hard woods making chairs and tables and other furniture. I was asked to criticise and to design also, which is not so easy, as I am not trained in wood. But there are many things to be said out of a background of Western life and furniture which are obvious to us and not to them, and the designs I worked on with these keen and intelligent craftsmen are simple and straightforward. A pair of Windsor chairs based on a combination of traditional English design modified by the lighter and more graceful variations which we saw in the Eastern States of America. There were tables as well, and quite a few turned wooden buttons which I designed, besides persuading them to simplify some of their own designs and to begin to give the wood a chance to speak for itself instead of staining it a dark brown. It is strange that this dark, outmoded habit of ours should stick here, whereas in native architecture there is the highest

appreciation of wood as such and not even oil is applied to it. Many things go by contraries, however.

AUGUST 28TH

A cloud eddies over the crest of our lovely 6,000 ft. peak, pauses on the lee and passes on. Mists wreathe imperceptibly over the shoulders of the steep mountain buttress which rises above our foaming stream and the terraced rice fields winding up the valley. A farmer leads an unwonted cow along a narrow path. Yellow leaves of cherry are scattered on the roof below my window. I saw one fall.

At every turn in these clinging mountain hamlets and villages there are pious carvings in local rock or deep-cut inscriptions on naturally shaped stones: Folk symbols and Buddhist conceptions of human attainment. The carving is primitive but good and sometimes not entirely unworthy of great periods like the Six Dynasties in China, or the Suiko age in Japan, say between A.D. 500 and A.D. 800, but beyond any aesthetic valuation is the reality of belief in the minds of the carvers, just as it was with our carvers and makers of stained glass in Europe in the twelfth century.

SEPTEMBER 1ST

Today we climbed the peak which has loomed out of the mists from time to time, up a side valley opposite my window as I have sat at my little desk writing these pages. A car (made in Japan) took us up to about 3,500 ft. on a rocky mountain path which I doubt if an English car's springs and gears would stand. Then we toiled up a stony track slowly for four hours. Hamada, who has put on flesh with the years, found it hard going, and so did I. I made small drawings during the rests. The weather, which has been wet for weeks, was kind and although we hardly got more than a glimpse of the Japanese Alps across the big valley of Matsumoto, yet we were in hot sun with glorious views over nearer valleys and lakes. At the top there were a

few huts, a wireless station, and the grassy plateau called Utsukushi ga hara (Fields of Delight), covered with blue scabious. On the way up I noticed golden rod, thistles, kingcups and hair-bells in flower and, amongst stranger butterflies, red admirals and saffron yellows, so there were reminders of the English countryside. On the way down by another longer route, zig-zagging on loose stones, we came to a stock farm and a camping ground and many acres of good turf, silver birches and a bouldered stream, and we had a long drink of fresh milk. Altogether we walked some twelve miles and were very glad to get to the car again and return to baths and supper and bed.

A few nights ago we went to see the Moulin Rouge film on the life of Toulouse Lautrec and in talking over the relationship between the sexes in the East and in the West, Kawai remarked 'This is strong meat for Japanese stomachs; Westerners cling, we touch and part – of course things are changing now.' I suggested that this was the most significant change and he agreed. 'American woman is at the furthest remove,' Yanagi added. I commented that I had met several Japanese women who were yet more 'emancipated'. They laughed and admitted that they were intolerable. Kawai pointed out that right through the East from the Mohammedan countries onward, there was an early segregation of the sexes and that in old Japan it began at the age of seven, and that Buddhism taught that it was very difficult for a woman to be saved. I questioned whether Gautama himself was responsible for this popular belief and its social consequences. Kawai went on to say that the Western attitude was more natural in a physical sense, and that the outcome in Japanese social behaviour was difficult for us to grasp. The apparent coolness of the old Japanese relationship obscured the real closeness of the ties. Woman was more 'woman'; life was more discreet. She was, in a sense, more precious.

SEPTEMBER 2ND

The craft supporter and bank director, Mr Nakada, fresh back from

a world tour, which included the coronation, joined us for a couple of nights. He told an amusing story of how, before starting his flight to Honolulu, he had been most careful to keep his baggage within the allowed 40 kilos, and was surprised and annoyed at the airport to find that it was 8 kilos overweight, for which he had to stump up about £12. He was still more annoyed when he opened his bag on arrival and found that his thoughtful wife had filled his large vacuum flask with water. We shouted with laughter, but as Hamada remarked, 'expensive water! but not expensive for a good wife'.

The mists have lifted today, the sun has come back to stay, twice I have watched a farmer come and walk around the narrow edge of his rice field looking thoughtfully at his slowly ripening crop to see how much it had suffered.

SEPTEMBER 3ᴿᴰ

It was cold this morning. Our nice maid brought in a vase of the first chrysanthemums, I bent and smelled the autumn. Looking up there was sadness in the aspect of the hills. Little red and silver paper scares twinkled over the green rice and a tattered paper umbrella swayed with the wind. The old farmer came again and peered at his crop.

Today we reviewed what has been accomplished during the month on the book. Yanagi has managed to get a rough draft of about seven of the twelve chapters of our combined pottery book out of our discussion. They have been checked by us and we still have to write the more technical footnotes and I have to make the illustrative drawings. We foresee another month's work together during the early spring at that little hotel in Boshu across the Tokyo bay. It looks to me as if we shall have to have yet another meeting next summer because our probing into the various techniques of pottery-making in different countries opens out a wider and wider series of motivations for form, pattern and technique which have evolved from different

cultural roots. The further exploration of this world of imagination, feeling and belief brings us to the necessity of comparing, ultimately, religious beliefs, and the task we have undertaken becomes thereby the more formidable. How I am to get my Koyetsu-Kenzan book written before the autumn of 1954, I don't quite see, but it is an endless surprise to me how much more work can be accomplished in a given period out here.

SEPTEMBER 4TH

My thoughts keep going back to Lautrec. We were all stirred by the moving rendering of the tragedy of one of the great artists of our time – as great a tragedy as that of his friend, Vincent Van Gogh.

Such is the price we pay for genuine, if tortured, art – art which is the work of recluses and reactionaries. There was always a struggle between the sensitive and the less sensitive but never to this extent. Consider Cézanne, Beardsley, Whistler, Wilde, Gauguin, Degas, Picasso and the whole character of art life in Paris and compare it with the calm of the Sung period in China or the normality of art in Italy before the Renaissance began to over-stress the importance of the individual.

SEPTEMBER 5TH

Kawai described, this morning, the refinement and secrecy prevalent among the best cake shops in Kyoto. He mentioned one in particular where the father of the present proprietor kept his eldest son busy grinding and preparing the sweet bean paste, which is the basis of most Japanese cakes, for ten solid years, constantly coming in to watch him and grumble at his work to such an extent that the young man told Kawai, 'I really began to doubt if he was my father.' At the end of that period however, the old man got as far as saying 'well, well, fairly good' when he took ill and died. Only when he was gone did this eldest son realise that he had passed his testing, and that

he had been given a real foundation whereby he made the best cakes in the old capital, until he died some ten years ago. Then his younger brother, who had meanwhile received a secondary education, had to take on the family business. A subtle change came over the cakes; he had not put in those ten years of grinding apprenticeship which had caused his deceased brother to give thanks in daily prayer for his father's severity.

I have heard many another tale about the preparation of food in Japan, how, for example, live eels were carried over the mountains between Tamba and Kyoto in a couple of wooden tanks slung on a bamboo pole and the carrier kept up a certain mechanical swing of the body and shoulders all the way so that the water in the tanks maintained a constant circulation in one direction which kept the eels in good fettle and preserved their flavour. When trains came, a man was employed in the goods van to circulate the water in the same way.

The quality and texture of all Japanese food is still highly appreciated, especially of fish, and the many conversations I have listened to, corroborated by my own tasting of most kinds of Japanese food, show that knowledge of locality, variety, season and skill is widespread. We had this once in England but wars, tinned foods, and mass production have ever widened the gap between the local producer and his customer.

September 6th

Keats' 'Ode to a Grecian Urn' was doubtless to a very bad pot, as was pointed out to me yesterday by Yanagi.

We had supper with the Maruyamas in Matsumoto. He had arranged a complete set of 'Sen cha' implements and furnishings for us to see and discuss. This is the third variety of formal tea drinking in Japan, but it is of more recent importation from China than the

The author, 1950s.
Photo credit: Imogen Cunningham

common daily infused Ban cha. The rituals of both Koi (thick) cha and Matt cha were developed in these islands. The setting of Sen cha is thin, sharp and literary in flavour. It has been associated with poetry and the southern Chinese, 'Bunjin' (literary) painting from Ming times. Tomimoto is an addict of Sen cha. The tea is infused and is made from the leaf of the same plant, but the plant is manured differently. The best quality is made from the finest leaf as with Koi cha, rubbed by hand and heated and most carefully selected. The bushes are covered with straw roofs to keep off both frost and direct sun. The finest quality of both Sen cha and Koi cha costs as much as £20 for one pound weight of tea. Ban cha is made from inferior leaf, dried and boiled and toasted before infusion.

SEPTEMBER 8TH

It is cold in the mornings now and the smoke of bonfires is blue in the evening as it rises over thatched farmsteads and blends with hanging mists. On sunny days, swallows dart, and thousands of dragonflies with their jerky flight, and the cicadae cry in the pines, and the clear water runs fast under my window.

SEPTEMBER 9TH

When Japanese women all dress in European clothes and 'perm' their straight black hair, even in these mountain villages, and listen to foreign music, or Japanese jazz, as they work all day, what does it mean? Surely the deep emotional identity of Japan is lost – its own soul – birthright is denied, direction is changed. It happened 1,200 years ago when Chinese Buddhism came over from China and Korea, but then it was the emergence of these island people from primitive life into feudal. Slowly the new religious ideal, and the culture in its wake, soaked in and was absorbed and digested. But today it is not a religious idealism which we bring so much as the grey uniformity of scientific and industrial internationalism. Is the

whole world to be painted grey?

I am told that there has been a 'great burning of the books' in communist China on a scale unparalleled for many centuries. It was curbed by a protest from literary men, but what has been lost before it reached the outer world!

SEPTEMBER 10TH

We visited a village down our valley perched high on a secluded, sloping basin of land, the lower half alongside the continuance of our river, the upper half tapering off in terraces to the steep pine fringe. All was still perfect, well kept, unified, man's handiwork imperceptibly merging into nature's. There was some machinery and more electricity than we would anticipate in a corresponding village in England. Roads, radio, papers, politics, schools, changing womanhood, break-up of family, western civilisation in general, what do they do in twenty years to a Japanese hill-village – what do they destroy? What real values do they bring?

There was a little separate white, thatched hermitage apart on a hill. We took a path to it through the paddies and wound our way up a steep zig-zagged track and found it occupied by a solitary nun who welcomed us with delight and made tea and pressed us to eat her simple fare and told of her birth in Kyoto. Kawai beamed and said 'I come from Kyoto, too.'

She was trained in the famous Buddhist temples on Koyasan. She met many foreign visitors there when she was young and was pressed to go to America, but came here twenty-four years ago, instead, and has lived alone with her shrine to the great Kobodaishi ever since. 'I have kept pure,' she said, 'and have never known a man.' She was happy and gave off an atmosphere of joy. It gleamed from her healthy face as she sat and chattered and peeled apples for us and begged us to come again and look down on the village and the flat plains of Matsumoto from her eyrie.

SEPTEMBER 11ᵀᴴ

One of the city officials came with a car and took us all across the big valley to visit a remote temple. It was falling into disrepair for lack of funds. Then we called on a woman-weaver-farmer. A nice roomy farm, hens, sheep, angora, looms, peace. I thought of Ethel Mairet and of how interested and delighted she would have been to see such good hand-spun and woven woollens being made in different parts of Japan. It is her influence which is at work at this furthermost remove. Then we called on a big landlord to see his house and garden and found it fine and noble. The older part was over 200 years old, which is considerable in a land of earthquakes and where wood, wattle, thatch, tile, and paper are the main building materials. Outside the porch there were twin, trained pines with a spread of 50 yards; trained to the roof lines and planned to the hills. One wing of the house was perhaps 20 yards long and there was a wonderful old rock-pool garden outside its veranda. The walled estate backing into the great hills stood high and overlooked the plain of Matsumoto to the mountain chain on the other flank, where we are in a side valley.

SEPTEMBER 12ᵀᴴ

Discussion group with twenty craftsmen and dinner with the mayor and corporation of Matsumoto, geisha and local folk-songs and dance.

SEPTEMBER 13ᵀᴴ

Return to Tokyo.

SEPTEMBER 14ᵀᴴ

Lecture to the Asiatic Society with our ambassador in the chair and about eighty foreigners present. Such a relief to speak in English.

SEPTEMBER 15TH

Visit to Mashiko. Once again I have been taken aback by Hamada's workshop. Everything is on a broad, easy, earthy basis, shot through by an unobtrusive spirit of quiet confidence which radiates from Hamada himself and finds a natural response in the hearts of workers brought up in long-established traditions. Yet the work for me is horribly inconvenient. They all do what they can to make it easier, for the feeling of co-operation and friendship is strong, but there is no escape from the fact that I am too tall for this land. I hate sitting on the floor with my knees over my ears, stepping in and out amongst rows and rows of pots, on uncleated boards resting on uneven floors, grouping the hot biscuitware from the kiln, or squatting on my haunches decorating and glazing, or writing on tables a foot high, even when sitting on a lovely old Windsor chair.

It is a continual marvel to me how so much more work gets done in the year than at St Ives with its larger team. With all our attempts at good planning and electric power and concrete floors, lighting and regular hours, we are less free except in the intellectual effort for freedom. They are at home with the earthen floor with the thick ash glazes, and with the various clays from the local pits which they tread to the right consistency with their naked feet. They don't need to be pushed to work, work to them is a friend as it is to all that traditional background of farmers who make the fields of Japan a paradise for the eyes.

Hamada said today 'Before the last half-yearly firing of our big kiln (eight chambers) the team, who had been packing all day and half the night, decided that, as they were in the swing, they would carry on to a finish all night.' 'Voluntarily?' I asked. 'Oh yes,' he answered, 'but they were tired and silent when I came in the early morning.'

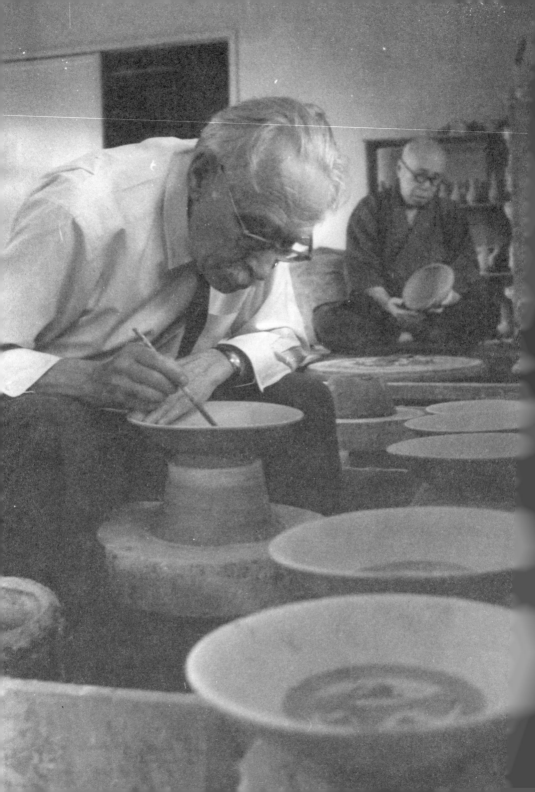

SEPTEMBER 18TH

In the evening a troupe of professional Okinawan actors and dancers gave the Craft Society a performance of traditional song and dance which brought tears to my eyes more than once. I shall never forget it. Out of the hearts and lives of these island folk, Japan of a thousand years ago, still fresh and true: Japan touched by China and the South Seas. Actually the Okinawans are descended from a mixed ancestry with a certain amount of white blood included and it can sometimes be seen in the cast of their faces. The emotion, often sad and nostalgic, as with much folk music, though restrained, was more directly and more plastically expressed than in Japan proper. It was the sense of form and style, quite un-spoiled by any modern falsity, which made an appeal by its wholeness. The eyes of the girls never looked at any eyes in the audience, they were dancing for the dance's sake, and there was propriety and high ritual. A strain of delicate eroticism, yes, but not in the least suggestive. How these people love their devastated little islands! I thought of Hebridean songs and Irish dances. Music and dance are the outlets of their emotional lives. Their history is lonely, oppressed, and isolated like the Korean.

SEPTEMBER 19TH

Lectures at Matsumoto University to a couple of hundred school teachers from all over this province. Yanagi on Mashiko and the Buddhist core; myself on education and the roots of Japanese tradition, now so seriously threatened. I dwelt on the fact that our modern education left out so much of the hand and the heart 'in its efforts, largely unconscious, to provide candidates for the factory bench and the office desk. I also put to them the question of the present value of art-school training and asked how many good contemporary artists had been produced by that means.

The author and Hamada decorating bowls, 1953.

Again we saw the Okinawan dance and music in a packed public hall. I was horrified when, half way through the performance, press photographers jumped upon the stage without a 'by your leave', and, standing between the dancers and the audience, began to use their flash bulbs. It struck me, as a foreigner, as being so abominably rude, and I must say that this audience at least was restless. The presumption of the press in Japan in general is unparalleled in any country I have visited. These men were doing what was expected of them, no doubt, and probably thought that they were being up-to-date in the Hollywood manner, but even at that level it was a caricature.

SUNDAY, SEPTEMBER 20TH – to the high Alps.

We went up in a bus on a road – well, I can only say, people in England would have pronounced it 'impossible' at first sight. Anyhow, it turned our insides into macaroni as we wound up that magnificent gorge, 15 to 20 miles in two hours, where I had walked down alone many many years ago. The mountains heaved up 10,000 ft., beetling rocks hung far out over us, the torrent raged white, sometimes just below, sometimes a thousand feet precipitately below, and our outer wheels were often within inches of the edge. It was single track and there were tunnels when the near side of the bus, where I was sitting, was within a span of the craggy walls at 15 to 20 m.p.h. When we met other buses and trucks we more or less hung one wheel over the abyss. We bumped, sagged, lurched, raced, paused and backed, and yet they say there has never been a serious accident.

How the soft friction of water can eat down through thousands of feet of granite through the ages! There were great scars of landslides and small overgrown screes of rubble and rock making green tunnelled vistas above and below us and waterfalls threaded the rock like falling lace. When we eventually arrived at the high, remote valley, the air was diamond clear, ferns, moss, cryptomeria, silver birch and a variety of large thistle in full purple blossom. We

walked by a white river with dead scarified trees standing knee-deep which had been blasted by a major explosion from the smoking volcano Yari high overhead. I went off by myself and lay on the white quartz sand in the sun and slept and awoke. Up and up over the wild precipitous forests looped electric cables. At our hotel in the early morning we watched the scintillating glitter of alpine light on Yari and all spontaneously said, 'Segantini'.

SEPTEMBER 22ND

An antique dealer called yesterday to consult me and Yanagi about a couple of pots attributed to the first Kenzan. They were both fakes and we told him so, to his chagrin. One of them might possibly have been made by my old master, but neither of them had the strong, free touch of the first Kenzan's brush. The number of faked Kenzan's knocking about the world is astonishing.

SEPTEMBER 24TH

A car was sent today by the city officials to take me to see a large furniture factory and advise on design. There were some 400 employees working mainly on sewing machine tables, partly for export to America and partly for home use. Every man and woman was working assiduously in regular streamlined western production in large wooden buildings. Conditions looked tolerable and working hours were from 8.15 a.m. to 5 p.m. I was able to make a few practical suggestions with regard to proportion, height, splay of legs, colour, etc., but I felt depressed at the deadly crucifixion of material and the lifeless, serviceable results. I think my old friend, the late Langdon Warner of Harvard, of whose fine book *The Enduring Art of Japan* I wrote a review yesterday for the *New Republic*, is right in saying that the prime need of a man's trade is to 'permit and train him to grow into a complete man'; what are we to do, not merely about design in industry but, much more radically, about the thwarted lives of the

workers? It is more obvious here, where so much handwork persists into the industrial era, that something primary and vital is being lost, the heart of the work. We have exported our grey, mechanical world of the machine and it is destroying the very spirit of Eastern people to the possible advantage of their bodies. The question for them, and for us too, is what can be done to vitalise work in the factory. That is a problem to which I have not found an answer. That is not my world, but I am concerned about it because it destroys my world.

SEPTEMBER 27TH

Again the car came to drive me to various points in and around Matsumoto so that I could make drawings to be reproduced as local postcards to be issued by the Municipality. After that at Mr Shimojo's house, the kakemono mounter Morizumi joined us and we laid out lovely Japanese handmade papers, some of them printed in vegetable colours with patterns by Serizawa or his pupils, and my drawings which are to be mounted in Japanese style. This is done according to inherited rules of proportion as, for example, the depth of border above the painting is double that below it. But in order to suit the eye level of a room, where one sits on chairs instead of the floor, Yanagi has discovered that a better proportion is five to three. One has to remember that such rules, although no doubt the result of a long refining experience, are always there to be broken at fresh necessity. It was stimulating and encouraging to find that the four of us in the room could come to common and spontaneous agreement on points of change and subtlety.

SEPTEMBER 28TH

An unannounced visit by a well-known poet and her three friends, one of whom was a good weaver. They brought all sorts of presents, food, a length of hand-woven silk, a poem written out formally on old paper:

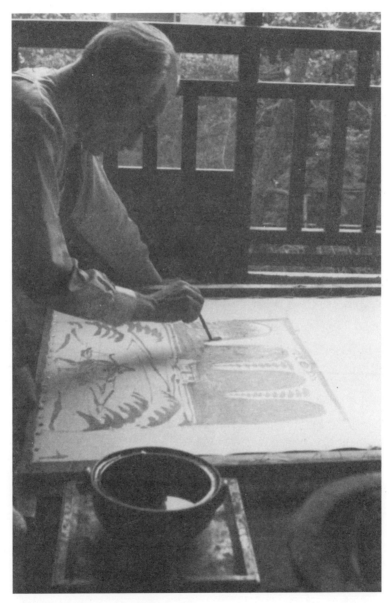

The author painting wax resist, 1953.

'Drops of last night's rain
On needles of Chinese pine.
The exquisite clarity of the mountains.'

After lunch together they asked me to write or paint for them. I did four, using Blake's couplets from the West and Issa's Haiku from the East as themes. They then retired to bathe and rest and I went on with my drawings for the town postcards, and then went out for a last walk alone. I had only gone a few hundred yards and was half-way through a sketch when our maid came running to say that two more visitors had come from Matsumoto with books of mine which they begged me to autograph, and that they had to catch a bus back again before I was likely to return. I finished my drawing hastily and returned to more presents and more painting. One of the visitors was a friend of Tomimoto's, one of whose kakemono he had brought with him, and he asked me if I would not autograph or paint a bare area! I said 'No; if anybody, the artist himself must do that.' There are certain occasions when Japanese don't hesitate to beg and, because a cultural compliment is difficult to refuse, especially for a foreign guest, I sometimes find myself in an awkward position. I feel that this painting habit is carried too far, as also the giving of presents.

Nobody comes without one, and the burden of giving Christmas presents every week is heavy. The result is sometimes amusing, for presents go in circles, unopened, and the fun begins when you get your own present back again from someone else. I vividly remember Tomimoto himself quizzically eyeing a great smoked salmon which had gone the rounds of his home village of Ando at New Year, when it came back to roost. On the other hand I would not like to see the custom of giving thoughtful presents disappear. It would be just one more step into the grey limbo of outward values and conveniences. Incidentally, giving paintings is one thing amongst amateurs, but another between amateurs and professionals. The giving of presents

is only one aspect of a code of social relationships which it takes foreigners a long time to unravel. To remain under an obligation is contrary to this ethic. Presents are either a return for something received, or they may be given to put you under an obligation; always there is a balance in give and take, howsoever disguised.

SEPTEMBER 30TH

It seems to me evident that the state of society all over the world is in a more critical condition that at any previous point of known history. The great religions are not meeting the need of humanity after two world wars. There is no prospect that they can stave off a third with the new atomic weapons, the outcome of which we simply cannot estimate. No real likelihood of reaching unity between the democracies and Russia exists and little enough of a prolonged truce. Everybody is anxious and so helpless that they avoid facing the issues and live from month to month vaguely hoping for the best. We have had fifty years in which to probe for the causes of this situation, and the consequent remedies, and the nearest we have got to is UN. My belief, derived from a life spent approximately half in the East and half in the West, is that it is now too late to avoid the third disaster. In fact it seems to me necessary, as well as unavoidable; necessary in order to bring sufficient humility to western man and his civilisation. UN would not have been achieved unless the bulk of comparatively free men did not see that a great unification of human society with some form of democratic overall government in the general interests was essential for the external relationship of the segments of society. Western civilisation has become more and more materialistic and further and further removed from any religious inspiration and guidance. In fact, religion has become more or less a private affair and God is seldom mentioned in political thinking. The basis of our international concept of unity can at best only be called humanitarian. The question remains how any kind of world unity

can be achieved without a common apprehension of values; in other words, a common groundwork of desire so that the minimum degree of necessary external framework should be a reflection of an inward unity. Surely to God, a vague humanitarianism is insufficient! In contrast to the West, the East has always been the source of light and, even in its decay, maintained the dominance of spirit over matter. If the unity of man is to be achieved, and with it peace, we have to choose between spirit over matter or matter over spirit. America has to choose primarily, as she holds our fate in her hands, and is the most mechanised of all countries.

CHAPTER 7

Around the Main Island
in Harvest Time

Now begins our longest journey, most of the way around the coastline of the main island, Honshu, arranged by Dr Yanagi and Hamada, as with the greater part of my activities. As usual, we travel together as far as possible, visiting groups of craftsmen, mostly affiliated to the Craft Society, lecturing, meeting, looking, talking and eating and drinking, enjoying the beauties of art and nature in good companionship.

OCTOBER 2ND

Leaving Ueno station at 8.35 a.m. we arrived at Ichinoseki at 5.45 p.m. where we were met by the excellent weaver, Mr Oikawa, and spent the night at a hotel which belongs to a member of the Craft Society. We had travelled 250 miles by a slow train passing through Abiko, where I used to have a kiln on Yanagi's land thirty-five years ago, on the verge of a lagoon. From the train it seemed little altered. Soon after we saw Hamada's Mashiko hills 25 miles away to the north. The rice harvest had been struck-by the tail-end of a typhoon and was wet and tangled where not shorn, and hung on bamboo trestles to dry. Golden corn-cobs hung decoratively from thatched eaves. The next morning we drove by car to the famous Chusonji temple built in the Fujiwara Era, about A.D. 1100 (before Chaucer), with one building

with all its faded gold and silver lacquer interior decoration still intact. We were taken around by Priest Sasaki and shown everything; the remaining 4,000 out of an original 7,000 rolls of the Buddhist Sutras, written in alternate columns of gold and silver on dark indigo-dyed paper by 1,000 monks in the eleventh century. There were fine wooden implements and statues and ancient illustrated maps.

Also some bad modern paintings which nevertheless gave an astonishing picture of the old city and its temples at a time when the Fujiwara Shoguns tried to make it rival Kyoto. But the ancient glory was only represented by that one building, and foundation stones, for the Fujiwaras suffered a crushing defeat on the banks of the river Keromo, which wound away to a blue haze between blue hills as we looked down between the trunks of tall cryptomeria and the crooked gravestones of former abbots. Behind us stood a grey, wooden, thatched, open-air Nō stage where the monks still perform under an August moon. That performance I would give much to see.

After that we drove by car 50 miles north to Morioka, where we arrived at dusk and were met by a group of craftsmen at the new Morioka Hotel and had a wonderful meal and much talk till bath and bedtime. This hotel has been designed by Mr Ito of the Takumi Craft Shop in Tokyo, it is in Japanese style but the old proportions have been altered to suit new conditions of life. It is the best hotel in the city and popular. I had a charming eight-mat room, a wooden floored verandah with a table and two chairs, a cupboard with coathangers, etc., a mirror and a low dressing table. Opposite the verandah was a small three mat ante-room-with a lacquered rack for Japanese kimono, another verandah, sliding papered doors leading to the passage way, W.C., etc. The decor was simple and on the whole good; as is normal the room was bare of furniture. Here is the proof that the Japanese Craft Movement has entered the life of the people and is even setting fashion. I could not help wishing that we could say as much in England.

There were some Kakemono with modern, mannered, decorative script by an artist who came to show us more of his work. Yanagi criticised him and his work firmly, pointing out the great difference between old and incidental qualities of irregularity in material and execution, and the new Japanese self-conscious artistry and over-use of intellect and taste. The direct criticism was given and taken in good spirit. There is a magazine devoted to this modern phase of abstract-art script and, strange to say, it has supporters and a considerable following in the United States and France.

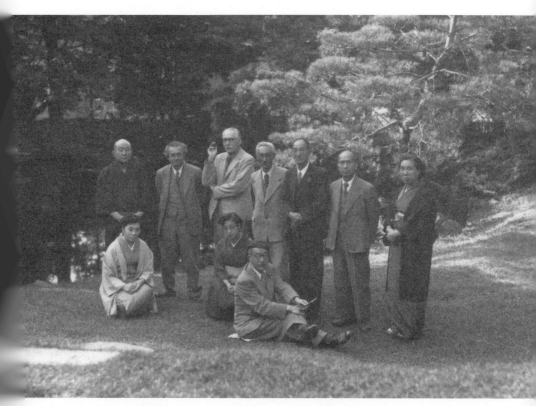

The author, Mr Oikawa and other craftsmen at the Morioka Hotel, 1953.

The following morning we spent at an exhibition of local handcrafts, old and new. There were many good things in it, peasant costumes, basketry, lacquer, toys and textiles, including some fine woollen homespuns and vegetable-dyed Japanese paper by Oikawa. I ordered various things including a warm waistcoat, as good in feeling for wool as Ethel Mairet's, from whose work, at this long range, he has learned so much of the approach to spinning and dyeing wool. Lunch was given by the governor and officials of the province of Iwate and there was also a craftsmen's meeting and discussion.

OCTOBER 7TH

Six hours by a slow train to Aomori in the extreme north of the main island of Honshu. We were too tired to do anything except gaze at the passing landscape between attempted naps. The valleys got wider and the expanses of yellow rice broader, being gathered, hung or stacked to dry on the stalk. The villages everywhere looked prosperous.

Next day we called upon a Mr Narita who showed us his fine collection of Jomon, Yayoi and Haniwa pots and figures and flints. The earliest Jomon pots are long pre-Ainu and are estimated to be upwards of 6,000 years old. Apparently the early folk came over from Korea, down from the Kuriles and also up from the South, but their culture appears little related to China and some Jomon wares show an elaborate and peculiar form sense. Lectures both before and after lunch to local audiences, then we set off with an official on a 25-mile journey into the interior by car. As we climbed, autumn maples burnt upon the mountains against dark green fir and red creeping grape vines; oak, silver birch, and beeches and the undergrowth were nostalgic of English woods. We stopped at one high tarn where the precipitous clean forest was reflected dark and still, and silver streaks of dead-wood were above and below the reedy margin. At the highest pass the firs were torn and twisted into fantastic shapes

by heavy winter snows and Siberian Winds. We spent the night at a real old-fashioned spar called Tsuta where electric lights were dim, and where the baths were huge and made of wood. The next morning another 12 miles to Lake Towada – a crater lake about twelve miles square, about which and its unspoiled beauty I have heard reports for years. But as we stepped out of our car amidst ranks of tourist buses, we were greeted with a blare of jazz from a Pachinko house and saw red and green swan-necked pleasure boats dotted over the lake, and litter strewn along its shore, and our hotel room was painted sky blue and was decorated with the most grotesque gnarled woodwork I have yet seen. This new aspect of Japan is false and repellent, bad even from the lowest standard of money and reputation. From feudal order to a foreign vulgarity in a bound! Pachinko houses are one of the most curious and popular post-war Japanese escape mechanisms. These 'pin ball' establishments are to be found everywhere, and nearly always crowded, often in clusters, and even in small towns and remote places. The machines, like our penny-in-the-slot machines, are vertical and in close rows. In front of each a serious faced working-class man or woman, or student, or housewife manipulates a lever which flicks a steel ball amongst the pins. Once in a while it will fall into a prize pocket and the player claims a packet of cigarettes, or razor blades, or, having received them, sells them back to a tout at the door for ready cash.

Meanwhile the sound of hundreds of falling balls and appropriate disk music. The word Pachinko has no meaning but is descriptive of this sound. The turnover of all Pachinko houses in Japan has recently been estimated by one of the daily papers as exceeding that of all the great department stores combined. To be alone, to forget, even for a short while, to play a game of chance, to have a little flutter, these appear to be the explanations but in sum total they seem inadequate. Pachinko may be the counterpart of the 'Tote' and the 'Dogs' in England, and therefore a phenomenon of industrialised society, but

I cannot help thinking that it is also a symptom of inner sickness of a defeated people whose way of life has been profoundly disrupted.

OCTOBER 9TH

We drove around the lake and then 50 miles to the city of Hirosaki facing towards Manchuria.

Autumn:
Grey gentle waves
Lapping the old root
On the shore of Lake Towada.

Rills
And waterfalls
Like naked swords
Within the folded hills.

We were shown all over the local industrial art school and found it better than the one in Tokyo, but dead for all that. A universal grey blight seems to hang over all such institutions. Reception lunch by the mayor. Craft dinner and meeting in the evening.

OCTOBER 11TH

Up at 5.30 a.m. and off by train at 6.30 a.m. and yet a dozen Mingei friends were there to carry our bags, buy tickets to Niigata, eight hours away by train. The sun after night rain slanting across the autumnal hills and the harvest standing stacked in sheaves, or hung in varying ways on poles or trestles making a wonderful fretwork of golden pattern across the flats. There they stood in the morning sun, sentinels of Harvest Home. Yesterday as we drove down to Hirosaki in the lowering dark, the ranks of poled rice were like ghostly armies 'forming fours' and marching in the headlights of our lurching car,

The author and friends at Horosaki, Akita Province, 1953.

hills looming dark, and heavy clouds sweeping down to river and mists. The continual rains have ruined more than half the crop and it is pathetic to see the disconsolate farmers walking along the narrow banks of their paddies eyeing their year's food bedraggled in the mud. Winds from Manchuria and Siberia must be fierce along this coast. A five foot average of snow in winter. Many roofs are made of shingle weighted down all over with heavy stories. We are threading our way through hard-toothed rock, some of it ridged basalt, which fringes this north-west coastline. Yet the incessant waves are eating their way in century after century and on the other side of Japan the land mass is slowly spreading into the Pacific in geologic time.

Arriving at Niigata we were met by Mr Tanaka and friends and were whisked off to a department store where an exhibition was

staged of Hamada's pots and my pots and drawings, old and new. Then followed a short broadcast by me in Japanese and a long stenographed discussion between Yanagi, Hamada and myself – craft problems and our impressions during travel abroad. In the evening a very good dinner party.

OCTOBER 12TH

The night we spent at one of the loveliest houses I have ever seen. An old manor house and garden of fine proportions and quiet dignity. This house was not rustic but stylish, fine without being over-refined, and certainly not rough and countrified. We have a parallel in England in the best of Georgian architecture. It seems to me to be a quality much needed in Japan today and also in the Craft Movement, which to my mind leans towards rusticity. There were two great trees in the garden, 900 years old, and it was a garden in which one could breathe and saunter. The interior of the house was admirably kept and there was not a false note in it. We left feeling not only gratitude to the owners but also respect.

Then we were entertained to lunch at the house of a collector who had many splendid pots, especially that type of Ming overglaze enamelled porcelain made to the order of Japanese Tea Masters, types which we do not know very well in the West and have not, I feel, learned to appreciate at their true value. They do not conform to that expectation of fine and precise potting which we associate with enamelled porcelain, they are much freer and more vigorous and the essential characteristics of body, glaze and enamels are permitted to speak for themselves. These pots might help to break down a prejudice which has grown up amongst modern potters in Europe and America in favour of stoneware and stoneware only. Later in the same day we saw another, but public, collection of old and new crafts. The night we spent in Mr Tanaka's friendly atmosphere, listening to his warm dogmatic enthusiasm, sitting at the edge of his lily-lake surrounded

with good Korean Ri Dynasty pots. I realised more fully their particular kind of rightness and beauty and its peculiar importance to the modern studio potter. A naked and unaffected freedom of treatment of material, of form and of pattern. These Korean pots grow like wild flowers. Their naive abstractions and formalisations spring from quite another approach to living, a complete antithesis to our self-consciousness and calculation. The Koreans and their pots are childlike, spontaneous and trusting. We had something akin to this in Europe up to about the thirteenth century, when religion and life and art were all one, and the people who lived and worked in that modality were whole. Backwards we cannot go; a greater consciousness is our birthright; our difficult task is consequently one of deepening consciousness towards a new wholeness It is the desire for that wholeness which draws us to the Korean pots.

OCTOBER 13TH

English plus Japanese breakfast; the town branch of the craft museum; our own exhibition; signing the box lids for my pots; a tea ceremony; Rotarian lunch (rice curry only) and half an hour's talk; seeing a private collection of good pots; two lectures with films and slides to the general public at the American Cultural Center; the museum again, and finally a great dinner party followed by an open forum craft discussion. Oh! I forgot, four drawings, a newspaper interview and a couple of dozen photographs thrown in here and there. What a day!

OCTOBER 14TH

One hundred and fifty miles by train down the north-western seaboard to a little village on the coast called Nō to stay a couple of nights with Sukeemon Ito. I met him first forty years ago and he had collected my pots and Hamada's ever since. But he is the chief collector of Tomimoto's work and must have over 200 examples of

his best pots and paintings. These were spread out all over his fine large house and we spent the time looking at them, talking and eating excellent food. His sense of refined hospitality was exceptional. All the paper of the shoji had been renewed for our coming, the bed quilting re-covered with fine old cotton, and a padded silk kimono made for my size and given to me on leaving. The retrospect of Tomimoto's work strengthened our belief in its significance.

He is an artist and a poet with fine sharp purity by birth. If I regret that his pots and paintings have become harder and sharper and brighter as he gets older, I still recognise the same unusual gifts and character constrained by the frustration of events.

OCTOBER 16ᵀᴴ

Two hours on by train to Toyama. The first thing we did was to visit the great Vinilon factory belonging to Mr Ohara. Vinilon is a synthetic fibre invented in Japan and developed after the war. The base material is limestone. Its advantages are greater strength than wool at one-third of the cost, three times the strength of cotton, freedom from insect attack and a great resistance to friction. Its disadvantages, some difficulty in dyeing, a greater tendency to crease and some hardness of texture. But it is being successfully used for serge, cloth, cord, fishing nets, fabrics and socks. My socks are made of it and almost meet my difficulty in getting darning done in Japan! The whole factory was well laid out and the consideration for the employees remarkable. One large building, approximately a 90 ft. cube, full of machinery from top to bottom was run by only eight men (in shifts) at the control panels. The night we spent at the Ohara visitors' dormitory, a fine old house in the city comfortably adapted to new usage.

OCTOBER 17ᵀᴴ

Reception by Governor Takatsuji and three hours of lectures and

films, etc. It is remarkable how enthusiastic Japanese audiences are about our colour slides of primitive, hand-formed unglazed pots made by the American Mimbres Indians which they see for the first time, and which we had made in America.

In the evening we were invited to a 'Tea' dinner by the governor's wife, he being away. It was very good, and she cooked it herself. It was interesting to find paintings by some of the best modern Japanese artists in their comfortable house in its western section.

During the next days we went around seeing collections, houses and gardens and being entertained and giving several talks, and then we started an inland detour of about 100 miles. First we drove to Yohanna for a meeting of the local craft guild in the great Betsuin

The author being shown a collection, 1950s.

temple where the priests have long been warm supporters. Again speeches, slides and discussions, etc. They showed us some fine country folk-dancing by men. Such a masculine strength, vitality and precision as made me feel pretty humble when I compared it with the English folk-dancing in which I had participated.

OCTOBER 19TH

We were up at 6 a.m. and drove through beautiful old villages in the slanting early morning sun again, great 25 ft. hedges of drying golden rice on the stalk partitioning the flat valley. It became a narrow valley, and then a gorge like the one on the way up to Kamikochi. Our party was eighteen strong and included Munakata, the wood-block cutter, and his wife. We came to an hydro-electric dam and a long artificial lake up which we wound our way in a motor boat, stopping for tea at a hot-spring hotel perched on the rock edge. Japanese people love bathing, and adore hot springs, and will travel to any remote spot in the mountains to rest off at them. As we continued we followed a watery track of great bubbles rising from the bed of the lake until we came to another dam and power-plant and then had to climb some hundreds of feet and take a narrow punt with no seating. We were poled and pulled up the next reach of fast, clear green water, breaking white below, overhanging grey rock and the blazing steeps of autumn bending to the stream. It was precarious with eight standing passengers and three boatmen in our narrow craft, but eventually we were pulled hand over hand on a straw rope, which looped from bank to bank, to a pebbled beach and the last mile or two on foot. Presently. we found villagers waiting for us all along the path and were led to a town hall where the mayor had arranged another display of folk-dancing in which he took part himself, and very well too.

At the next village yet another performance, out of doors, in the exquisite setting of the Shinto Shrine flanked with tall cryptomerias.

We all wished that our Hungarian friend Haar could have taken a colour film of that delightful scene. Japanese folk-song and dance should be known to the rest of the world, when it is as good as this, but unfortunately there are many up-to-date Japanese who are ashamed of what they think we would consider old-fashioned. They simply do not realise that one of the commonest questions visitors ask of residents is, 'Why are the Japanese abandoning their fine old traditions? We don't want to come out here to see second-hand imitations of the West.' That, of course, is the foreign point of view, but from the Japanese end it would appear that there is a deep inward compulsion, now that the defeat has broken down the last barrier to the outside world's life after the long seclusion.

I feel at a loss to find words to express the feelings aroused during this incessant journeying. There are no more than a few minutes here and there in which to jot down verbal or pictorial impression, and these minutes are usually spent sitting rather painfully on the tatami, writing or drawing, at a low table, not knowing what to do with my long thigh bones, or where to rest my back. Otherwise it is jotting in a shaky train. Apart from that, winged words won't come to convey impressions of unfamiliar beauty or odd turns of conversation, much of the finesse of which I miss in the fast talk. Naturally one hesitates to break in and stop the flow of a group by asking for explanations.

What a journey up that valley by open truck with twenty aboard sitting on matting, by launch, by punt, on foot, starting on a broad river-lake and following it into the folded mountains until it became a rivulet at watershed amidst the burning maples! Then down by jeep, rough-riding round hair-pin bends for hours, in this remote autumnal air on the other side of the Japanese Alps. Actually we were not more than 20 miles from Kamikochi and the high dog-tooth of Yari which we visited during the summer from Matsumoto. We have made the great circle of northern Japan, the greater part of 1,000 miles, and I am confused by the number of people we have met and

from whom we have received such great kindness and by the flicker of constantly changing scenes.

Beyond that watershed and over the mountains there was a further high valley peopled with great thatched houses of a kind not found elsewhere. The village called Gokayama, the pitch of the roofs steep and the ridges 40 ft. above the ground, which in winter is covered with 12 ft. of snow. The largest were 100 ft. long by 30 ft. wide. They have three floors, the family lives on the bottom and the upper two are vast and slatted for sericulture. They were like great shaggy mammoths herding up the valley and gave a powerful impression of primitive communal life – man against the wolf and bear – ridden forests. The wolves are gone these hundred years, but the bears still come down for food. The boatmen told us of one which swam out to a punt a few days ago and grabbed the gunwale whilst the boatmen dived overboard and got safe to land.

OCTOBER 22ND

Eventually we got back to the coast and caught a train which passed once more through Toyama where the governor and his wife were waiting on the station to greet us as we passed through. Before we started, however, there was lunch at a Buddhist vegetarian restaurant which made me wish once again that I could share the meal and its setting with artist and craftsman friends in the West. The manner of serving surpassed all, it was the service of the heart. There is a saying that the Chinese eat with their stomachs and the Japanese with their eyes. The sheer beauty of each tray or dish of food, the quiet discretion. This represents a peak of culture and its home is in Japan.

OCTOBER 23RD

Another four hours by train took us to the city of Kanazawa. Another reception by the Governor of Kanazawa Prefecture, lunch, lectures and sightseeing, including the fine park and the old

family mansion belonging to the feudal lords. Then we drove out to Yamashiro Onzen, or Spar, in the heart of what used to be the Kutani potteries. There we put up at a hotel and met the Sudas with whom I am to work for the next fortnight, and Shiego Suzuki who has come down from Shizuoka to be my assistant.

October 24TH

Mr Funaki's son Kenji was to have come from the Fujina pottery, near Matsue, for this purpose, but as he was taken ill, Yanagi and Hamada thought Suzuki would be the best substitute. I have come for two purposes, first to decorate a number of porcelain pots with over-glaze enamels, secondly, to advise upon the shapes and patterns of tea and coffee sets and other articles for western usage. Everything possible has been done to make things easy and pleasant for us. A quiet workroom has been built upstairs furnished with chairs, tables, tools and pigments and constant attention. Downstairs a potter's wheel, clay and any help we may require at any moment. Old Seika Suda is quiet and kind – a lover of tea – with a sincere appreciation of the fine old wares which used to be produced in this area. But the tradition has weakened and the fine white bodies and meticulously painted patterns of Kyoto have ousted the greyish local clay and the old vigour of black painting under thick green, yellow and grape purple enamels. The demand has altered, no young artisans are entering the workshops and the old men cannot stem the tide. Young Suda and his active wife were keen and very helpful but there is a deep-seated uncertainty about the way forward. The old sap does not rise any more to a creative level and the new stimuli are too many and too unfamiliar. The pottery is very much the size of ours at St Ives and well planned over three generations. The climbing kiln is like ours but it has four chambers and it takes considerably longer to raise to a temperature of 1340°C. Saggers only are employed for packing. The fuel is pine.

Yanagi has returned to Tokyo and I am more on my own. Suzuki shares my good, if noisy rooms and acts as my factotum and buffer. He is primarily a lacquerer by training but being highly intelligent he has turned his astonishing skill of hand to many crafts. It was he who discovered a way of applying lacquer to paper and who made the lacquered cover designs for the pre-war 'Kogei' craft magazine. In reply to my questions as to why he had turned away from lacquer he said that the reason was economic. The difficulty of obtaining the turned wooden cores today was such that it would necessitate long spells in the mountains, drying and selecting and turning the wood himself with resultant prohibitively high prices. Like so many of us he does not want to work for the collector with a long purse, first and foremost. I don't know yet how much latent creative power he had, my first impression is of an inventive virtuoso and in that case it appears to be my task to indicate to him the field of the composer on the one hand, and upon the other, the more modest acceptance of born faculties, if he is limited to sensitive interpretation. He has an eager leaping mind and considerable power of concentration, and the truth probably lies, as it so frequently does, between the two alternatives.

OCTOBER 26TH

Yesterday I continued throwing teapots and cups with a semi-porcelain body specially made up for me to resemble the old single clay. Suzuki practises the brush and enamel colours, copying the banding and simple repeat patterns on the 'jiku', or roller ends, for Kakemono, which I had done clumsily with an obviously ageing and shaky hand. After lunch we were invaded by the Kanazawa Ceramic Society but instead of having a troupe of twenty in the small workshop watching us struggle with unfamiliar materials, I had the party in a large room of Mr Suda's house and tried to answer their questions there, broad general questions about crafts in England

and America, the relationship between hand and machine, my impressions of Japan, etc. That night after supper our host showed us some of his collection of fine pots. Four Korean tea bowls, two of them of the kind called 'hakeme', a dark body swept with white slip as if by a nonchalant garden broom, and the other two, called 'totoya', which had lean glazes and which were very 'shibui' indeed, but lovely in shape; as fresh as sea shells, clay-like, and admirable for 'Tea' and the Japanese interior. That is a taste difficult for the European to acquire but none the less true for all that.

Then taking box from within box, and untying the silken cords of padded bags of old printed cottons, he passed us five of those hand-modelled first Kenzan plates which Kenzan describes in the Edo Densho, a Book of Pottery Notes,[1.] as having been glazed with an addition of 10 per cent of lead to the normal stoneware glaze, so that they would mature more easily at the lesser heat at the rear of each chamber, just as we have discovered at St Ives. We also examined a 'Shonzui' style blue and white porcelain bowl. A splendid singing blue with crisp, living, detailed panels of pattern.

OCTOBER 27TH

Worked all day, from 9 a.m. to 6 p.m., with the reddish porcelaneous body. It was just possible to pull handles with it, but they tended to break when we bent them on the pots. The workmen were all very interested in this, to them, new process, and quickly set to work learning it. At 6 p.m. I was suddenly informed that there was to be a meeting of the local potters at 7 p.m.! A rushed bath and food and I got there at 7.15 p.m. Suzuki had no supper and was already showing the slides to about 150 people when I arrived. I did some talking and joined in the discussion which got quite exciting when we got right down to contemporary and old examples of Kutani

1. A translation of these will be included in my book on the *Four Great Decorators, Koyalsu, Sotatsu, Karin, and Kenzan.*

wares. It is extraordinary how potters can have noble samples around them and yet produce work themselves which so utterly contradicts the essentials of what they appear to admire most.

At Kutani I have verified a curious fact, namely that just where there is the tail-end of high old skills, and pride in them rather than in the artistry which lay at the back of the skill, as in Kutani, or Stoke-on-Trent for that matter, one finds the most parochial outlook, the least grasp of the total position of the modern potter, and the greatest resistance to fresh and vigorous thought.

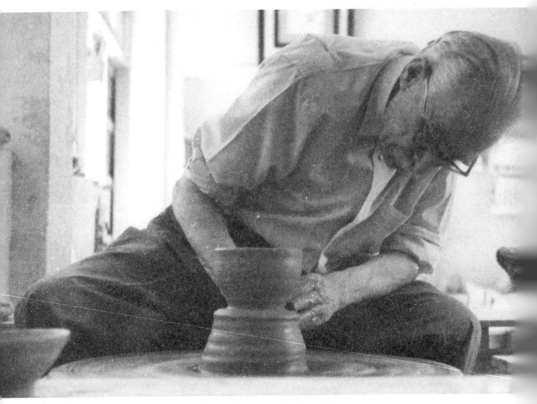

The author practising traditional Japanese technqiues, 1950s.

One evening, when Hamada was still there, old Mr Suda showed us his treasures, the chief of which was a splendid Kutani dish made about 300 years ago. Green, yellow and purple over severe black lines and hatchings, with a little blackish thin iron red, all showing the influence of Chinese Ming export wares. Bold, expressive, naive and non-personal. Also there was a six-sided Ming porcelain dish on three legs with that lovely fat glaze which tends to chip off on the edges exposing a reddish clay. This dish was, like many others of the period, made to the order of Japanese Tea Masters. Hamada's remarks are always so illuminating. The dish had a spray of quartz sand in a trail across its face as it had fallen between the two halves of a split sagger in the pile above it during the firing. Hamada pointed out how the enamel painter had taken advantage of this accident and used the granules to hold a sweep of green representing a little woodland scene in the middle distance. Accidentals, so treated, help to give the characteristics of clay and fire to such pots, bringing the user into sympathy with the unaffected Chinese, or other, potters struggling with the porcelain at great heat. The pot becomes human.

I am dissatisfied with the work I have done here with the comparative lack of quality of bodies and glazes, all thinned out and finessed, but still more by the synthetic approach of the artist-craftsman when it is placed alongside the easy, broad, direct and impersonal attitude of the traditional craftsmen. We are inescapably different, but that is no excuse for the artist turned craftsman to niggle. I would have liked to alter the clays and glazes more than has been possible during this brief spell, and then to set about painting with a stronger and even harsher frame of mind. The root of the matter lies in the integrity of the artist and this requires a severe self-discipline. I am too easy-going and full of soft acceptances. My Japanese friends politely call this quality 'Sunao'.

NOVEMBER 1ST

My pots have been biscuited and some enamelled wares fired, and I have made careful drawings and measurements of the tea-set which I have designed for the Sudas. They have also made copies of these pots, but as I have explained to them at length, influence absorbed is one thing, and copying is another; if the latter is difficult in my own town in England, it is almost meaningless, in any vital sense, out here. They cannot possibly know the inside feeling from which such shapes evolved by a natural process, even if I do show them how to 'pull' handles, and where to attach them, and explain why. As a matter of fact, there are many cups which they used for eating buckwheat noodles, or even for tea, without handles, which if enlarged, patterns and all, would serve as an admirable jumping off ground; the clays are still in the hills, and the skills are in the workshops, but the desire, the sap, the natural inventiveness, answering even commonly understood local needs, have dried up. Were I, an alien, in charge of that workshop for some years, I might either get them to execute my tea-sets by careful supervision and encouragement (a strange hybrid performance) or I might attempt something yet harder and requiring more time and patience, and complete self-forgetfulness, by encouraging a group until its own sap rose again in one small oasis. Even so it would be an artificial thing doomed to wither because the sap would not really rise from the soil of Japan. No, the wrong shapes will have to be made for many years, except in the case of a rare personality like Hamada who has the capacity to know and bridge two cultures; many mistakes will have to be made before any bulk of craftsmen perceive instinctively that which is true, and can work in unison to provide by hand once more, things which are really Japanese and a contribution to modern life at the same time.

Morita, who is now the head of the art school in Kanazawa, came out one evening and spent the night and we talked and talked of the early days when I came to Japan at the age of twenty-one. He was

then the teacher of English at the Imperial School of Art in Tokyo, and he owned the little house which I borrowed in Nippori, lived next door and shepherded me through my first months. That was in the spring of 1909. During the hottest days of that summer he and I borrowed a stern-oared river boat, and spent a week in it up the Sumida River in equal discomfort and pleasure. Incidentally we both nearly drowned on the first day when the wooden pin, upon which the stern oar pivoted, fell overboard and he dived after it and presently I dived after him. It was very interesting to recollect those old days and early friends. He has not changed much in all the years.

OCTOBER 28TH

Suzuki told me an interesting story about Yanagi: Suzuki persuaded him to visit a certain temple in Shizuoka in order to see two wooden statues of the Fujiwara period. To Suzuki's surprise, Yanagi, on entering, and before even greeting the priest in charge, riveted his attention upon a piece of handwriting hanging in a frame high up in the gloom. Eventually he came down to earth and greeted the monk and asked how the temple had come into possession of so admirable and ancient a script. The monk replied that it was written by a young man who had died not long ago. Yanagi was still more impressed and continued to talk about the quality of the writing all day. A little later he wrote Suzuki from Tokyo and asked him to try to find some way by which that specimen might be added to the museum collection. Suzuki turned the matter over in his mind, wondering whether to go to the governor of the province and try to get him to add his persuasions to Yanagi's or to make a gift of money to the temple. Eventually he decided that neither of these methods was in keeping with the occasion, so he went to see the priest himself and talked to him for hours about Yanagi and his work and the Mingei Museum. But the monk said he had a deep respect for the young writer and did not feel he ought to consent. However he fell silent and began

to pray and meditate. Afterwards he explained to Suzuki that he had been visited by the soul of the dead man who was delighted by Yanagi's request and who had asked him to comply, which he now did with pleasure, as his sole desire was for the good of the departed. He was a priest of the Shingon Sect in which such communication is not unfamiliar. Yanagi sent the temple a piece of his own writing (Great-Shingon).

Suzuki tells me he wants to go on with pottery but that Yanagi has discouraged him and has often advised him to stick to lacquer. He says he regards Yanagi and Hamada and myself as his 'sensei' (teachers or guides). He went all through the war, his mother was killed in the bombing and he has had no love for America in consequence. In his late teens he came in contact with our work, and abandoned the world of machine design and the background of mass-production, because they did not provide the things for daily life which gave him warmth and delight. When the war came to an end and unconditional surrender was announced, the officers in his battalion went half mad and began destroying things right and left with their swords. Suzuki, a sergeant, stood amongst his comrades and appealed to them saying that it was still their responsibility to set an example and to preserve order. They listened to him. After demobilisation he went and worked for a farmer, and so kept body and soul together, but he said that no matter how hard and well he worked, the farmer would only cast a glance over his light body and grunt, 'You will never make a farmer'.

Then he received a letter from Mrs Yanagi saying that her husband had been ill for a long time and that they feared for his life. Three telegrams followed begging him to come. He arrived in frayed uniform, the maid did not know who he was, he brushed past her and went upstairs and found Yanagi lying in bed very thin and weak. Yanagi said, 'It is you? You are alive? You have come back?' and tears flowed down his face. Suzuki stayed and dug up the pots which had

been buried all over the garden, collected other treasures which had been sent out of Tokyo, and began to put the museum in order whilst Yanagi slowly recovered.

NOVEMBER 2ND

The last day. Last night I invited the young Sudas to supper and gave them drawings for all the workers, made the night before, also a couple to Suzuki who has carried out or forestalled my wants at every turn. The essence of what I have tried to impart to him (at his request) has been Yanagi's philosophy of nakedness, the acceptance of one's own born character and faculties. His response has been direct and immediate.

Upon leaving I ordered sake for the crew and 250 pots to be made for my return next spring. I could not persuade old Mr Suda to accept any money for the pots made so far, but I said I would not come back unless he agreed to a proper monetary arrangement.

CHAPTER 8

Back in Tokyo and Kyoto

The folk museum has been completely rearranged with fresh exhibits done as only Yanagi can do it. They included many of our purchases abroad and the woodwork, chairs, tables, buttons, etc., which I designed and supervised in Matsumoto. A few things are simple and serviceable, based on English or early American traditions, and some of the others are improving. They will be wanting renewed suggestions when I get up there again next summer.

There was a reception at the British Council for Sir Robert and Lady Robinson who had expressed a desire to meet me. He is the F.R.S. and Nobel Prize winner. On the way I had a minor accident and tripped head-long on some rough paving when crossing a road hurriedly. I was cut and bruised and half stunned, but no Japanese came to my assistance and it was only when I had got to my feet again that a passing G.I. came and put his arm around my shoulder and asked if I was all right. Somewhat later on it was explained to me that a Japanese would not offer help, unless it was quite necessary, in order to spare one's pride. How easy it is to jump to wrong conclusions in the East.

All the same, speaking of rough surfaces reminds me of something which I notice constantly. One can never walk or drive in Japan, confidently, not even on Ginza. One has to keep one's eyes constantly

on the way ahead because a six inch pot hole, dry or wet, may otherwise engage one's foot or wheel. For this reason drivers have a way of 'weaving' which adds considerably to the excitement of traffic regulations which are honoured in the breach, and particularly by taxi drivers. The marvel is that there are few accidents. This I ascribe to the quick reflex action of Japanese nerves and, of course, the slower rate of progress which obstacles entail. People walk across the headlights of cars nonchalantly, children carrying babies on their backs move the necessary number of inches in the last fraction of time without turning a hair, projecting bicycles are shunted into doorways, drivers reverse, never get angry, and nothing actually touches anything or anybody.

Considering that there were no roads in Japan thirty years ago it is wonderful that today cars, trolleys and buses go everywhere. A country's roads take much time and money to build and Japan has had neither. The landscape is nine-tenths mountain and volcanically steep at that. What car springs, tyres and gears are made to do has to be painfully experienced to be believed. Automobiles do everything except climb trees!

It is far too much to expect a poor country to produce a road system comparable to those in the West, overnight as it were, but it seems to me that the concept of upkeep might be altered. At present it is the usual practice merely to dump some pebbles of various grades into a hole, when the road or path has become almost impassable, and to leave the traffic to work them in. Economically I am given to understand that it costs less to do the repairs at an earlier stage.

What the Japanese do with bicycles is also astonishing, three up is commonplace, and when it is, as often as not, a man in foreign clothes peddling with 'geta' or clogs on his feet, and his old mother is sitting side-saddle at an angle of 45°, in kimono, the overlap of two ages is vivid. Perhaps the most surprising common sight is to see a shop assistant delivering a tray of piled basins of macaroni to some

house – a dozen or more held aloft in one hand, the other on the handlebar, threading his unperturbed way through the throng – our paper boys have still something to learn.

NOVEMBER 7TH

My small exhibition in the second floor gallery at the Tokyo Takumi shop opened today but all the pots were sold before the opening, so we collected fifty more pieces out of stock to save the natural irritation of people who had waited until the proper day. Many of these pots were made at Fujina and I felt annoyed when I discovered that almost exact copies of my pots were for sale on the first floor at about one-third of my price. This is absurd, and the height of absurdity is reached when on some of these pots I even find my signature, B.L.! My protest is at the copying of personal design. The Western assumption would be that this was plain dishonesty, but it is nothing of the sort, in fact the intention was complimentary. That is how the issue is looked upon in the communal background of the Far East, and it is only when the individualist West disturbs the old group-soul order that the problem becomes acute. The old order does not supply the moral code with which to face the new individualist and more competitive life.

We can afford to abandon the overstress on the soloist, but we cannot pretend to do without leaders and one corollary is that design should be paid for reasonably and not copied. It all comes back to the recurrent problem of imitation and integration – death and life. Money is the least important part of the issue, but it is the most outward, and ought to reflect an inward truth. In the old world of folk-craft most of the designing was impersonal creative copying which is quite another matter. Life was whole and integrated and the craftsmen drew their inspiration from a common cultural stock, from the accumulated experience of right making, which we call tradition. They could copy, or rather absorb, fresh ideas into their life

and action. This is a capacity which has been almost lost and must somehow be regained.

I am not content with Yanagi's, Hamada's and Kawai's principle of not signing pots, either; design and leadership today are dependent upon individual perception and not upon broken or breaking tradition. The designer is also 'worthy of his hire' and not signing his work, although a significant symbol of protest against over-egotism, is not the complete answer. It just cannot be right today, when the capacity of creative assimilation is wanting, for one craftsman to merely copy another and profit by it. I might point out that although Kawai and Hamada do not sign or seal their pots, pot lovers throughout Japan know their work at sight and both of them yield to public pressure and sign the lids of the boxes in which collectors keep their pieces.

NOVEMBER 8TH

A flying visit to Utsunomya for a lecture to a selected audience, 'Craftsmanship Today in Relation to Work and Japanese Society'. Whilst we were having lunch with the governor and officials, a Mrs Takamatsu's card was handed to me and she came in and was introduced. Forty-four years ago she was the brightest of the girls of about seventeen whom I taught at the Ueno High School. She took me aside and said clearly and quietly in English, 'Dear teacher, I have never forgotten that you were my first teacher of English. I wish to thank you. I pray for your health and happiness.' There was a pause and everyone beamed with pleasure and surprise.

NOVEMBER 9TH

Another lecture to 150 schoolmasters of the province of Nagano, where there is a high level of education. Many of the audience were old subscribers of the *Shirakaba Magazine*, of which Yanagi was the editor and I was a contributor, forty years ago.

We stayed at Kutsukake near the active volcano, Mount Asama, which was cloaked in snow, and the mountains down to Myogi, where we climbed rock pinnacles when we were young, were garbed in exquisite white traceries. Our landlord was a real bird-lover and told us fascinating stories of the bird life in these mountains. The strange habits of the cuckoo and the Japanese nightingale. Apparently the cuckoo not only lays its egg in the nest of the nightingale but subsequently returns, in the absence of the parent birds, and ejects their young, one at a time, until it is assured that its own offspring receives the full attention of the nightingales!

In the train Yanagi told me the history of the 'Kichizaemon Edo' Tea-bowl – the most famous of the classic Korean tea-bowls made in the Ri Dynasty as common-or-garden rice bowls. This one belonged to Fumaiko, the Feudal Lord of Matsue who died about 100 years ago. His son placed it in the great Zen monastery of Daitokuji in Kyoto and it has not been used since. The tea masters of today say it has gone dry from lack of use, for tea soaks into crackle and leaves a slight deposit on the surface which adds quality and a friendly warmth to the glaze and exposed clay. When the bowl is exhibited thousands come to see it from far and near; after a week it is turned upside down and thousands come again to see its foot-ring. Yanagi added that there are better bowls. But the really strange and interesting thing is that the perceptive eyes of the early tea masters not only selected what two or three hundred years of highly critical aestheticism has continued to rank on the highest plane, from out of a background of quite ordinary country craftsmanship, but further-more built up a new background, centred in the tea room, where these masterpieces of the unknown craftsman became the classics of a new culture.

November 15th

To Osaka by Hato (Pigeon). I am sick of spouting a half-caste Japanese and hearing my own voice come back on the tape, and of

being given photographs of myself. Everybody has a camera, and everything is 'zeitaku' (luxury) in an age of poverty, whilst we hang on the edge of disaster. That is the mood I am in, true as far as it goes. The old Japan, yes; the country, yes; that golden harvest of hard work from Aomori to Kanazawa. 'The sazanka (a variety of camelia) will flower again, quietly, half-hidden', but not yet awhile, as Tomimoto wrote in a poem and letter to me, translated below:

'All people with grief
Beating each other and crying
When war came
Like hail over corn.

But the time will be
When the red sazanka
Will bloom again,
Quietly, half-hidden,
Fear not,' that time
Will come again.'

'I wrote this poem at the end of 1947. I wished to send it to Leach but I could not translate it so I did not send it.

KENKICHI TOMIMOTO.'

NOVEMBER 20TH

Kyoto. I have been taking stock of all of last month's travel and discussion, searching for roots and meanings and directions, and back beyond, right to my first coming to Japan forty-five years ago. Something has happened to me almost below the level of consciousness – 'Dr Suzuki's 'jirikido' and 'tarikido', the mystic paths – 'Tat quam asi' and Manifestation, or the Great Prophets – Buddhism and Christianity – and latterly the conviction that

without the matrix of religious faith, and today the need for an overall World Faith, the artist-craftsman cannot become the real leader of any craftsman's team, only the conductor of his own compositions, keeping the orchestra in its place as purveyors of his thoughts, save for the exceptional personality who breaks out to form another orchestra, or to walk the tight-rope of personal expression. This does not liberate art in ordinary work and is an insufficient solution. It becomes inescapable to me that until the sweeping compulsion of a great inclusive belief from the deep core to the outer circumference blows through the world once again, all we can do is to tinker, art cannot bring salvation to the many, nor can the solitary road of the mystic; it needs the vision of the individual without individuality.

NOVEMBER 21ST

I met Tomimoto at his little house yesterday afternoon and had supper there. A tiny house, but all the contents fine with his own character running through all arrangement and selection – Sen cha (green tea) taste, different from 'Matt cha' and certainly not 'Mingei'. Afterwards we took a car to an oasis in the hills behind Osaka called 'Hari Han', the luxury retreat of the Osaka rich. Tomi had been an art adviser and had designed some of the contents. We were exquisitely fed, showered with presents and shown four paintings by Tomioka Tessai, made a few years ago before his death at the age of ninety. Pure ink brushwork and good. The last of the old painters.

NOVEMBER 22ND

The next afternoon a party of us, including the Tomimotos, visited the noble Zen temple of Daitokuji. The monks were cleaning up after a gathering of some hundreds of pious visitors; the keen-eyed abbot, sweeping with the rest in ordinary working 'mompei' (loose overall plus-fours), came and spoke to me saying that he knew my work. They showed us the great kitchens where fine vegetarian cooking is

done for hundreds. These were akin to medieval English kitchens. We drank tea and admired rock and sand gardens. The finest of such gardens is at the Ryuanji temple, raked silver sand and a few rocks so justly placed as to be unforgettable. Austere, noble and symbolic, the spirit of Zen and the root of 'shibusa'.

NOVEMBER 23ᴿᴰ

Today an excursion with the whole Horiuchi family to Takagamine, the craftsman's village built by the great Honami Koyetsu in 1615, in the hills to the north-west of Kyoto. As soon as I saw the twin domed hills they reminded me of the form of his lacquer writing boxes and I was certain that he drew the inspiration for them from observation of the nature which surrounded him. These hills falling to the vale of Kyoto as we sat in the afternoon sunlight of an autumn day looking

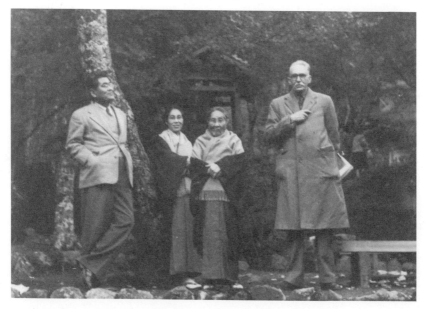

The author with Dr Horiuchi, his wife and mother, Takagamine, November 1953.

through vivid maple leaves carried me back over the 300 years to his own looking. With the priest of the Koyetsu temple I poured water over the simple grave of the first and greatest of artist-craftsmen. Then we wandered around the temple precincts of the Jakkoin, secluded in its little side valley amongst tall plumes of bamboo. Worn stone steps and the quiet voice of a nun patiently telling the beads of history.

After a dinner party we decided to go and see a film called 'Muhomono' (Lawless Men). What a film! Set in the forests of Hokaido amongst Japanese lumberjacks. Nothing but the bad points of American 'Westerns': the mannerisms of the bum actors; the rankly false psychology, Hollywood, not Japan; the sentimental love interest; the Gary Cooper tough mounted police rot; horseback silhouettes of bad riding and shapeless horses; the runaway trolley with hero and heroine aboard which should have been derailed at the first curve; the bad men; the breaking ropes which held the run of timber from the trolley below; the shooting with guns which never required loading; the all-in fights, with Japanese short swords added, and the never ending pursuits and the death-bed repentance of the villain. Not a touch of genuine drama or acting, no iota from real Japan, and yet a full and appreciative audience of about 2,000. Oh, post-war Japan. How can I be blind to this inner defeat? A shame to the influencer and a shame to the influenced.

NOVEMBER 25TH

Shizuoka on the way back to Tokyo.

A terribly long meeting, lectures, films and slides at another industrial art school – newer but no better. The city has just spent £100,000 on yet another lifeless error. The whole affair topsy-turvy, outside in and no 'in' of real Japan at all – just the thinnest veneer of worn-out Japanese design in artificial lacquer. These institutions, instead of fostering the remnant of Japanese craftsmanship as a good gardener would treat native plants, are bent upon importing foreign

plants and making them grow upon Japanese soil, whether they want to or not, and according to foreign standards which have evolved in foreign countries. The same thing is happening in horticulture itself and the question is whether the resultant fruit has more flavour even if in some cases it is bigger.

They are proud of their new toys, just as the drivers of taxis are proud of their radio sets, and turn them on without considering the possibility that some, if not all, customers might want to go on talking, might dislike bad music, or might even prefer silence.

As to the expenditure of public moneys upon institutions which are fast destroying handcraft traditions, a tithe of the money judiciously applied could work wonders in preserving and adapting, and even in exporting Japanese handcrafts alongside improved industrially-designed goods. Japan is not likely to make this improvement unless the effort is based upon those home-grown ideas of material, shape, colour and pattern which are the residue of her hand-made history. This is a national treasure which, even to the average foreigner, it appears a madness to throw away.

NOVEMBER 26TH

Quite a long earthquake at 2.45 a.m. A grey day. Twice-burned Shizuoka looked to me just about as interesting as the Mile End Road, noisy, dusty, shapeless and drab. In fact the negative aspects of new Japan have got me down and I would like to be out of it for a month of quiet in England, just to relax and talk to my friends in my own tongue and to feel the under-currents of ideas and the emotions of home.

Back in Tokyo I received a letter from an Italian sculptor questioning me for omitting the inter-relatedness of North and South in my writings about East and West and asserting the importance of cultural integration in Europe itself prior to any grand schemes of world unity. The following passages are taken from my reply: 'We as

Westerners, or as individuals for that matter, must expand from our own cultural foundation if we are to understand any other, otherwise we are thrown off balance. Modern Japan is in just such a position, America has not yet reached balance or, as I generally express it, found her tap-root. I am deeply engaged with this problem amongst Japanese craftsmen. There are those, a handful, who have passed through Western influence and reached integration, or reintegration, and there are a multitude of half-baked artists and craftsmen who have been disintegrated by Cézanne, Gogh, Picasso, etc., and by the overwhelming confusion of modern movements. Also some 30,000 country potters for whom the sap is nearly dry in the root.

'I am here because I was born in the East and fate has thrown me between East and West. Perhaps I have understressed North and South in Europe and elsewhere. Yours is a valuable reminder.

'The mortar of Christianity, yes, but the very Christianity which succeeded Plato and Aristotle was non-European in source and without it I do not think we would have had either the medieval English pitcher or the German Bellarmine. It was Christianity which digested Greece as far as we are concerned (with constant throes of indigestion); ergo, it is an overall religious concept which we as inheritors of all cultures require in order to gain a world equilibrium. It does not seem to me feasible on an exclusively occidental or oriental platform for we are interlocked as never before. If the Christian concept could come out of Palestine 2,000 years ago and spiritualise and individualise Greek thought, then it is more possible for a fresh dispensation in our time of yet greater need. If it were sufficiently embracing in character there would be no necessity for crushing Greek or Christian or Oriental values.

'As to Michael Cardew's 'Greek Vase' footnote in my *A Potter's Book*, yes, Greek art until about 500 B.C. Then comes a split between beautiful drawing on pots and artificial and dying forms which became dead mutton in the hands of Wedgwood in the eighteenth

century. I admit that until late in life I could not see the early truth and beauty clearly because of that pseudo-Greek foreground: the Greek stood for the first time in history, a naked man in the sunlight of the Aegean, proud and unafraid, the Goth hid in the shadow of the spire and the Cross, crouching in the North. Rouault inherits today from the stained glass of the twelfth century; Cézanne essayed the South; Japanese have said that he was a bridge to the East. Individuals will always spring but we need a much greater release; a spiritual fire sweeping from the centre to the circumference again. At the international conference last year, in England, I observed that the essential craft problems are the same today from East to West and from North to South.'

Industrial society appears to have lost the spiritual core without which scientific, intellectual, indivdualist and artistic activities become barren to the extent that humility is no longer their leaven. Our Christian light came from the East where the continents join. Before that there was the light of Moses, of Krishna and of Buddha, and after Christ, the light of Mohammed. Can we find peace and the maturity of man without such a light illuminating the whole world?

DECEMBER 16ᵀᴴ

The end of the year approaching. During these three weeks since my return from Kyoto I have cleared up a year's arrears of correspondence and I have sent upwards of 200 cards and letters to friends and I feel a weight off my shoulders. With the excellent help of my assistant, Mr Mizuo, I have also got well launched into the Koyetsu-Kenzan book and for the first time really dug into Japanese history. I have gained an insight into that epoch when the rule of the Ashikaga Shoguns was broken down by Nobunaga and Hideoyoshi and that of the Tokugawas established by Iyeyasu, between 1558, when Koyetsu was born, and 1743 when the first Kenzan died. Their lives, and those of Sotatsu and Korin and their associates, have been the loopholes

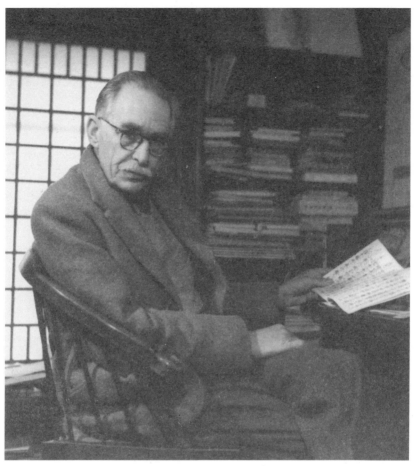

The author researching Japanese literature, 1950s.

through which I have looked intimately into a period during which an aristocratic idealism, dominated by Chinese Zen Buddhism, gave birth to the cult of tea, to the Nō drama and to many movements in poetry, writing, painting and the other arts, and then changed its character owing to the rise of the merchant. class with its popular arts of the Kabuki theatre and the colour print.

Animals: The dogs of the neighbourhood hold long converse at night, they discuss trivialities and complain in chorus. Little wonder, they are seldom off their chains, for official dog-catchers in special vans prowl the streets and pick up any dog which has got loose without a collar and badge. There is a price on skins and on good dogs. Chinese and Koreans eat dog. As an Englishman, I have often felt that, despite Buddhist beliefs about not taking life, and the ultimate destiny of all life, Buddhahood, Japanese are less sensitive about animal suffering. In China too we used to notice that horses and birds were well treated as long as they served man, and no longer. Here unwanted kittens are not killed; no, but they are often left to die in remote places.

DECEMBER 17TH

I took Yanagi's little granddaughter Miwako with me two stations up the fast tramway to Shibuya Station and searched the great big Tokyo department store for a tolerable Christmas tree and decorations for it. There were plenty, for Japan has adopted Christmas Day without its religious significance, but most of the trees were thin and vulgar and we had difficulty in finding small candles and holders because the trees are covered with coloured electric lights which abhor. Then we decorated it with much mutual help and pleasure.

DECEMBER 18TH

Dale Keller, Mark Toby's young friend from Seattle, came and met me at noon and we went off to Suido Bashi and spent six wonderful hours at the Kanze School of Nō. I wondered if I would get the same reactions and if he could enjoy it too. There was no question, the hair stood up on my neck. I received the thrill of great art and lived in it all day, and so did he, in a world beyond, of long ago, yes, but of all time. This was theatre, great in the sense of totality. Drama, music, dance, costume, decor and spacing, all perfectly united and springing from

the ancient roots of belief about life, evolving over centuries into a perfect technique. No doubt the Greeks had something to compare with this but they are dead and gone and this is still wonderfully alive. By comparison our opera is, to sight at least, raw and immature. The restraint of Nō is so impressive; almost imperceptible movement at the outset conserving power for moments of drama. Perfect poise and footwork on the polished and reverberant floor. The stamp of white cloven feet and the strange unfinished half-stamp combining with the staccato tap of fingers on the little, waisted, corded drums and long drawn, plaintive notes of the flute and the sonorous chanting of the chorus. Mime and masks, severities against splendid bursts of brocaded colouring and groupings. Symbolic stage properties and a plain wooden background with a formalised pine tree painted on it. This is a still living aristocratic and heiratic art with 500 years of history; an art to which the four great decorators, Koyetsu, Sotatsu, Korin and Kenzan, all contributed.

DECEMBER 25TH

On Christmas Day fourteen of us, old and young, sat down to a great dinner. We drank the health of absent friends and relations, ate enormously, lit candles on the tree, gave out the presents and all were gay and happy, but I was far off within myself.

Sheep are nibbling the grass
On Romney Marsh.
Would I had a pillow
On Romney Marsh
Where flat winds blow through willow.

Love's door is shut on Christmas day,
My heart is full on Christmas day
Of what has been, great seas between.

CHAPTER 9

Onda

Every so often since my return to Japan I have been in receipt of invitations and messages from the potters of a remote village called Onda, in the southern island of Kyushu. They seemed to be most earnest that I should go and work with them for a time and they offered to make me a foreign bed, to prepare foreign food and to build a special bathroom. Yanagi told me of his first visit after hours of walking over mountain tracks many years ago, of the simple unspoiled life which they led and of the good pots which they made. He and Hamada were most anxious that I should go there and finally it was arranged, but not before I had done all I could to discourage special preparations.

APRIL 1ST

After three winter months of study and writing in Tokyo I eventually started out on this journey alone, on April 1st, taking the 'Tsubame' (Swallow) express, once more, to Kyoto, where I was met by Kawai and his nephew, Takeishi Kawai. We changed into a fast tram and were met at Kobe an hour later by a group of 'Mingei' supporters who entertained us royally at the craft restaurant, 'Chikuyotei'. We had the best 'Tai Sashimi' (raw fillets of sea-bream) which I have yet eaten. At 10 p.m. we boarded a steamer bound for the port of Beppu

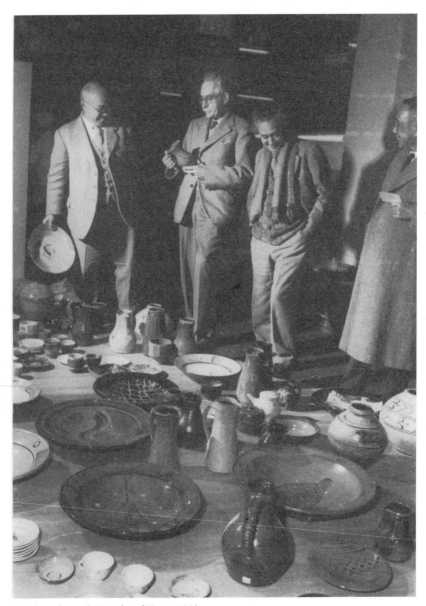

The author with Hamada and Yanagi, 1954

at the other end of the Inland Sea. At dawn we picked Hamada up on the coast of the big island of Shikoku. He came aboard loaded with some excellent cakes called 'Tarto'. They resembled good swiss rolls, only instead of jam they were filled with a dark sweet bean paste. About 300 years ago the local Daimyo imported this new foreign food from Nagasaki where it had been introduced either by the Dutch or Portuguese traders. We reached Beppu about 8 a.m. This is a famous hot-spring centre and bulges with Japanese Inns. Visitors were strolling the streets in 'yukatta' (cotton kimono provided by hotels). From miles out at sea we had seen the spumes of steam rising against hills as we skimmed. over a calm sea. During the night hours we had missed the most exciting scenery when the ship threaded its way with or against fast tidal currents, yet it was a beautiful dream yesterday morning with the ever-changing outlines of the myriad islands and the little dark fishing boats hung in transparency.

On arrival at our Japanese hotel we were met by Hosoda, the Governor of Oita Prefecture, and his officials, and entertained to dinner followed by a long and warm discussion about the preservation of crafts in the province Then we went for a stroll in the busy and unbombed town. Spring festival, cherry blossom, crowds and all shops open until midnight. First we visited antique shops and saw some good things and I bought a Seto oil lamp plate, about 150 years old, for a friend in the British Museum for £2. The prices were lower than in Tokyo where nothing is cheap any more. We were recognised by the dealers, because of the evening papers, I suppose, and proper prices were quoted. I was given a further third reduction 'because I had come to help local crafts. The others then got busy with bamboo productions, very debased and fussy and finicky, catering as in all places where there is a 'memento trade' to the lowest taste. The other contents of the shops were enervating as well, the awful mannequins, textiles, dolls and pots too, and the ever-lasting radio turned on like forgotten taps.

APRIL 4ᵀᴴ

Over the mountains by car to the inland town of Hita to the Sanyokwan Hotel and another large dinner party with local officials. More discussion, the meaning of traditional crafts; why have I come to Kyushu, why to Onda of all places. Some twenty years ago when the late Prince Chichibu, who had read what Yanagi had written, wished to visit it, even the officials did not know just where it was.

Journalists and photographers morning and night, but we got out for a stroll in the evening and I bought another dish with a pattern called 'horse-eye'; we have a slip-ware dish in England with a pattern called the 'boney pie' dish made about the same period by corresponding folk-craftsmen. Hamada possesses an example. The town was much nicer than Beppu, there were good rows of shops and houses – more conservative – more genuine. Next day we called upon a bright and decisive old doctor who wanted us to see his ancient and beautiful house. The earlier portion was built in the Genroku period when the First Kenzan (my landmark of history) was alive. The little pocket gardens were lovely, gentle with the touch of time and an exquisite maple flamed in a quiet enclosure. Indoors everything was in 'Sen Cha' taste and carefully kept. He begged me to come and spend a night on the way back. Then we drove some miles and entered a long valley where the road got narrower and rougher and rougher and the slopes came down to us steep and dark with tall evergreen cryptomeria. At last on a bend we caught a glimpse of fine bark-thatched roofs and men standing, 'Onda no sarayama' (Onda of the mountain plates). We were late for lunch by an hour or more so they must have waited long. All along the winding stream people were waiting in front of their beautiful homes with tall bamboo plumes overhead and flashes of pink cherry in the abrupt slopes. After a light meal we went the round of workshops and were introduced to some of the 180 villagers.

Long communal kilns reached down to the rough roadway, but

the thing which astonished me most was the potter's clay and its preparation. It is hewn from the hillside as a half-decomposed ferruginous rock and then pounded by wooden stamps of the most primitive kind, a great baulk of wood some 18 in. square and perhaps 15 ft. long with a heavy wooden pestle right-angled at one end, a pivot towards the other which is hollowed out into a bath holding say 30 gallons of water fed through bamboo pipes until the weight of the water raises the pestle end 6 ft. or more, causing the water to empty and the pestle to come down every half-minute with a heavy thump into the hollowed earth where the soft rock is heaped. Twice a day it is reshovelled and that is all the attention it requires. Each workshop has a pair of these 'Kara usu' (Chinese stamps) as they are called (with a small one alongside for hulling rice), and that makes just enough powdered rock which when mixed with water, and sieved, provides sufficient fairly plastic clay for throwing the year through at practically no cost. A few years ago visiting officials decided that this was all too primitive and installed up-to-date electric machinery in a concrete building, but very soon the villagers had more clay than they knew what to do with, they forgot to oil the unfamiliar bearings (they do not even have to do that with their wooden pivots), and the machinery went to rack and ruin. We came in for a bath in a tiled bathroom, neat and clean and specially built despite my protestations. Supper followed; butter, cheese, cocoa, meat, fish and even crisp toast away up here in the remote mountains – and somehow they have found out how to prepare them. I hardly like to think of the trouble which has been taken. There is a table for me and a soft chair which they wanted me to sit in whilst they all, twenty-five of them, gathered for a grand meal on the matting. I thanked them, but refused to sit above their level and we put the chair by the desk in the next room where I can sit comfortably and write or draw when I am tired. Old Mr Sakamoto, our host, made a short welcoming speech to which I replied, stumblingly, saying that I

had come to learn, but that if in any way I could help them in return, nothing would give me more pleasure. After the food and sake and beer, Hamada and Kawai and everybody else warmed up and talk became free and funny and when Kawai selected a bed-pan for special praise, the conversation became Shakespearian and uproarious, but never nasty. Kawai and Hamada sat most of the next day directing the young throwers who were making tea-bowls and covered water-pots for them. The pots flowed out so naturally and the suggestions of one or another of us were taken up and incorporated with ease. But on the following day when the bowls were being turned, I fell silent as I simply could not agree with the foot-rings which Kawai favours and I felt that they contradicted the impersonality which he had so warmly advocated only the night before.

APRIL 8TH

Hamada and Kawai have gone, Takeishi and I remain. He looks after me with such thoughtfulness and foresight and acts out of his good nature as a kindly solvent all round. Early this morning, as I lay abed, sounds of water gushing and periodic thumps of the stamps pounding the clay fell upon my ears and the sweet low notes of the Japanese nightingale coming in from the thickets. It is cold before breakfast and I must go and warm up in the 'Kotatsu', which is a low table covered with a rug under which there is a well in the floor with charcoal in the middle. People sit all round and plunge their legs into the warm dug-out. Very friendly. Today I started with my big pots, plates, jars and bread-pans as they take longer to dry. I did not attempt to throw, myself, there wasn't the necessity and I have not got a comparable skill nor familiarity with these tools and clay. Young Sakamoto carried out most of my wishes without difficulty and with a breadth of easy traditional handling which I could not hope to match.

April 10th

A long day's work. Up at 7 a.m., cold wash, diary, selection of drawings of pots, breakfast at 8 a.m. Back and forth decorating the big pots with brush and slips, with comb and gravers, keeping an eye on new pots growing on the wheel and yesterday's drying in the sun. Pots everywhere strewn upon the ground amongst playing children and scratching chickens and yet they rarely get broken; potter's children and presumably potter's hens too! I put one pot on its side with its bottom towards the sun and a toddler came in to tell her father that one of the pots had fallen over! During the morning a press photographer interrupted our work to take this charming photograph of the Sakamotos and myself drinking a cup of tea, spring in the air and the mountain cherry a-bloom. An interval from 12.30 p.m. to 1.30 p.m. for a light lunch, then work until dark interrupted by an interview with a representative of the Mainichi Press who arrived unannounced after a long journey across the island. Bath and supper. Half a dozen brush drawings on the prepared cardboard-backed forms called 'Shikishi' to give to various people who have been kind.

April 11th

Today half a dozen young potters turned up after walking four hours over the mountains from Koishibara which is the nearest potters' village. In fact, Onda's tradition derived from Koishibara 240 years ago. The origin of both, as is so frequently the case in Japan, was in Korea, ravaged by Toyotomi Hideoyashi about sixty years before that. Pottery was a passport, then as now, and the Korean potter-prisoners were settled by the feudal Daimyo in their provinces and usually treated well. These young artisans, for the owners in Koishibara are a clan apart, watched me decorate and 'pull' handles all afternoon and then were persuaded by the Onda potters to stay for a warm-hearted sake supper and a discussion with me afterwards

on shape and vitality in pots. Incidentally, they asked the invariable question, 'What did I think of Picasso as a potter?' I gave my usual reply that, however gifted as an artist, he simply was not a potter. Potters start from clay up, he starts from painting down. His pots are often vital and interesting as creative design, but the 'Picassiettes' of his thousand imitators, without his birthright, are an international disaster. They were keen and intelligent in a countrified way and we carried on until bedtime. At four in the morning they set off homeward over the hills.

April 12TH

Today the village has got up an hour earlier than usual to prepare for its Spring Festival in the afternoon. Each of the sixteen households takes bottles of sake and a great dish of special food to a meeting place, out-of-doors if possible, but today it is raining and so it is to the village hall. Conch shells are blown from household to household to gather the clan and I am seated in the middle of a throng of men, women and children, and toasted, and I toast them back, and reports and speeches are made, and all are merry, and when we cannot eat any more, an entertainment begins. Song and dance and mimicry, broad and very local. I was glad to get to bed, however, as I was not feeling well.

April 13TH

Yes, I have picked up what threatens to be a nasty cold. But I cannot afford to break the rhythm of work and the time-table. So all day I pulled handles for pitchers and jugs, medieval and English in general character, and enjoyed doing it as much as anything connected with the making of pots, the feel of the tongue of wet clay slipping through the palm of one's hand, the ribs and indentations which the pressure

The author working in Onda, 1954.

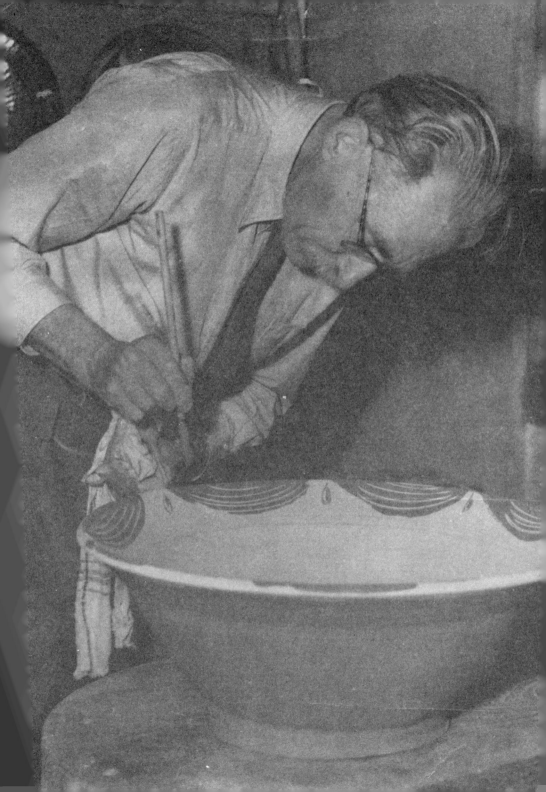

of one's fingers makes, the clean nip-off with a spade movement of the right thumb. Then the ramming home of the butt-end at the right point in the profile of the pot, the new bridge with perfect tensions and suitability for easy grasp, and finally the attachment at the other end of the span, with its grace note of wipe off and clean finish. This is very English and nothing more true and beautiful exists than the handles of our old slip-ware. In making handles something other than myself is at work and that, no doubt, is why these remote Japanese mountain potters were attracted, even as I have been attracted by the impersonal rightness of their traditions. In fact, I knew more clearly on this day the underlying motive which has drawn me back to the East once again. It is to rediscover the unknown craftsman in his lair, and to try to learn from living and working with him what we have lost since the Industrial Revolution of wholeness and humility.

Strange to relate, they do make a traditional pitcher with a handle here, and here only, in all Japan. Something like this and with rather a hard handle. Definitely un-Japanese in shape. We concluded that it must be yet another residue of old Dutch or Portuguese influence. I have learned two methods of decoration, one of which was employed in Sung China and which has intrigued and puzzled me for years. They call this one 'Tobe gane' or 'jumping iron'. Instead of a normal right-angled tool for paring the half-dry shapes, they use a springy curved one which, when applied at right-angles to the slowly spinning, slip-covered pot, chatters on the surface, removing a touch of the engobe at each jump, and so exposing the colour of the clay body below. So simple, so quick and so effective. The other process, also with slip, is softer. Slip is basted on to the pot with a broad straight-edged brush, smoothly, and the surface is dabbed rhythmically, as it turns slowly, with the loaded brush.

I don't think any European craftsman can have had such an experience as these weeks with these delightful, unspoiled hill-potters, in the remote mountains of Kyushu, has given me. I keep

wishing that this one or that of my friends in the West could share it. It has not been the kindness and courtesy alone, extended day after day not only to us, but also to the many visitors, often from far afield, who have been fed and wined and often given beds for the night. What impresses me most is the spontaneous community action with its basic unity of heart. Long may it beat and the 'Karu usu' thump in the stream below. Evening after evening, bath and supper over, the young men, or the old men, or the women, come in groups and talk and ask questions. They want to know about our customs and feelings and I want to know about theirs. They know so much more about us than any corresponding group of villagers in the British Isles knows about them! Am I a dreamer if I think that in some ways they are more prepared for world citizenship? They own their land and homes, there is no dire poverty or great wealth, they grow their staple foods on little terraced fields and paddies between the steeps; clay, water and wood cost but the labour and now they are mentally free from the bondage of tradition. That, however, is where the danger lies. Suddenly take away the props and the resulting stresses and strains may be too much for the old building.

I have been around with some camera men taking a movie of the village and was rather horrified to find, despite all that we have discussed of an evening, that my shapes and even patterns have been copied in every workshop. I found my children everywhere dressed in ill-fitting garments! That means to say that instead of a 10 per cent absorption of outside influence, which I have suggested as normal and healthy, this is at least a 75 per cent invasion without any resistance. And that as I see it is what is happening to Japan, in general, now. This problem of imitation, which appears to the Western mind, at first sight, as commercial dishonesty, requires study and open understanding. Here at Onda the usual superficial interpretation would be wide of the mark. As far as feeling towards me is concerned, the intention is a compliment; I am positive that nothing contrary

crossed their minds. To them it was simply the obvious thing to do, and my warnings they read as springing from personal modesty. I lack the training with which to probe the subtleties of group psychology and social evolution involved but it seems fairly obvious that the sense of proprietary rights in design grew with the industrialism and individualism of the nineteenth century. In Japan, and especially in this outlying remnant of old Japan, we run into another set of communal values. In Onda or in some good old country pottery, like Fremington in North Devon, let us say, a good handle, or a good shape, were just good, wherever they came from, without any of this new nonsense about copyright. Craft guilds existed to preserve standards and protect livelihoods, it is true, but it is only with the entry of the machine, on the one hand, and the separation of artistry from life, upon the other, that this high sense of proprietorship has developed. But it is equally obvious that the assimilative capacity of the far less articulate communities like Onda and Fremington has waned and requires new props. In Japan these are the leaders of the 'Mingei' or Craft Movement, with their philosophy of humility, and a subordination of over-stressed individualism to a co-operative and social proportion. My anxiety, even before I came here, was that the effect would be just so much more of the alien and indigestible. Yet Onda cannot be kept as an artificial enclave, it must swing with the national tide and one can take comfort by remembering that this, or a very similar process, took place in Japan when Buddhism brought over Chinese culture and about 300 years were required for assimilation.

As for my own pots, I am far from pleased with their too carefully planned decorations – how different from the carefree, birthright flow of the large traditional jars and bowls and bed-warmers and sake and Shoyu containers, just made to serve requirement in the most straightforward way possible without any art-anxieties. They come out of the life of these hill-farmers, and that is why we replied

to Governor Hosoda and his officials, when they suggested that it would be a good thing if the Onda potters were freed from the labours of cultivating the soil, that we could not agree. Theirs is a farmer's art and is as true to nature as the rice they grow and nearly as unconscious of beauty. They like and dislike and possess the broad practical 'know-how', just as with their sowing and reaping and rotation of crops – it is all the same, and unity is the keynote – but ours is in fragments and we cannot pretend to such innocence. For us the hard road of re-integration, either by self-culture, of which I am heartily sick, or by self-forgetfulness. My pots do need a fresh and more naked impulse, less planning, less reliance on the past and more openness to immediate intuition.

APRIL 19TH

Takeichi Kawai returned yesterday morning. Half the village gathered to see him off. He went around to each, bowing and thanking them so warmly and with such fine manners. His selfless consideration of others has been an object lesson.

The cold has got worse, coughing and a little fever. I was thankful to get away down to the town of Hita for a break. Whilst there I managed, however, to make about twenty drawings mostly for various people who have been so kind that I cannot refuse. Is there any other country where an artist's drawings are so wanted?

Young Mr Sumi came across the island from Futagawa where I worked for a fortnight, nineteen years ago. His father is still alive and well but, sad to relate, the war put an end to their old pottery. Young Sumi talks of reviving it on a small scale, I hope he does, if only for the sake of the most beautiful white slip on a dark body in all Japan; it causes the transparent amber coloured glaze called 'ame' to come out a lovely orange-yellow in their oxidised firings.

APRIL 21ST

Back again at Onda, the abominable cold is still heavy upon me. Nothing worse for colds than watching kilns at night, but I had to see how they did things and drink a cup of sake with the gathered potter stokers in front of the crackling wood fires at the lower end of the long climbing kiln which contains most of my pots.

I was called into a cottage where a dozen laughing, chattering men and women were about to listen to a broadcast which I made a few days ago, mainly about themselves and their mountain life. A pot-loving Dr Inouye came to visit and scold me and he gave me a penicillin injection.

APRIL 22ND

Out in the early slanting sunlight to watch the side-stoking of chamber V. Smoke rising gently amongst the bamboo plumes, crackle of the 6 ft. pieces of cryptomeria wood being shot in from side ports, rush of water, thump of 'Karausu' and that nightingale. The firing of the Onda kilns is almost unbelievable. This one with eight successive chambers up a steep incline, each averaging 15 ft. width, 5 ft. height and 7 ft. from front to back, containing large raw wares, took only twenty-five hours from start to finish. The temperature averaged 1280° C.

The preheating from the main lower fire mouths took about five hours and each of the chambers only 2½ hours of side stoking. No saggars and no ordinary shelves were employed, and only about a third, at most, of the cubic area contained pots, the remainder was empty. To the scientific Western mind this might well appear at first glance to be an appalling waste, but the figures speak for themselves. The local calculation is that one of the large storage jars, approximately 2 ft. x 2 ft., is raised to the requisite heat by the average expenditure of one bundle of the fuel weighing 50 lb. Red pine is the best wood, but the demands for pulp and tobacco have driven the

price up so outrageously, apart from the ravages of war, that most country potters are feeling the pinch acutely. I was told that before the war it cost about £5 to buy a hill, and the wood on it, but that now the same hill would fetch £5,000. The last time I came to Japan the yen was worth a little over one shilling, now it is Y1,000 to £1.

Governor Hosoda and many others came up for our last day and cars crowded the rough narrow road. A broadcast, a last supper and our films shown out of doors. They clapped and clapped over the St Ives film. Yanagi arrived from Tokyo. Twenty-five of the best pots were taken down to Hita for exhibition where Mr Hosoda took the chair at a lecture and film meeting. He spoke well and with real feeling told the audience how, after defeat, he experienced what so many still feel – a loss of direction – something to hang on to – turning to us he said, 'You have given me something to work for, the preservation of Japanese expression through her crafts.' There was a grand dinner party at our Japanese hotel in the evening and next morning we set out in cars, in the rain, up another valley to Koishibara. Our party having arrived, we plodded through thick clayey mud from workshop to workshop and were delighted to find that, although at Koishibara there may not be as intimate a co-operation as at Onda, the work is, if anything, broader and larger. We had lunch with the potters, the most substantial 'bento' I have ever seen. 'Bento' is the equivalent of a luncheon basket. Each consisted of a plain light wooden box containing chopsticks, cold rice, fish, vegetables, pickles, etc. In this case, two large fish and meat as well, enough for a family. On the way back, the car I was in literally slipped sideways, at dead slow speed, more or less into a paddy field and we spent ages, with the help of farmers, heaving and levering it back again.

April 26th

Farewell to Kyushu, to lovely Onda, to Governor Hosoda, and to those whole-hearted mountain potters.

APRIL 27TH

Train to Kyoto, sway, jerk and rhythm of indented rail hammering out mesmeric miles. I wrote a card to Onda folk. 'Yama Zakura to isho, nantonaku mijikai' which may be translated, 'With the mountain cherry, how brief!' Three weeks, 300 pots, many of them large and, what I have not mentioned, excellently fired, almost without loss. Hills receding to faint blue and the steeps of the cloudless sky shot with gold this April day in Southern Japan. Boys' Festival carp floating over grey tiled roofs once again. The passing sun-soaked beauty of the hills!

It was good to be with the Horiuchis again in that warm-hearted Christian family, and to be looked after for a bit for I had not quite recovered, and found myself getting tired. So I took it easy for a few days. Strolled Kyoto's attractive streets. Bought a good book on old Karatsu wares, a piece of old lacquer and a few pots, but I have a feeling that I don't want to collect even beautiful things for myself unless they are stimuli towards production. We went into a book shop and were told that they had just received and already sold thirty copies of my *A Potter's Portfolio* at £4 10 s. a copy. Visited Tomimoto with Horiuchi. There is a tired look in his face offset by spurts of enthusiastic talk. He is terribly disillusioned about modern Japan and when it came to discussion of his proposed visit to England, he began to grumble about our winter climate. Tomi told a story of a curio dealer who turned up one day with an old pot of Tomi's and a box, the lid of which he asked Tomi to sign. Tomi said to him, 'If I do so, the value will be increased and I think you ought to pay me a 10 per cent fee.' 'That is not unreasonable', said the dealer quoting the pot's value at Y1,000 instead of Y50,000. Whereupon, a friend of Tomi's, who was sitting in the room, immediately added 'right, I'll have it'. Exit dealer, minus signature.

I think I should make it perfectly clear that Tomimoto was not seeking money for himself so much as putting a check on the avarice

of a dealer who was attempting to make bare-faced profits out of Tomimoto's signature.

We visited the School of Art where he has about eighty students. I was not really excited by their work or that of his group on show in Osaka. I also saw an exhibition of pots from all over Japan arranged by the Asahi Newspaper. Hamada and I both estimated, separately, that not more than 10 per cent ought to have been selected. At the Kyoto Museum where there was an excellent small grouping of Sung and T'ang pots and early Chinese sculpture, Mr Fujioka showed us interesting fragments from the site of the First Kenzan's kiln at Narutaki, north-west of Kyoto. He asked our opinion about a porcelain bowl signed 'Kenzan'; we both said at once, 'Yes, that is an original'. The interesting point arose as to where it was made. Amongst Kenzan's kiln shards are rough experiments in porcelain body and glaze, but this was well potted and no experiment. After careful examination, we came to the conclusion that Kenzan had decorated a plain Arita bowl with overglaze. There was no mistaking the Kenzan touch in this case and I am having a coloured illustration made of it for my Koyetsu-Kenzan book.

MAY 11ᵀᴴ

With Horiuchi we drove out to the Ninnaji Temple where I had heard that there was a small house known as Korin's. It turned out to be actually the very house built by his brother Kenzan in Genroku 7 (1689) when Kenzan was twenty-eight. A Zen priest, who was a friend of his, called Gettan, wrote a charming description of 'Shu sei do' as it was called, and of its owner. This I had already translated. Our pleasure in sitting in Kenzan's own tea room was keen, and afterwards when we walked to the site of his kiln at Narutaki and picked up fragments of his saggers, and even a bit of a pot with a plum blossom pattern painted on it, which Mr Horiuchi saw shining on the path, our excitement was great. At the small adjoining temple

we were shown more shards and also the formal grant of land, quite a large piece, to Kenzan from his friend Prince Nijo, countersigned by the village elders. Finally we went on to Omuro and found the pond which was in Kenzan's garden over which he built the bridge called 'yatsu hashi' which is often depicted on his pots and 'on his and his brother's paintings. During these days we had two meals with Mr Kobayashi, who has written the most scholarly work on Kenzan, and much helpful talk. He was kindness itself and I am under a great debt to him.

MAY 12TH
 Returned to Tokyo.

CHAPTER 10

Conclusions and Farewells

The foregoing pages have been taken more or less from my diary, or from the journals which I have sent abroad from time to time, written between February 1953 and April 1954, whilst the experiences which they describe were thick upon me. Much has been omitted and still more unattempted for sheer lack of time. I have been foolish enough to allow myself to be over-persuaded and to undertake too much. More than 10,000 miles of travel, over 1,000 pots and 1,000 drawings, lectures, articles and broadcasts, the greater part of two books written and ten exhibitions of work done during a total of twenty-one months. Altogether too much and with a consequent lack of clarity which I regret. A diary, however, is by its nature shapeless and all I can do to bring it to a conclusion is to summarise a few of the more important convictions touched upon in various chapters.

MAY 15TH 1954

At this year's annual craft meeting at Utsunmya, near Mashiko, I raised the problem of the copying by traditional craftsmen of designs by individual potters, after telling the gathering of my own experiences at Onda and Matsue. A few agreed with my protest, but Kawai jumped up and challenged me to say that my designs, or any

The author, the Yanagi family and Kawai, May 1954.

other artist-craftsman's for that matter, belonged to me or to them in any sense of exclusive possession. I admitted that they did not, any more or less than children do, and that it did not matter so long as the result was good but that in fact they were not successfully adopted and not truly alive. If they had been the problem would not arise, for they would no longer be mere copies.

His reply did not explain the fact that there are many more such unhappy orphans in our day than in any other. The same issue arises in the West, but to a smaller extent, because in the slow growth of individualism a far wider public has come to recognise the difference between copying and creative influence and to decry the former. I was somewhat taken aback by Kawai's protest and, to avoid public dissension, did not pursue the argument.

After the meetings a small group of us, including Kawai, Yanagi and Hamada, were driven to a strange place of Shinto pilgrimage at the head of a long, narrow valley twenty-five miles away. We put up in

a huge private house, some six hundred years old, containing a shrine to 'Tengu Samma', the 'Mountain Guardians' of a living mythology. The heavy structural beams of the vast kitchen quarters were black with centuries of wood smoke. The walls were covered with votive tablets and carved masks of long, red-nosed 'Tengu Samma'. Two such masks, five feet long, looked down upon a room filled from side to side with indigo blue 'futon', or quilts, for a large party of fishermen's wives from the promontory of Boshu, one hundred miles away, who make this long annual journey to pray for the safety and success of their husbands at the very moment when their boats push off for the first catch of the season. Today they are informed by telegram of the exact hour. We were up at 6 a.m. to join the supplicants in their intense chanting to the accompaniment of drums and the constant sound of offertory coins falling into wooden coffers. Superstition – maybe, but also a selfless belief.

MID-JUNE

For the second time I have made the long journey down to Kanazawa to work at the Sudas' pottery in the Kutani tradition. Suzuki is with me again and we have been hard at work all through these days decorating some 200 pots which have been made to my design since my last visit. He looks after my minor comforts, grinds the colours, lays the ground of thin size, covers my black brushwork with layers of transparent enamels, very skilfully, and acts in general as my batman, companion and buffer.

JUNE 18TH

We spent the whole day visiting potters in the neighbourhood. First, a Mr Yaguchi at Yamanaka hot springs ten miles away. He has a lovely house and workshop looking abruptly down on a green river gorge with maples bending over the rocks. After a ceremonial tea he showed us some of his treasures which included ten First Kenzan

dishes made at Narutaki. These were Raku ware and genuine, but two' other pots, signed Kenzan, were more dubious and were probably copies made in the Awata kilns at Kyoto about the time when the ageing Kenzan decided to leave Kyoto and to settle in Edo. Mr Yaguchi's own porcelain pots were highly accomplished and in a different class'to the effete copies, still being produced, of old Kutani, but still they did not seem to me to draw a vitality from that interblending of cultures which constitutes New Japan. I find myself in complete agreement with my Japanese friends, and apparently in disagreement with Western critics, who appear to value most highly those qualities in porcelain which may be described as Court Taste – whiteness and translucence of paste, meticulous finish and elegant décor. The Japanese like the earliest Kutani best, that which

The author discussing works with a fellow potter, 1950s.

was closest to the Ming period export-wares of China. The body is greyish and non-translucent and it has a severity and vigour absent in the porcelains, such as Kakiemon, or Nabeshima, characteristic of Arita.

During one day in rural Japan I have been shown sixteen pots purporting to be by the First Kenzan, and most of them have undoubtedly been genuine. Despite schoolwork and much downright forgery, there must remain, mainly in Japan, a good many pots of his making.

JUNE 29TH

Back to Tokyo for the opening at the Takashimaya Department Store of a large combined exhibition by Tomimoto, Kawai, Hamada and myself. Besides pots, Tomimoto and I showed drawings. His, and many of mine too, were mounted as Kakemono. His brush drawings are lyrical and pungent, and it is illuminating to see how he has developed from the pen and pencil of his youth into an even sharper and more delicate oriental brushwork.

It went off very well and there were quite a number of foreign visitors, but I was not happy about my own work, nor for that matter about Kawai's pots, which I seldom like, nor indeed about some of Tomimoto's. Hamada's pots had their usual well ballasted earthiness, but even they seemed to me to be less invigorating than usually find them; too earthy. I was tired and probably jaundiced in outlook.

In a recent talk with a group of craftsmen I told my good and bad impressions of present Japan with unwonted frankness. I was prompted by the question I have often been asked by sympathetic foreigners, 'Why do they copy all our errors?' I said that it seemed to me that the Japanese were often confused between East and West, inner and outer, old and new. That they wanted deeply, unconsciously, to enter that other Western world, so long forbidden, so new, so powerful, that they abandoned their heritage of culture for the sake

of what they think is ours. Their own inheritance appears to imprison them, to stand in the way, so they abandon it until such time as they reach the outerworld, see it from within and then return. Inevitably they must pass through every error before they can know error from truth. Only a very few sensitive and creative minds, like Hamada's, have made the round journey and begun to build a bridge. I took him and his pots and his home at Mashiko as an example of how it can be done in the right way when the expanded consciousness of an Oriental returns, fresh-eyed, and he, as a full and integrated Japanese, faces towards the future.

On July 10th I went down by invitation with my assistant, Mr Mizuo, to Kamakura to see the Museum of Modern Art. One of the directors, Mr Koyama (the well-known authority on Japanese pottery), met us at the station and showed us the best collection of Western pottery I have yet seen in the East; Egyptian, Cretan, Greek, Persian, medieval and eighteenth-century English, Northern and Southern European tin-glazed wares, a Picasso plate and, alongside it, one of my own. I was delighted to see, with as dispassionate an eye as I could contrive, how well our old English pottery stood up to the test of comparison. Apart from my own, possibly prejudiced opinion, it may come as a surprise to people at home to hear that the 'seeing eye' of Oriental pot-lovers so far away should place in the first rank the rude but warm and vigorous pitchers and platters which until quite recently we have neglected.

We had a delightful Buddhist vegetarian lunch in the quiet rooms of the Zuisenji Zen temple and then went to see the great tenth-century bronze Daibutsu bending in meditation and mercy amongst the treetops of a small park. The noisy children of American GIs were clambering over the knees of the Great Buddha and their parents were taking photographs of them amidst the admiring crowd of defeated Japanese. After that we made our way out to Kugenuma to call on a Mr Akaboshi to see his collection of Korean Ri pots. He kept us

to dinner and we talked about our common friend, Asakawa, from whose pen the Western and Eastern world has so long awaited a book on Korean pottery of which he has a quite unrivalled knowledge. At the back of the craft museum there are large cases of shards from many kiln sites, which he and his late brother excavated years ago, waiting to be tabulated and re-examined to yield their history to mankind. Koyama, Akaboshi, Yanagi, and others, myself included, have tried to persuade the old artist by every means in our power to make the effort to give the world his unique knowledge. Temperament and old age make it hopeless.

MID-JULY

I have recently made two broadcasts; the first was on 'Why Western Craftsmen come to Japan', the second, with Dr Yanagi, was a discussion on craftsmanship abroad and in Japan.

AUGUST 6TH

To escape the heat and to get ahead with my writing we have come up to the quiet of the mountains and the cooler air at Matsumoto once more. Welcoming faces at the Kazanso hotel, the high alps lifting to the moon again – sickle moon and one star shining.

Janet Darnell has come up with me to do the typing of my manuscript. She arrived recently from New York to work with Hamada. She was one of the pottery students at our seminar at Black Mountain College in South Carolina and shortly afterwards asked Hamada if he would accept her as a student in Japan. It took a year before he decided to do so and meanwhile her letter remained unanswered. Three months later she arrived, having wound up her affairs and closed her own small pottery. I met her in Tokyo and set her on her way to Mashiko from where we have just come. She has character and sincerity of purpose.

We visited the little nun, whom I mentioned last year. For twenty-

five years she has lived alone and spotless in her thatched, hill-top hut, rosary and shrine, hands joined in prayer for the living world, that we all become one in Nirvana. She gave us green apples and we drank her green tea looking out on the sun-soaked plain of Matsumoto. On parting she presented us each with a Buddhist rosary.

AUGUST 14TH

The books progress, I have finished the section on Kenzan and Korin and I have been reading Fenollosa's *Epochs of Chinese and Japanese Art* written half a century ago. I have found his appreciation of what he first called the Four Great Decorators, Koyetsu, Sotatsu, Korin and Kenzan, keener and more generous than anything. which I have come across written since. Nevertheless much information about these artists and craftsmen has come to light in the interval and to this I have had access.

The author pictured later in the 1960s with his wife Janet Leach (née Darnell), whom he met whilst on his travels to Japan.

AUGUST 15TH

Yanagi, Hamada and Kawai arrived, work has gone well and I have come to know Janet.

SEPTEMBER 2ND

August gone, another three months and all this experience will have sunk into time past.

During these last weeks our long daily discussions, resumed from last summer, for the book on the way of the potter, East and West have ranged over territory which concerns life as a whole. The more we gathered of means of making pots the more meanings have forced our attention to essential underlying problems. Means are but consequences of meanings, both change almost imperceptibly, thus the meanings of the present as the outcome of what has gone before is our point of departure: the character of art today: the evolution which has led up to it from the anonymous craftsman, through the designer for the machine to the artist-craftsman of our time, the nature and interplay of pottery in East and West as reflecting the cultures of the two hemispheres; thence to the cultures themselves and to the cultural roots in race, climate, aesthetics, morals and philosophies, and ultimately to religious beliefs. Out of all this has emerged a considerable degree of common agreement on fundamentals.

For me the greatest gain has been in appreciation of the meaning of 'Mu', or unattachment, deeply imbedded in Taoism, Buddhism and ever present in Zen-inspired arts and crafts. It is from this Eastern source that I believe that the Western world can draw sustenance and fresh inspiration. This is the ground out of which Oriental art has grown: this is the source of Shibusa, of nothingness, of emptiness, of non-action, of Nirvana. But Western interpretations of this antithetical thought have hitherto been altogether too impregnated with overtones of rational thinking. 'Mu' is no mere negative but a state of undifferentiated being unattached to either negative or

positive. It is the quality we most admire in pots and it is that rare condition of which we catch glimpses in men and women when the Spirit of Life blows through them as wind through an open window. Then action flows easily and naturally and without overstress. This is the antidote to a 'universal grey' but it is not the outcome of individualism or of intellect. It is the treasure of the humble craftsman and the haven of the greatest artist.

Dr Yanagi's aesthetic philosophy, consistently supported by Shoji Hamada and Kanjiro Kawai, is rooted in a belief in the 'unknown craftsman'. In the kind of people I found at Onda and in the kind of work which sprang from life nurtured in the framework of an old and wholesome culture. The twin foundations of such life and such work are belief and humility, two virtues of which we have become sadly bereft in the Western world. Dr Yanagi's opponents accuse him, and the movement, of being retrogressive, they say that an attempt is being made in the teeth of progress to manufacture folk-art. I do not believe that he is so foolish as to think that such a thing is possible. The challenge in his doctrine is more radical than that for it is directed at the modern artist, the artist craftsman and the tea master alike. He does not suggest that they should pretend to become unconscious but, for the lack of a better term, what I shall call super-conscious. He states that the artists and the craftsmen, whether they be Bachs or Beethovens, Koyetsus or Cellinis, produced less significant art than the unknown writers of Plain Song, and the unknown weavers of Coptic or Peruvian tapestry, or all the hosts of unknown artisans who worked humbly in clay and stone and metal and fibre in the protective unconsciousness of great belief all over the world. This is a drastic revaluation which leaves the modern artist stripped and naked on a dunghill of over-stressed individualism. It is an attack upon our current social values, but it is not an attack upon the function of the genuine artist in his proper unobtrusive place in a healthy society. What Yanagi proposes

is an abandonment of ego-centricity and pride, which is both good Buddhism and good Christianity. Losing oneself in art in order to find oneself, whether by the simple way of belief in tradition and hard repetitive work, let us say as a journeyman potter, or by the intense search and self-discipline of 'satori', or reintegration, of the more conscious artist or craftsman.

It may be that I personally would place more emphasis upon this process of reintegration, or attainment of wholeness, in the individual artist, because I am one, but it is also because, as Western man, we are disintegrated. But this has also become true of modern, and particularly urban, Japanese. Which is illustrated by the fact that forty years ago in Tokyo artists and craftsmen were closer together than they are today, and also by the imitation and indigestion to which I have drawn attention on many pages. The process in Japan has been hastened by an increase in an already powerful national inferiority complex which was the inevitable result of the first defeat of a proud race. Therefore Yanagi's meaning to us Westerners and to Westernised Japanese is reintegration, whereas to the Japanese artisan, as distinguished from artist, and to these of a conservative turn of mind, it is the preservation of integration.

So much for the people and their life; with regard to the works which they produce, these may be judged upon their merits and defects, but we can rest assured that if they are good there must be truth of being behind them, though that may be, and often is, only a private truth of life in comparison to the congregate truth of good traditional periods of society. The best of these appear to me to lie not in those periods when we are accustomed to look for them, such as the High Renaissance, but earlier, even perhaps in what for centuries we have called the Dark Ages. These incubating or smouldering periods burst into first flame in China in the fifth or sixth centuries, in Japan in the seventh to eighth and in Europe between the tenth and twelfth and never was the light so bright again, although there

may have been more of it. Then it was that 'men of abounding energy', those whom we later called geniuses, themselves enflamed, worked in the common cause like Prince Shotoku or the great monks of East and West.

If I read Yanagi right, and he says I do, this is what he means. The only difference between us is that he, however he may feel the desirability of the sweeping unifying power of a great inclusive wind of religion, does not see its likelihood, but as a Japanese with the characteristic 'seeing eye', knows that art is an unarguing language of communication between one man's heart and another in his 'Kingdom of Beauty'. I, as the reader may have already sensed, believe that the Great Wind is already on the way.

Another form of the same kind of criticism which is levelled against Yanagi and his followers is that he, and they, talk and write so much about 'Gete' (the ordinary) and so little about 'Johin' (the refined). Taking the former to mean the plains and the latter to mean the hills, it appears to me that the landscape is incomplete without both and that the one calls for the other. If, as I am told, it is true that Yanagi writes little about the mountains, it is surely because they are mole hills and not real mountains. Koyetsu not a hill? Bach not a mountain? That certainly is looking gift horses in the mouth! And yet I am with Yanagi for wanting to look every gift horse in the mouth in this age of ours, for if we don't we'll never get out of the rut we've got into. It has taken us long enough to discover that we are in one and most people, including artists, complain, but won't admit the fact even now. Besides, Yanagi has never said that both of these great men were not mountains in their landscape, what he did say was that there have been bigger ranges formed out of whole peoples over long periods of time. We are at the close of one age and at the commencement of another, that of the maturity of mankind as a whole, and one of the focal points where the greatest experiment in the fusion of the two halves of human culture is painfully taking

place is Japan. Our English historian, Arnold Toynbee, explains clearly how Japan has gone headlong into industrialism and lost the ballast of her inheritance. He also states that 'unity is the only alternative to self-destruction in an Atomic Age'. If, as I believe, this is true, we must seek a road towards human unity. Beyond my love of the Japanese people and of the beauty of their land and the warp of its culture, that is why I have come back again and again.

It is the excuse for the foregoing pages with all their shortcomings. This is Dr Yanagi's contribution to the world of art and by reason of his life-long search, persistence and eloquence he has gathered his followers and held together the strongest craft movement of our day. By the examination of art in the light of 'Mu' he has broken the dualistic tensions between the 'I' and the 'not I', between artist and craftsman and between the individual and community. One of the best examples of 'Mu' in pottery is the work of Koreans during the Ri Dynasty, but it shows itself all through Korean crafts to such an extent that it is almost impossible to find any really bad, impure or diseased work. As with the drawings of unspoiled children, no ego obtrudes, never does self-consciousness show its uncomely face.

To a large extent this is true about all folk-art. Such has been the service of the unknown craftsman all over the world. We who have split personalities and split culture are no longer unselfconscious. We have to discover a process of reintegration; the journey from the self back to the whole.

SEPTEMBER

Before I came up to Matsumoto this year, Kaneko Yanagi told me of a Mr Suzuki who has his school of music in the city. She said that he was the leading teacher of the violin in Japan, and a remarkable man, and she hoped we would meet. In due course he invited us to come to his school and hear his children play. We arrived just as he was about to start his afternoon class and he asked us if we would

like to sit and watch and listen. There were about fifteen boys and girls between the ages of five and thirteen in the large room and a number of parents sitting against the walls on chairs. He called the youngest, a boy of five, who came out into the middle of the room, quite unabashed, with a tiny fiddle under his arm. Without any fuss, fully concentrated, he put his bow to the strings in no uncertain manner, and played a short and simple piece by Bach which made me sit up in astonishment. It was so pure. Then one of the older girls played a Bach Chaconne, I was going to say like a concert artiste only it was better than many, there was no seeking for effects it was just Bach. I had never heard a child play like that. Mr Suzuki then took the whole group in unison. Standing before them he started a few notes on his own violin on fragments of one piece after another – Chopin – Mozart, without explanation or warning, and in a second they were all with him as one, true and free. Tears came to my eyes and I saw that the rest of our party were also deeply touched. After that this strange Japanese teacher divided the group, waving to one half to stop, and then to the other, at any moment, leaving the rest to continue without pause or break. Next he asked them all sorts of questions whilst they continued to play 'How many electric bulbs are there in this room?', 'Tell me what is written on that scroll', 'If you cannot see, go and look, but don't stop playing', 'Now, stand on one leg and play, now the other, now squat'. Then he asked half the group to go downstairs to the floor below, walk along the corridor and come up the other stairway and see if they could return to the room having kept perfect time with those who had remained.

They did so. These children obviously loved their teacher, but directly they began bowing they were completely engrossed in the music. Afterwards we had much talk with Mr Suzuki and subsequently invited him and the whole class, with their parents, to spend half a day at our hotel. The proprietor and his wife and the staff entered into the spirit of the occasion and we had a wonderful time with

good music and food and fun. It seems that Mr Shinichi Suzuki spent eight years in Germany and married a German. When she parted from him he returned home and gave up the idea of being a concert artist himself in favour of teaching children. He became convinced that the usual training in music for the highly gifted overlooked the almost untapped latent potential of, not only the average child, but even of those who are classed as tone-deaf. Mr Suzuki concludes that the latency is due entirely to post-natal conditions.

This I find difficult to accept, but whether ante- or post-natal, a more or less infinite potential seems to be revealed. The fact remains that the majority of the children Mr Suzuki teaches belong to the last category, as do also his best pupils, some of whom have been sent to famous teachers in the West for further study.

It is Mr Suzuki's belief that the tone-deaf child, so called, is the product of an unmusical background, or of fear, and that it takes about as many years to undo the damage done as it takes to produce the condition, and that is why he likes to start with the child very young indeed. He mentioned one infant of only two years of age to whom he began playing the simplest tunes for a few minutes each day to penetrate and sustain the child's aural emotions by constant repetition. This man holds the magic of release, and not in music alone, as we discovered in conversation. He saw the infinite potential in the human soul, he knew his gift and was alight. So were his children. He told me that he had arrived at his original conclusion by considering the fact that all children master the complex instrument of their mother-tongue with ease. At one point I asked him why he was teaching Japanese mountain children foreign music. He turned to the group and they played various Japanese melodies; turning back to me, he answered, 'Am I not right in thinking that there is only the music of mankind?'

I am not sure that I can accept all Mr Suzuki's premises outright, but results speak with an inescapable authority and we have not only

been deeply impressed but have also begun, at least, to relate his conclusions with our own concerning the teaching of crafts.

AUGUST 28TH

There would seem to be unplumbed depths in each soul, but the framework of souls, the conditions under which the depths may be plumbed, so that the hidden riches may be exposed without any self-assertion, that is the voyage of discovery on which we are embarked. How moving such dedication to life is, away from the bonds of the little self, when one meets it in strange and unexpected places.

We were invited to supper by a Mr Kotaira who lives on the other side of Matsumoto. He is a collector of pots, a friend of Mr Suzuki's and an angler. We feasted upon trout which he had got up at 3.30 a.m. that morning to catch in a mountain stream. Chatting about anglers, he agreed that they were all a bit 'touched'. He suggested that they fished to be alone with nature, to forget their worries, their wives and their children. Also to play with fish rather than to catch them; to become fish, odd fish. I thought of fishermen on the banks of English streams, fast or slow, on the banks of the Seine, of fishermen everywhere, timeless between water and sky.

Today there came a long distance telephone call for me from Tokyo and a voice asked if I was not coming to the UNESCO Conference – the first in Asia – as I had been asked to act as the British Observer. I was taken by surprise, first, because I had received no prior communication from London or Paris; secondly, because the leaders of the Japanese Craft Movement were with me and had made no mention of this conference which was dealing with the subject of Crafts in Education. Subsequently I did receive an official letter from London which arrived a fortnight after the conference opened in Tokyo because it had not been sent by Air Mail! I decided to put my work aside as soon as possible and to attend the last fortnight of the meeting in Tokyo and find out what was afoot.

During these last hurried days I have completed the Japanese version of this diary and corrected Janet's typescript and we have sent off the bundle to the Mainichi with a great sense of relief and release. We have also been to several farewell supper parties, at one of which we were confronted with a most unusual Japanese dish consisting of thin fillets of raw horse-meat assuaged with a piquante sauce tartare. I must confess that not until we had fortified ourselves with several cups of hot Japanese wine could we overcome either British or Texan prejudice. However, when, remembering former unjustified antipathies to raw fish, we tasted the meat, we both found it tender and tasty. Another strange food which we have eaten recently with an effort, but have again found good, consisted of young bees, but this time cooked. At the final party we were guests of the proprietor of our Kazanso Hotel, Mr Nakamura, and his nice stout wife. The meal was out of doors and consisted of what in Japan is called Genghis Khan Yaki – thin slices of beef and onions and garlic cooked by each person for himself on an iron grill over charcoal, dipped in Shoyu sauce and eaten with rice. Very good indeed. Mr Nakamura made a speech and told us that we were the most welcome guests he ever had and that he hoped we might claim him as an old friend.

On September 10th I returned to Yanagi's house in Tokyo and proceeded, next morning, with my suitcase to the hotel which had been reserved for this conference. I was introduced to Mr Trevor Thomas, the UNESCO Administrator, and to Mr Chowdhury, Director of the School of Arts and Crafts, Madras, and to some of the thirty to forty representatives of fourteen countries, eight of them Oriental. I decided to listen and try to catch up on what had been happening during the first fortnight, but I was surprised that no representative of the Mingei Kwai (the independent National Craft Movement) was present. My surprise increased as I slowly gathered that its existence had been ignored, and when I was told by one of the American representatives that to his enquiry as to where the National

Craft Museum was situated, the official Japanese reply had been, 'What museum is that?', I began to look for an explanation. When the opportunity came I spoke briefly about the museum and the work which the Mingei Kwai had done. Contrary to my expectation I received support from several of the Japanese delegates. The fact was that the Japanese Ministry of Education had reserved an office in the building from which it could keep a keen eye on proceedings. Even after the war the old deference to authority remains and independence is not officially appreciated. Once however, I, as a foreigner, had started the ball rolling it actually seemed to make it easier for the Japanese delegates to speak more freely. But still the official line had to be followed in the main.

As the days passed we listened to some very interesting and some boring papers, and there were keen discussions and good fellowship prevailed, but the spirit did not compare with that at our conference at Dartington either in vitality or vision. I could but recollect how Yanagi and Hamada had riveted audiences both there and all across America, but here in their own country they and what they have stood for was being shamefully neglected. What this conference lost by not having Dr Yanagi present to speak for Japanese and Oriental craftsmanship I leave to the judgment of my readers.

I was asked to be chairman of a sub-committee to consider the request from half a dozen Eastern countries for a compendium manual of all crafts. After two or three days' consultation this committee came to the following conclusions:

(1) Children are better off without a handbook. Such books become of value at a later stage, i.e. for advanced students and for teachers.

(2) A single volume covering all the main crafts and dealing with the techniques suitable for different age groups would be impracticable.

(3) We suggest therefore that when the time comes each craft should have its own manual based upon common principles and practice but enlivened by constant reference to local variation which the compilers feel have more than local value.

(4) Believing as we do that the teaching of Arts and Crafts should be a fundamental part of education, we feel that it is UNESCO's particular function to encourage that kind of teaching which introduces the modern child to the aesthetic background of all cultures, beginning with its own and expanding outwards.

(5) At this stage, in place of the proposed handbook, we suggest that each Asiatic country concerned should investigate its own crafts, whether traditional or modern, and make a report to UNESCO, so that headquarters would at least have the opportunity of gaining a more thorough grasp of the varying conditions in different parts of Asia. I am glad to say that the conference adopted our proposals unanimously.

During the nine days in which I have taken part in general discussions it has become clearer and clearer how difficult it is to obtain from the Asiatic representatives, especially those from Japan, a free expression of their true feelings. Not from lack of opportunity, or encouragement, but because of a predominantly Occidental approach and setting in which the Oriental mind functions with little real ease. The education into which a belated injection of arts and crafts is being sought is predominantly Western and post-industrial in character. Most of the members of this conference have been trained in it. Little attention has been given to Asiatic culture or to any difference of approach to either education or craftsmanship. This appears to me lamentable, and with all the goodwill in the world the danger of a grey internationalism resulting from UNESCO's efforts remains.

If one considers the difference of approach to craftsmanship in, let us say, Europe or America, where the objective is individual and

creative, and in thousands of remote villages in India, China or Japan, Where traditions of right-making have been handed down from master to pupil for centuries in a kind of protective unconsciousness, or by stages of initiation, it becomes evident that no standardised methods of instruction can meet both needs.

I would like to make a plea both as an English craftsman, and as an old participant in Japanese Crafts, for the workshop as the proper place for the transference of craft skills from one generation to another. With the decay of traditional right ways of making things, which are both useful and beautiful, developed out of centuries of communal experience, we have arrived at a stage where only a handful of artists or craftsmen in any industrialised country produce work of real and lasting value. The natural desire of these artist-craftsmen is to make, and teaching is a secondary issue.

The fact is that with us there are not enough sound craftsmen to teach the teachers, with the result that a very high percentage of craft instructors are theorists with amateur skills. All too often they are expected to both learn and to teach a smattering of half a dozen crafts with bad materials, unworkmanlike tools and inadequate time. They face mistrust and a despising of a non-intellectual subject by the academic majority. This might not matter so much if there was any guarantee that what they encouraged was a broad appreciation of genuine art and craft, but the results as shown in the works of diploma students in England, and everywhere else where I have examined them, are almost invariably deplorable when compared with the work of uneducated country craftsmen.

Two problems are involved: first, craft teaching as a part of general education; secondly, the professional training of craftsmen. The more highly industrialised a country the greater the shortage of teachers for either purpose. What we need to rectify in the West is the spread through education of superficial and false ideas about crafts. No training whatever would be preferable to much that is going on. By

contrast, in the less industrialised countries much sound tradition and many craft skills remain and for them it is more a question of vision and discrimination on the part of their educational authorities. At any rate the traditional craftsmen and the natural materials exist; with us this is no longer the case and the difficulties of making a contribution of craftsmanship to real education are far greater.

The East has always had its own ways of passing standards and skills down the generations; we too had them in the West before the Industrial Revolution. I feel very strongly that our characteristic Occidental organisation and external clarity, even when proposed to the East by men of exceptional sensibility and goodwill, will only lead to an increase in the quantity of second-rate Oriental crafts unless a radically different contribution is forthcoming from Asia.

I am convinced that, apart from the harm which an external approach to education and crafts would do to the less industrialised peoples, the whole world stands in need of a fresh understanding of work as an expression of the spirit of man. We have yet to discover the means of releasing our buried potential of wholeness. We have not only split the atom, but ourselves to boot, and somehow we have to put the bits, heart, head and hand, together again.

SEPTEMBER 29TH

I went with Yanagi and Hamada to visit Dr Daisetsu Suzuki at Kamakura once more. After supper, in reply to a question which I asked concerning the Shin Buddhist concept of 'Oya Samma' in comparison with the Christian concept of God, he replied, 'Your Western idea, which is Judaic, is of God, the Father – Oya Samma is Mother, too'. He paused and added this charming little footnote, 'Once Christ was making the rounds of Heaven with St Peter and remarked, "Peter, there seem to be some tenants who really ought not to have been admitted", Peter answered, "My Lord, I am afraid that that is so, I try to obey your instructions exactly, but the trouble

is that the Lady, your mother, is always letting some unworthy people get in through the windows. She is too kind." '

OCTOBER 18TH

Last journey to Mashiko to complete the pots for my final exhibitions.

During these few days Prince Mikasa, another of the Emperor's younger brothers, came out to spend a night and to ask Hamada some questions about the history of pottery as he is himself an historian. The visit was informal and the Prince was unaccompanied by officials, but the house and grounds were surrounded by inconspicuous detectives. I learned later that by the Hamada family unobtrusive, but considerable, preparations had been made. The 'shoji' (sliding doors) had been repapered, the mats recovered, the bathroom reconcreted, etc. Mrs Hamada and her maids prepared the best country food (she is an excellent cook), but Hamada himself retained his working 'mompei', or rough, but clean, indigo-dyed overalls. This I felt was unconventional but characteristic of Hamada and not disrespectful.

We, Janet and myself and Richard Hieb, were all introduced and together we made a tour of the houses and workshops. After that we sat round the long table and ate heartily and then forgathered round the open fireplace and talked easily about pottery and many other things until bedtime when the Prince, who is addressed as 'Denka', took a bath and was shown to his room in the new house. The following morning there were the usual press photographs and a delegation from a neighbouring small town to demonstrate an excellent and very old folk-dance – the Lion Dance. On his way back the Prince's car stopped at the little house in Mashiko where old Minagawa, who can no longer walk, had begged that Prince Mikasa would honour her by stopping and drinking a cup of tea. And so Farewell to Mashiko.

To Osaka. Goodbye party at the Kwansai Club where some forty craftsmen and a few foreigners had gathered for an open-air tea party. The next day we motored out with Tomimoto to the Harihan Hotel to spend the night as I did once before. Thence to Kyoto and the Horiuchi's home.

On October 26th we drove out in Mr Ohara's car to Tamba where Janet is expecting to work all next winter. I wonder how she will stand the cold and the hard mountain fare.

The local potters took us across their narrow valley to show us the remains of an ancient type of kiln of the kind which I have elsewhere described as a bank kiln. A long trough dug down a slope and domed in; an inlet as main firemouth at the bottom and an outlet at the

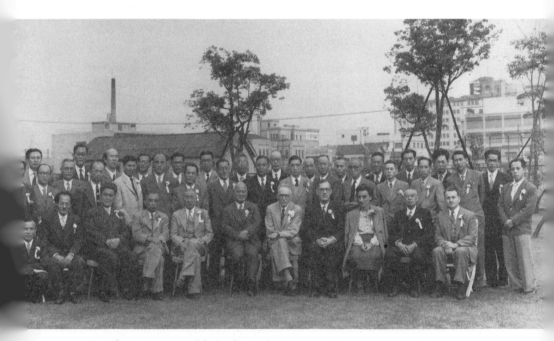

Farewell party at Kwansai Club, October 1954.

other end for smoke, and along the flanks, just above ground level, a series of port holes through which wood fuel was pushed right on to the serried pots as the heat travelled further and further up the bank. This kiln-site is about five hundred years old and is undoubtedly of the kind which preceded the present climbing kilns of China, Korea and Japan. The Tamba pottery traditions go back twelve hundred years and are the oldest in Japan.

Back in Kyoto we visited Tomimoto several times and went through the translations which Mr Mizuo and I have made of the First Kenzan's pottery notes. Whilst I was sitting with him on the last day, Moriguchi, the head of the Osaka Craft Shop, called and said he had something to show me and that he had been trying to find me for hours. He untied his 'furushiki', a coloured kerchief, and took out of an old box a set of ten 'raku' dishes wrapped in faded blue cotton and laid them on the table between Tomimoto and me. I was excited; I knew the clay, the glaze, the pigments and the brushwork, but I looked at Tomi and he looked back and nodded; yes, they were a set of dishes made by Kenzan at Narutaki undoubtedly. I asked if they were for sale and if so, at what price. Moriguchi said they belonged to a friend of a friend of his, that they had not come on to the market, that the owner was hard up, that his friend had heard that I was anxious to own an original Kenzan so Moriguchi had borrowed the set and got into touch with me as soon as possible. The price was moderate. I thanked him warmly and bought them on the spot. Since then I have discovered one of the same series in the basement of the British Museum.

OCTOBER 27TH

Great farewell dinner party at the Alaska Restaurant with many speeches. Most of the Kyoto craft group and about ten foreigners amongst whom was one Englishman called Bavier, whom I have met a few times, dressed very quietly and correctly in Japanese style and

speaking excellent Japanese. To the surprise of all present, instead of making a speech he sang an old 'Song of Parting' written by an early Chinese poet, and he did it well and with feeling. It was moving and I felt my impending departure keenly.

OCTOBER 29TH

Returned to Tokyo by night train.

NOVEMBER 16TH

My final exhibition at the Mitsugoshi Department Store opened today. The largest exhibition I have ever held, seventy drawings and two hundred and fifty pots, six sets of chairs and tables, etc., which I helped to design, and a model Western room of furnishings, normally sold by this shop, which the directors asked me to select and arrange.

At 6 p.m. last night I arrived and found the huge room in the hands of paperers, mounters, cleaners, etc., and some thirty of my friends forgathered, without my knowledge, to lend a hand. By midnight all was complete, order out of chaos, and looking very well.

The show has been crowded. Prince Mikasa came for lunch, Prince Takamatsu for tea. The British Ambassador, Sir Esdel Denning, and many foreigners. Practically the whole exhibition was sold out by closing-time. I feel quite overwhelmed. The management has been extraordinarily good and generous.

NOVEMBER 20TH

The last farewell party at the Mingei Kwan. Speeches by craftsmen from many provinces – even far away Kyushu. I tried to reply, I don't know what I said, I think it was quite inadequate, I was exhausted, and happy, and sad, and very confused. The kindness and generosity has been so great all over this my second homeland for close on two years, nothing I could say could meet the occasion; I am afraid of

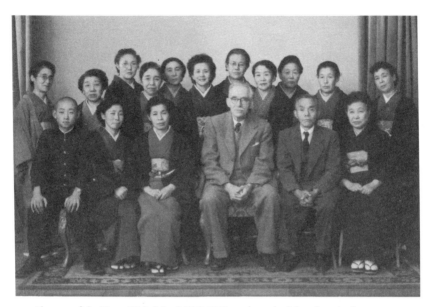

Alumnae of the Vyeno High School 1910-1913, at the author's last show in the Mitsugoshi Department Store, 1954.

oversights, things left undone, my own lapses; Europe, England, seem so far off, but I must go.

NOVEMBER 26TH

Everything packed and settled with a bare quarter of an hour to spare. Farewell at the Long Gate to the children and a dozen others then the drive out to Haneda. Formalities, the impersonality of an airport, so many friends gathered, photographs, last minute presents, telegrams, messages, two press interviews and a final broadcast, then through the barrier, loaded with bundles, looking at them all – a long look – climbing up the gangway, waving from my port window, moving off faster and faster along the runway, alone, airborne into the night.

GLOSSARY

BENTO	Picnic food usually carried in a box
DANGO	Rice dumplings
FURUSHIKI	A coloured handkerchief universally used instead of paper for carried parcels
GETE	Common, ordinary or rustic
GINZA	The Piccadilly of Tokyo
HAKEME	Coarsely brushed white slip decoration on pots
HATO	Pigeon
ITADAKIMASU	Polite form of 'itadaku', to receive
JIRIKIDO	The individual path towards enlightenment
JOHIN	Refined or in good taste
KARA USU	Chinese stamps for breaking up dry clay
KOICHA	Thick ceremonial Tea
KOTATSU	A shallow well in the floor of a Japanese room, heated by charcoal brazier and roofed with a quilt
KURA	A fire-proof storage room, or 'godown'
KWANSAI	A large area of Japan surrounding Tokyo
MAEBUTSU	A packaged local food product
MATCHA	Powdered Ceremonial Tea
MINGEI	Folk art
MINGEI KWAN	Folk building or museum
MOCHI	Steamed and dried cakes of glutinous rice
MOMPEI	A kind of baggy overall trousers
NEUBAI	The rainy season, June
OBE	The waistband over the Kimono
OYA SAMMA	The Ultimate Principle of Life
PACHINKO	The Pin Ball game
SASHIMI	Fillets of raw, boned fish
SATORI	Enlightenment
SEMI	Cicada
SENCHA	Infused green tea

SHIKISHI	Cards for calligraphy or painting
SHOJI	Latticed sliding doors covered with paper instead of glass
SHOYU	A salty brown sauce made from fermented soya beans
SOBA	Buckwheat
SOBAYA	A buckwheat macaroni restaurant
SUNAO	Friendly, warm or affectionate
SUSHI	A favourite dish composed of mouthfuls of cold boiled rice wrapped in slices of raw fish, etc
TAI	Sea bream
TAKUMI	The name of the main Craft Guild shop in Tokyo
TARIKIDO	The broad path towards enlightenment for the many
TATAMI	Compressed straw mats
TENMOKU	The name of the ferruginous black glaze commonly used in China and Japan
TORII	A ceremonial gateway erected in front of Shinto Shrines
TSUBAME	Swallow
YUKATA	The Kimono provided for all guests in Japanese hotels
ZEN	The main sect of Northern Buddhism
ZORI	Straw sandals